W9-DET-454

DATE DUE			

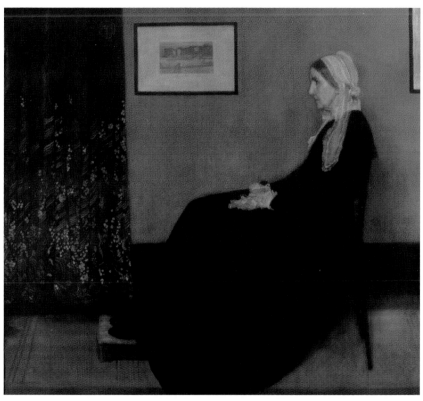

Arrangement in Grey and Black, No 1: Portrait of the Artist's Mother,
by James McNeill Whistler. Restored by Sarah Walden.

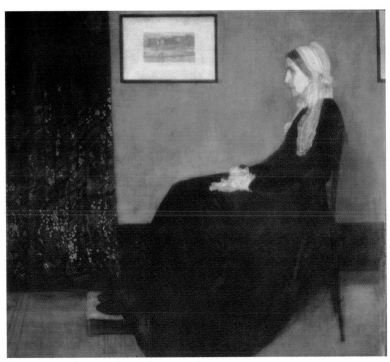

The painting in its unrestored state.

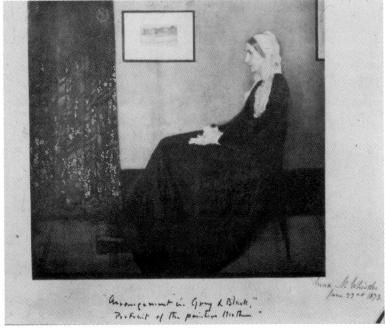

An early photograph with the handwriting of Whistler and his mother (1873).

WHISTLER AND HIS MOTHER

WHISTLER AND HIS MOTHER

Secrets of an American Masterpiece

An Unexpected Relationship

Sarah Walden

GIBSON SQUARE
&
UNIVERSITY OF NEBRASKA PRESS

This HB edition first published in the UK in 2003
by Gibson Square Books Ltd
15 Gibson Square, London N1 0RD
Tel: +44 (0)20 7689 4790; Fax: +44 (0)20 7689 7395
publicity@gibsonsquare.com
www.gibsonsquare.com

UK & Ireland sales by Signature
34 High Petergate, York YO1 7EH
Tel 01904 631 320; Fax 01904 675 445
sales@signaturebooks.co.uk

UK & European distribution by Central Books Ltd
99 Wallis Road, UK London E9 5LN
Tel +44 (0)845 458 9911; Fax +44 (0)845 458 9912
info@centralbooks.com
www.centralbooks.com

Australian, New Zealand and South Africa sales, please contact
Gibson Square Books Ltd for distributors.

ISBN 1-903933-28-5

Published simultaneously
by arrangement with Gibson Square Books Ltd
in the United States of America by the
University of Nebraska Press, Lincoln, NE 68588-0255

Library of Congress Control Number: 2003104221
ISBN 0-8032-4811-3 (cloth)

Printed by WS Bookwell Ltd

INDEX

ACKNOWLEDGEMENTS

In addition to my own research, I have received a good deal of help and advice in writing this book, and drawn on a number of existing works on Whistler. I am especially grateful for the help and encouragement of Françoise Cachin, former Director of the Musée d'Orsay and of the Musées de France. Denys Sutton's wise words on Whistler as well as his book were inspirational. Margaret MacDonald and Richard Dorment discussed Whistler with me. Saul and Janis Bellow kindly read the manuscript. I am also grateful to Michel Laclotte who personally oversaw the restoration of the Mother as Director of the Louvre, before the picture was transferred to the new Musée d'Orsay, and to his successor Henri Loyrette. To Geneviève Lacambre of the Musée d'Orsay, to the Fogg Museum at Harvard, The Freer Gallery in Washington, and to the staff of Whistler's House at Lowell, Massachusetts.

In addition to the works mentioned in the text I am indebted to *Whistler* by Pierre Cabanne, *James McNeill Whistler* by John Walker, *Whistler* by Stanley Weintraub, *The Man Whistler* by Hesketh Pearson, *James Abbott McNeill Whistler* by G.H. Fleming, *James McNeill Whistler* by Hilary Taylor, and to the wider perspective given by Barbara Novak in her works on American painting.

Finally I would like to thank my husband George for all his help, and my three children for their tolerance over my absences in Paris.

'We happy, idle chosen ones are few, who scorn utility, proud priests of beauty.'

Alexander Pushkin, *Mozart and Salieri*, 1831

I am still shown only a few, very few, who seem willing...

— Rahbek, Mozart and Salieri, 1801

1

THE PORTRAIT AS ENIGMA

'It is rare that one can judge an artist by a single work.'
The French painter and critic
Jacques-Emile Blanche on the 'Mother.'[1]

'Never touch that picture.' The warning took me aback. It came from one of the most venerable restorers at the Louvre at the very moment the porters were lowering James McNeill Whistler's 'Portrait of the Artist's Mother: Arrangement in Grey and Black' onto the easel in the studio where I was to work on it. It was a strange remark to come from someone used to laying his own hands on some of the most imposing masterpieces of the gallery. Stranger still was the tinge of apprehension in his voice. It was as if the picture, like the portrait of Dorian Grey in the story by Oscar Wilde, had some inner life of its

9

own that would be mysteriously disrupted at the first touch to its fragile, forbidding surface.

In a sense the old restorer was right: there *is* something oddly intimidating about Whistler's picture of his mother. In the many months I was to spend alone with it when I restored the portrait for the Louvre, it came to have a compelling, almost bewitching presence. Partly this was because of the place of the painting in the American consciousness; touching the 'Mother' at all seemed like tampering with the coin of the realm. Partly it was because all masterpieces exert a powerful effect on our senses. But there was a simpler reason for my growing fascination with the painting.

As I came to learn over those months, almost everything about Whistler's 'Mother' is a mystery. The extraordinary fact is that next to nothing is known for sure about one of the world's most familiar images. We do not know precisely when he painted it. The methods and materials he used are obscure. We have only an indistinct idea of what the picture looked like when it left the artist's easel; for reasons this book will seek to explain, it is a very different picture today. And above all, we have only the haziest notion of why the artist painted it and what his picture means.

The 'Mother' is frequently seen as one of Whistler's most straightforward pictures: a simple, moving image, easy to read and to like. Yet the simplicity masks an astonishing psychological and stylistic complexity. Born of an artistic crisis and of the artist's highly ambiguous relationship with his mother, its creation was almost an act of desperation. The 'Mother' was unrecognized for decades by the obtuse artistic establishment of England

and by Whistler's American countrymen, and its eventual sale to France — where it was destined for the Louvre — was the supreme and unrepeatable moment of his career, the summit of the artist's life.

Because we know so little about it, our view of the painting has often been distorted. The 'Mother' has been misread more often and more thoroughly than any other great image. As an icon of motherhood it is the best known picture in America. In fact, it has suffered from its very over familiarity, a painting reduced by time, by taste, by ignorance of its origins, and by the physical condition of the work itself to a tedious one-dimensionality, its power over the popular imagination too easily explicable. It has stopped being a picture; it has become a cartoon. Generations of Americans have seen in it merely a powerful symbol of maternal devotion and puritanical rectitude. Yet the 'Mother' was painted not as an icon but as an aesthetic object. And the more I discovered about its history, the less simplistic its 'meaning' became.

Even when I was away from the restoration studio in Paris, it became hard to get the picture out of my mind. For the purposes of my work I needed to know when and where Whistler painted it, the materials he used, and its subsequent history. All this was difficult enough to establish with any accuracy. But gradually I found myself searching for more than that.

On my frequent returns to London during the time I worked on the portrait I sought out the house in Cheyne Walk, Chelsea, where it had been painted more than a hundred years earlier. But my attempt to re-create in my mind's eye Whistler's studio as it had been on the

day he began the picture, on an impulse, was frustrating. All accounts left by his students and contemporaries are second hand; no one except Anna Whistler herself was present on that day. Why was so little known with any certainty? Slowly I began trying to piece together the different elements in the personal and artistic crisis that had led to his sudden decision to embark on the portrait and to discover how the idea had come to him.

The trail was well covered. Whistler led a highly public life, yet as my search widened, the enigmas surrounding his most famous work didn't diminish; they grew. The source materials for that time in his life proved far skimpier than I had thought; at one point I even found myself searching Whistler's mother's cookbook[2] (with some success — Whistler called it the family Bible) for clues to help me understand the portrait. I scoured the writings and memoirs of his wide circle of acquaintances or contemporaries, who ranged from Oscar Wilde to the French symbolist poet Stéphane Mallarmé, for references to it.

Reports from long defunct newspapers — whether the *Pall Mall Budget* in London, the *Boston Evening Transcript* in America, or *Le Gaulois* in France — only compounded the problem, since they illustrated the astonishingly different reactions of the critics in the three major countries that featured in Whistler's life to his greatest painting. I even collected as many as possible of the endless cartoons that have been made of 'Mother,' to see what they revealed about popular perceptions of the picture, as well as some of the semi-devotional sepia reproductions with pious verses lauding motherhood from earlier in the century.

Slowly the origins of the portrait, like the picture itself as I worked on it, came into better focus. What became clear was that the painting was at the centre not only of the artist's achievement but of his emotional life; of his relations not just with his mother but with other women who lived with him at one point or another; of his struggles with his art; of his attitude toward England and France; and above all, of his ambiguous feelings about the country of his birth, America, where he spent so few of his years.

Ambiguity is inherent in good pictures, especially portraits, and restorers are not immune to the evocative powers of great painting; it is part of their function to be alive to them. Working alone on a portrait by Rembrandt, for example, can be a disturbing experience. But the 'Mother' was different. Here, it seemed as I looked deeper into its history, in a single picture were the clues to an entire life. The painting turned out to be exactly what most people's lives are: an accumulation of ambivalences. Like one of those Japanese novelty postcards, it began to present a quite different image according to the angle of vision. The painting, in effect, is a self-portrait, which just happens to be of his mother.

*

To an extent unparalleled among other painters, Whistler's art has been smothered by Whistler's life. His exotic personality and the scintillating anecdotes surrounding him have distracted attention from his work. Whistler himself was partly to blame; as Jacques-Emile Blanche, one of his followers, put it, he 'took care

to hide behind an admittedly somewhat charlatanesque outward show for the naive and simple public which he decided to intrigue as a man, since he couldn't conquer it as a painter.'[3] The smoke screen of this amazingly diverting life — almost a work of art in itself — has succeeded in deflecting generations of biographers, as well as the public, from the seriousness, even tragedy, of his struggle as a painter. The most minor facts about his chaotic existence have been lovingly sifted and documented; we know exactly what he wore, what he gave his guests for his extravagant brunches, and every quip and sally spun by his lively wit. And yet nearly everything about his finest and most famous work seems shrouded in uncertainty.

How was it that this absurdly vain, self-centred and self-indulgent man, this Beau Brummell of art, could have produced a painting of the rigour and integrity of the 'Mother'? What does it tell us about his flesh-and-blood relationships with his mother and the numerous other women in his life? How did this cosmopolitan butterfly come to paint his New England matriarch of a mother in the Chelsea house, from which his mistress had been temporarily evicted? The more I learned about Whistler's life — his debts, his treatment of women, his bohemian conceits — the more incoherent he seemed as a man and an artist.

The simplest of questions have never been adequately answered. Another is, why does this emblem of America hang in Paris today and not in New York or Washington? Is it because at the time, it evoked such a confusing range of responses? There is surely something special — almost uncanny — about a painting that once nourished the

cult of dandyism and decadent sophistication among late-nineteenth-century aesthetes in France, and that was later to be seen by Americans as a symbol of plain, puritanical homeliness. How can the same painting be at once factual and suggestive, appealing to both the 'elite' and the crowd, aesthetic and democratic sensitivities?

We think of aestheticism as a fin de siècle phenomenon. Yet it was as early as 1835 that the French writer Théophile Gautier had announced in the preface of his novel, *Mademoiselle de Maupin* (which Whistler read as a student in Paris) that 'things are beautiful in inverse proportion to their utility ... Everything useful is ugly.'[4] The idea clearly appealed to Whistler; for the rest of his life he mocked the notion that a painting must have a subject and tell a story. The literati of late-nineteenth-century France came to prize Whistler's tonal painting — the balancing of the intensity of light and shade rather than of colour, of which the 'Mother' was the finest example — as the perfect illustration of their creed of aestheticism. Immune to sickly sophistication, the millions of Americans who flocked to see it when it crossed the Atlantic nearly half a century after the French had bought it knew that it was beautiful but saw it as something to be put to practical, moral, and patriotic use.

To realize how far we are from understanding the portrait, it is enough to pose a few of the most obvious questions. Is it 'cold' or 'warm'? Reserved or sentimental? Severe or sympathetic? An intimate portrait or a monument to motherhood? And in style how much does it owe to Japan? Or is it essentially a European work by an American? Or a quintessentially American

work from the brush of an expatriate artist? Or a unique synthesis of both?

Again it depends on how you look at it, and who's looking. The French writer Joris Karl Huysmans, whose work *Against Nature*[5] was a study in refined depravity and who was a devoted admirer of Whistler's work, once described the 'Mother' as 'une peinture de convalescence.'[6] By that he did not mean that Anna Whistler was ailing when she sat for it (though as a matter of fact, she was); what he was suggesting was that he and others like him saw the style of the portrait as an intimation of a sort of delicious sickliness in European culture. Yet the reverential crowds who gazed at it during its triumphal tour of America during the years of the Depression saw in it a symbol of robust moral health, which was why it was used to illustrate a Mother's Day postage stamp. Nobody saw anything decadent, dandified, or still less Japanese about her. How was it possible that where the Americans saw clarity, Europeans such as Proust, Mallarmé, or Huysmans saw a mood-laden blur?

It is not only a matter of nineteenth-century Europe and America. The artistic styles of other continents and eras are reflected in the portrait, too. Stylistically the maze of influences at play in the painting seems impenetrable. Wherever one rates him on the scale of artistic achievement, no one will deny that Whistler was a brilliant eclectic. His 'Mother' leaves us the task of working out what possible connection there can be between American primitive painting, Japanese woodcuts, classical statuary, Pre-Raphaelitism, Velázquez, French realism à la Courbet, and the new art of

photography. Somehow he managed to combine them all into a simple, harmonious whole.

★

As I made my first, tentative tests on the picture, gently opening up 'windows' through the grime and accretions to see what lay beneath, it was partly in the hope that somehow everything about it would become clearer when the work was eventually complete. Yet I had no illusions. As I already knew from the reports about the condition of the portrait kept by the Louvre, from other paintings by Whistler, and from forensic as well as somewhat dubious and scanty documentary evidence about the techniques he had used, in the state it has come down to us the portrait itself has become a major part of the puzzle.

In 1986 the 'Mother' made the short journey across the river Seine from its secluded upstairs room in the Louvre, reached through the Egyptian gallery, to a more prominent position in the new Musée d'Orsay. Before this, except for one or two emergency repairs, periodic regeneration and slight thinning of the old varnishes and revarnishing, it had been virtually untouched since it entered the Louvre, via the Jeu de Paume, from the Luxembourg Museum in 1926. Pictures that have not been subjected to frequent interference and dubious restoration methods in the course of their lives are in increasingly short supply, and the fact that the 'Mother' had escaped the over zealous attentions of previous ages buoyed my hopes that the process of cleaning and

restoration would provide new clues to what the portrait meant to the painter and was intended to mean to us.

Not the least of the perplexities we face over the 'Mother' is that it is a great portrait painted by a flawed technician. The combination is rare. The hope of 'recapturing the original' in order not just to enjoy the painting the more but to decipher it more convincingly was always more remote in the case of Whistler's work than in that of artists who fitted more easily than he into the great schools of painting, with their tried and trusted methods and sound traditions.

The dilemmas of such a restoration are among the most difficult I have faced. As with all such delicate undertakings conservators are greatly helped by the advice of the director of the Louvre, at that time M. Michel Laclotte, and the staff of the Conservation department. But in the last resort the restorer is alone with the painting, and the ultimate second by second decisions of how far to go and what methods to use in the attempt to resurrect the picture while keeping faith with the artist's intentions are his or hers alone.

As I struggled month after month with the consequences of Whistler's unconventional handling of paint, I consoled myself with the reflection that there was something to be learned from his shortcomings as a technician. In a sense, his failings are prophetic. Seen in retrospect, they foreshadowed later experiments in painting, not least in his own country, where the restless striving for innovation has so often sacrificed durability to effect. To take a single example, the line from Whistler's brilliant but perilously constructed images to the equally dazzling but now quietly decomposing

Rothkos in the cellars of the Fogg Museum at Harvard University is disturbingly direct.

A painter's technique is no mere technical matter; like style to the writer, it is close to the essence of his work. In the back of his mind Whistler had a clear enough vision of what he wanted. But he was an American in a hurry. While consciously contriving to produce lasting masterpieces in the great tradition of European art, he lacked both the historical and technical knowledge to match his aspirations. He was seeking to simulate and exceed the achievements of the past with an inadequate artistic training and without mastering the basis of his craft. It is a miracle that the 'Mother' came off as well as it did and has lasted as well as it has.

The changes that have taken place in the picture are not all a result of Whistler's questionable methods. Some are due to the natural effects of time; others can be traced back to the treatment the portrait received in its early years, including at the artist's own hands. From today's viewpoint, the most intriguing aspect of these changes is that they converge in a single direction. The cumulative result has been to alter the appearance of the portrait in subtle but significant ways. The effect has been to detract from its pioneering style, making it seem to us now more conventionally 'European' than it must have looked in its earliest years.

One reason we are less shocked or delighted — maybe even less interested — by the 'Mother' than some of Whistler's more thoughtful contemporaries may be that experience since then has coarsened our sensitivities to the surfaces of paintings, making it progressively harder for us to read pictures backward in time — rather

as the writing of some nineteenth-century writers can seem either indigestibly rich or impossibly allusive to a modern audience.

Another reason it is hard for us to register the excitingly diverse range of signals the 'Mother' once emitted is that it is the most revolutionary 'New World' side of the portrait that has suffered most from its condition. It looks far less futuristic, and far more at home in Europe, than it should. Even after restoration, the picture we see today is only a partially reliable witness to the 'original'.

Hence another paradox. When it was first painted 'Arrangement in Grey and Black' was uncomfortably in advance of its time. Yet now that we are ready to look at it with a more open mind, its most provocative aspects no longer leap to the eye. Some of the painting's most exceptional qualities were as brilliantly novel as they were excessively daring, depending as they did on an ephemeral intricacy of texture and a hypersensitive tonal interplay that has altered over time.

Even within his lifetime Whistler was by no means unaware of the change in the portrait, urging critics of a later work to 'wait until it is as old as the Mother with a skin of varnish on it that has mellowed.'[7] He was flattered by the image of the picture cultivated in the 1890s by the Symbolists in France, which the painting's increasing patina did something to evoke. He was also at the same time himself leaving his American roots further and further behind and maturing in the same European atmosphere as the 'Mother.' His newly acquired stature as arbiter of taste in fin de siècle Paris may have led him not only to delight in the added veils of age over his picture

but even perhaps to forget its starkly American beginnings. In mocking self-identification with his work he wrote late in his life to his friend Comte Robert de Montesquiou: 'I feel that I have become more mysterious and more enveloped in mist than all the mysteries so far undertaken.'[8]

Restoration has done something to recover this intricate surface, and the force and honesty of the artist's basic concept ensure that the portrait still has a powerful presence. But a point of this book is that there are limits to what restorers can or should do to summon up the ghost of the past. To see the picture as it was, and to appreciate fully its decisive importance in the artist's life and work and as a neglected precursor of later American painting, we must rely on a reconstruction of the circumstances of its creation and on an intimate acquaintance with the painting itself — but also on our imagination.

The task is made more difficult by our modern perceptions of old paintings. It is not just a matter of their condition; Whistler's portrait has become remote from us in less tangible ways. Over the years we have become far more familiar with the incessantly reproduced image than with the picture itself. It becomes increasingly hard to link the two, as if the mythology surrounding 'Mother' had dispensed with the need for the actual painting. So used have people become to seeing or hearing of it as a national symbol — on postage stamps, in reproductions, school textbooks, caricatures, and cartoons — that it is easy to forget that the picture is still there, a highly fragile arrangement of paint on canvas, into which the artist

poured a large part of his soul. It is as if the original had ceased to exist, successive layers of popular imagery gradually obliterating the reality of the painted surface that the artist had taken so much trouble to perfect, and that for him was the key to the real sense of the picture.

When I mentioned to American friends and acquaintances that I was restoring the 'Mother' for the Louvre, the reaction was instructive. By no means all of them realized that it had spent the last hundred years in a French rather than an American museum. Fewer still had sought out the original in its obscure upper room in the Louvre, or in the Musée d'Orsay. A recent tendency to equate art with Impressionism has also played its part in expunging Whistler's masterpiece as a flesh and blood painting from the popular consciousness.

When I ask Americans whether — even as an image — the 'Mother' still carries the same symbolic charge for them, there is a certain equivocation. Some think that it still has all its old force as an icon of motherhood, American style. Others — younger perhaps — are less sure. In their view, now that the social composition of America has changed so much with its centre of gravity shifting away from the East Coast, and as the puritanical ethos becomes less marked, the portrait is less obviously the emblem of a nation.

It is certainly not clear what Whistler's 'Mother' will convey to new generations of Americans of Hispanic descent for example, and it appears from an article in the Florida Art Education Association journal of 1987 that for black students 'appreciation of the form and colour was blocked because ... Whistler's portrait did not say 'Mother' to these students. Many viewed her as a stern

authoritarian figure.'[9] The same may be true to some extent of most young Americans; schoolchildren, it seems, still know of it, but without knowing why they should.

The sociological study of the impact of Whistler's portrait in present-day America might prove a fascinating area of discussion, though one, I suspect, that would quickly lead in directions as far removed as it is possible to conceive from the artist's intentions when he painted his mother. The painting itself is a less speculative and more rewarding field of inquiry.

The way our perceptions of works of art are changed through reproduction to the point where they can become quite detached from the original is a familiar process, well documented by art historians and others. The 'Mother' is not the only great painting whose significance has been distorted by its own popularity. The 'Mona Lisa' was admired by Leonardo's contemporaries as a miracle of naturalistic illusion; now it is seen as enigmatic and elusive. A still better example is Millet's picture of two peasants stopping their work to pray in a field — the 'Angelus.' As his letters and other paintings of rural life testify, Millet himself was allergic to sentimentality. Yet when the 'Angelus' became the most widely disseminated popular image in France, it was somehow transformed into the epitome of maudlin religiosity. His painting of 'The Sower' was used against his wishes as a political emblem in his lifetime. Further instances are not difficult to find.

In the case of the 'Mother', the picture has changed together with our perceptions. Added to this are the uncertainties surrounding its painting — its hidden

genesis — making the 'Mother' an intriguing example of a 'lost original.'

★

The interest of the portrait extends beyond the canvas itself. It is another of the points of this book that as well as being Whistler's supreme achievement, the 'Mother' is a milestone in the history of nineteenth and twentieth century painting, whose significance has been thinned and narrowed by its overwhelming popular success. With his background in America, Russia, France, and England and his interest in Japanese art, Whistler in his best work intuitively synthesized the currents of his time. The range of his acquaintances was extraordinary; it included Degas, Proust, Mallarmé, Monet, Courbet, Fantin-Latour, Baudelaire, Rossetti, Oscar Wilde, Swinburne, Henry James, and John Singer Sargent. In retrospect the artist appears not only as an intensely individualistic painter but as a link between contending cultures and epochs. Not surprisingly, his most outstanding painting was a summation of a unique blend of his influences and experiences. Aesthetically, intellectually, technically, emotionally, and nationally the 'Mother' reflects many of the movements in art and ideas of the time.

This is not to say that Whistler was in any sense an intellectual. The notion of him as a cerebral and imaginative force who pulled the strands of his era together in a single picture would clearly be absurd. A highly unsystematic thinker (it is hard to describe him as a thinker at all, and certainly not in the same category as, say, Degas, a colleague who considered their works indis-

tinguishable at one moment in his early life). Whistler simply didn't work with that degree of rational self-awareness. It is more persuasive to see him as he portrayed himself — as a butterfly: a restless, knowing, and retentive butterfly who circulated among all the dominant artistic currents of his time and collected enough from them to help inspire his one great picture.

Being a butterfly, he lacked not only the technique to realize his ideals but the seriousness of purpose and sustenance of a great tradition to carry forward the promise of his major work. Such a tour de force was to be achieved only once. As Degas, a vastly superior artist as well as a man of acute perception and mordant wit, in whose presence Whistler always displayed an uncharacteristic humility, reflected, 'It must be very tiring to keep up the role of the butterfly. Better to be an old bull like me? What!'[10]

Despite its element of eclecticism, the 'Mother' is no mere synthesis of the trends of the time. Though he spent most of his life as a self-exile, Whistler was an American through and through. As America has evolved its own distinct national style, the 'Mother' as he painted it comes to seem a supremely American painting, a fact disguised by its subtle 'Europeanizing' over time.

When we reconstruct the 'Mother' as it looked when it left Whistler's studio and present it afresh to our mind's eye today, the 'Americanness' of the painting becomes startlingly clear. Perhaps the very absorption of many cultures into a new form is in itself an explanation why one of the most extraordinary things about the 'Mother' is that, while it is pervaded with European and Japanese influence, almost everything about the picture — style,

composition, technique — foreshadows in some way aspects of twentieth-century American painting, from Grant Wood to the New York School.

2

PRELUDE TO A MASTERPIECE

'The masterpiece should appear as the flower to the painter —
perfect in its bud as in its bloom — with no reason to explain
its presence — no mission to fulfil — a joy to the artist — a
delusion to the philanthropist — a puzzle to the botanist — an
accident of sentiment and alliteration to the literary man.'

Whistler, *The Gentle Art of Making Enemies*[1]

There is something profoundly gratifying about the idea
of a masterpiece being created in a fury of 'inspiration.' It
appeals to our romantic concept of the 'true artist,' whom
we see as the personification of technical mastery and
sudden genius. The evidence of when Whistler first
conceived the idea of doing a portrait of his mother is
tantalisingly sparse and occasionally contradictory. We
know it was painted in 1871, even though he mentions
such a portrait in a letter some years before. Firm
knowledge of exactly how long it took is equally elusive.

All that is certain is that the portrait is a rare and satisfying example of inspiration at work.

Yet contrary to our fond supposition, inspiration does not descend like a winged muse. The conditions which caused the creative spark that produced the 'Mother' came together in the decade or so preceding 1871. Whistler's earlier years, spent in America and Russia and France, were obviously important, too, for both his artistic and emotional development and will be touched upon later. But the immediate task is to track down the reasons he painted the portrait how and when he did.

The period that led up to the painting of the 'Mother' began in 1859, when Whistler moved to London after four years as an art student in France. He was then twenty-five. With his mistresses, his fecklessness about money, and his inattention to his studies, he had used his time in Paris to play the part of the bohemian to the hilt and had enjoyed every minute of it. As he took every opportunity to make clear later on in his life, he did not go to England because he cared for its people or its customs. The immediate reason seems to have been what he saw as the unexplored artistic attractions of London, especially the Thames. Linked to that was the little matter of making a living, which he was convinced he could do more easily there than in France.

He was lucky in having as his brother-in-law a wealthy doctor and talented engraver, Francis Seymour Haden, who lived in some style in Sloane Street and had kept a fatherly eye on Whistler for some months as a boy when he was convalescing in London from the rigours of the Russian winter. The French painter Fantin-Latour, who visited him in London, was astonished at the constant

supply of roast beef, sherry and champagne. With his breezy style and high spirits, Whistler soon became a great hit in the Hadens' drawing room, while his linen duck suits and jaunty straw hat made him a striking figure on the streets of the capital. Socially he was much in demand and had soon made friends with leading figures of his day: the writers George Meredith and Algernon Swinburne and the Pre-Raphaelite painter W.M. Rossetti.

Artistically his recognition was slower, his prints better received than his painting. His work was well out of tune with the artistic establishment. It was the high tide of English academicism which meant, above all, that pictures must have a clear subject and convey a readable narrative. Whistler left a mocking description of the sort of picture that guaranteed success at the time: 'It was the era of the Subject. At last on Varnishing Day, there was the Subject in all its glory ... in the Academy there you saw him: the familiar model — The soldier or the Italian — ... brows knit, eyes staring; in a corner, angels and cogwheels and things; close to him his wife, cold, ragged, her baby in her arms; he had failed! The story was told; it was as clear as day — amazing! The British Subject! What.'[2]

The first work he himself exhibited at the academy did have a subject and sold (for thirty pounds); it was 'At the Piano,' a portrait of his sister and his niece, which had been done in the Hadens' drawing room. Yet the reception was mixed. The writer William Makepeace Thackeray greatly admired it. The response of the *Daily Telegraph* was more grudging but, in the light of the line of development that was to lead to the 'Mother' twelve years later, perspicacious; in the view of the newspaper's art critic, 'At the Piano' was a 'smudgy, phantom-like picture'[3] — a

complaint that was to be made in more virulent terms about the artist's greatest portrait.

Meanwhile, he was diligently at work on his river etchings and paintings, taking lodgings for a while in Wapping in East London to be close to his theme, then renting a small house at 7 Lindsay Row (101 Cheyne Walk today) at the least fashionable end of Chelsea, opposite Battersea bridge. The decor of the house astonished contemporaries: unlike Victorian artists of the time, Whistler did not drape the walls with tapestries or clutter the rooms with objects but merely hung up a few oriental fans and placed pieces of blue and white china amid large bare spaces. The silvery reflections in the corners of whitewashed rooms gave him particular pleasure. He slept in a huge Chinese bed. Beautiful silver was on his table. He ate off blue and white. A Japanese bath filled with water lilies and goldfish was mistaken for a settee by one of his guests. The bare grey walls of his studio with black wainscoting and door, Chinese matting and a few black-rimmed prints, formed the background to his later pictures, including the 'Mother.' His painting and his way of life — his surroundings, his clothes, even his meals — formed a single composition.

The early years in London were a period of daring originality. It was a time of restless, sometimes brilliant, but never sustained innovation as his search for a distinctive style took him in a number of directions. The famous 'White Girl' was painted while he was domiciled in England, though during a stay in Paris. The model was his mistress Jo Heffernan, who had gorgeously long copper coloured hair and was now living with him in Lindsay Row. It was rejected by the Royal Academy in 1862. Not

for the first time in Whistler's career, French critics showed themselves more receptive to his work: a year later 'The White Girl', with its haunting expression and play of whites much admired by Degas, competed with Manet's 'Déjeuner sur L'Herbe' as the sensation of the Salon des Réfusés in Paris. Emile Zola's tragic novel *The Masterpiece* describes the scene: 'A lady in white, the very curious conception of a future great artist ... also stupefied people and drew them together; folks nudged each other and went into hysterics almost; there was always a grinning group in front of it.'[4]

'Wapping,' one of the first fruits of Whistler's fascination with the river-life of London, was an odd and unprecedented composition, with its rather obscure close-up of figures, including Jo, against a splendidly painterly background of the pool of London. In 'The Music Room,' again set in his sister's Sloane Street house, his use of perspective and mirrored reflections was still very much in the vanguard of Parisian painting, and almost too sophisticated to be easily readable. With characteristic verve and ingenuity he had also been among the first to seize upon the newly discovered artistic potential of Japan. Ideas were far from lacking, sustained development of any of these brilliantly disparate themes was. Already his aspirations showed signs of outrunning his technique, and his critics were murmuring about a failure to fulfil early promise.

★

His sudden decision to sail for Valparaiso in 1866 to take the Chilean side against the Spanish colonialists left his

friends and contemporaries astonished. For his later biographers the Pennells, the gesture remained the most unaccountable event in his life. Certainly Whistler's personal account to the Pennells throws little light on the affair. According to the artist, it all began when some South Americans simply approached him one day 'as a West Point man'[5] (Whistler was immensely proud of having attended, however briefly, America's Military Academy) to help in the struggle against the Spaniards. Instantly, Whistler claimed, he embarked on a steamer from Southampton.

It seems certain that more complex motives underlay his decision and that his impetuous escape to South America was a sign of an approaching crisis. In addition to offering immediate release from his artistic frustrations and his family (he was now quarrelling with Seymour Haden about his mistress Jo, among other things), Whistler's seemingly gratuitous gesture may have reflected an urge to live out in practice one of the least convincing aspects of his self-image: that of a military hero, a swashbuckling Southern gentleman.

Unlike his brother William, a surgeon on the Confederate side who had gone to England toward the end of the American Civil War the previous year, Whistler had taken no part in the conflict. Its outbreak had brought his mother to London in 1863 and stirred a streak of romantic patriotism in him; in contrast with Anna Whistler, he was a champion of the Southern cause. It was easy enough to sound off over the dinner tables of London, but as among many expatriate Americans at the time, stories of the ferocity of the fighting must have inspired horror mixed with obscure feelings of guilt.

Whistler, who read Walt Whitman's patriotic *Leaves of Grass*, may even have felt uncomfortable if he noticed the lines the poet had written at the outbreak of the war in 1861:

Arm'd year — year of the struggle
No dainty rhymes or sentimental love verses for you
 terrible year,
Not you as some pale poetling seated at a desk
 lisping cadenzas piano,
But as a strong man erect, clothed in blue clothes,
advancing, carrying a rifle on your shoulder.[6]

Whistler's portrait of his mother was — among other things — a manifestation of his patriotic sentiment. Seen in retrospect, the Valparaiso expedition many have been a late reversion to his national roots, albeit after the end of the Civil War and in a randomly chosen cause. Predictably enough, it turned to gentle farce. He never found himself 'advancing, carrying a rifle on your shoulder.' Instead, by his own testimony, he headed a horseback retreat at the first sound of firing. The nearest he came to combat was an unseemly assault on a Haitian who irritated him on the journey back, obliging the captain of the vessel to keep the irascible artist out of further mischief by locking him in his cabin.

Artistically, the escapade had been more productive. During his stay in Valparaiso he had done work that was later to prove significant, prefiguring the development of the loose, liquid style characteristic of the 'Mother' and the subsequent 'Nocturnes.' The evening views of Valparaiso Bay were notable for their moody use of thin,

dark paint to produce minimalist seascapes in which night and day dissolve in washes of colour. It was a promising development, but there was no immediate follow-up. Back in London in October 1866, his work moved into a series of blind alleys. His etchings were still successful and — unusually for a living artist — bought by the British Museum. But at a time when he might reasonably have expected to be moving toward election to the Royal Academy, official recognition as a painter was still withheld.

His contributions to the academy in 1867, including 'Symphony in White, No.3,' were not well received. He was used to the incomprehension of the English, but this time French critics, too, were not enthusiastic. The slow crisis in his work was deepening. From 1867 to 1870 he showed nothing in the French Salon and from 1868 to 1870 only a single painting in the Academy in London: 'The Balcony,' an attractive but essentially decorative Japanese confection featuring young girls and plum blossoms, which he had begun six years before. Even his highly indulgent biographers the Pennells were to be critical of this period of his work: 'The models do not live in their Japanese draperies; Eastern detail is out of place on the banks of the Thames.'[7] And Walter Sickert, the most perceptive of critics and Whistler's pupil in the eighties, wrote:

Whistler had the egomaniac view of art and life, and did not understand the spirit of the hive. So that when ... he came under the fascination of the Japanese imports, he did not digest what they had to teach. He painted pictures in which Japanese fans

were arranged on English shelves, and English ladies
... were popped into kimonos on Chelsea balconies.
He took the art of oil painting, of which he was just
getting a real grasp, and thinned it into an imitation
of the gouache delicacy proper to a Kakemono.[8]

For lack of any confident style of his own he was slowly
becoming absorbed in the quirkiness and whimsicality
that had dominated English art since Constable and
Turner. It was the moment when the French painter
Camille Pissarro was writing to his son Lucien in England
advising him to avoid becoming entrapped in what he
called the 'by-ways of English painting.'[9] From today's
vantage point it was a salutary warning. English art at the
time was at its most sterile and artificial: mock gothic,
mock classical, mock sentiment, mock everything.

The Valparaiso paintings had underlined the
completeness of Whistler's rejection of the realism he had
learned with Gustave Courbet in France, but this radical
new style was still precarious, tentative, and slow to
mature. Despite himself, the artist drifted discontentedly
with the fashions of the day. Though attracted by their
languidly romantic treatment of women, his involvement
with the Pre-Raphaelites was more social than artistic;
when his friend Rossetti, who lived a few doors away in
Chelsea, showed him a poem and a picture, in his best,
slighting manner Whistler advised him to substitute the
sonnet for the picture in the frame.

Although he once described the English neo-classicist
Albert Moore as the 'most honest English painter,'[10]
Whistler's own experiments in the field were a failure.
From the surviving sketches of classical nudes in drapes, it

is easy to see why Whistler destroyed the rest. They were gauche, though pretty in a fashionable way. Yet although it did not help him to acquire knowledge of anatomy or draftsmanship, his brief flirtation with neoclassicism seems to have left him with a feeling for the restrained, frieze-like organization of monochrome figures on a surface, so superbly realized in the 'Mother.' With his paradoxical genius, instead of discovering in classicism a sense of line, Whistler may well have been more forcefully inspired by its absence of colour.

It is clear from his letters to his closest friend, the French painter Fantin-Latour, around this time that Whistler himself knew he had lost all sense of artistic direction. At one point, when one of a series of paintings attempting to combine classical with Japanese motifs, the 'Six Projects,' came to nothing, he wandered in despair with a friend through London. Significantly again for the 'Mother,' he took heart only when he stood in front of a Velázquez in the National Gallery. He had long had a passion for the Spanish painter, especially admiring his use of blacks — the key element in Anna Whistler's portrait.

The years before he painted the 'Mother' marked the deepest trough in the artist's life. Until he began work on the portrait, 1871 was a nadir. It was not simply that he was reaching middle age. His work was not going well, and he felt restless and rootless in London. Sickert says with feeling:

He had come from the wholesome, common sense of Paris, the positive knowledge of his art, by which he was there surrounded, to the lilies and languors of the Chelsea amateurs. I had almost written

'aesthetes,' when I reflected that they were perhaps anything but perceivers ... What warmth, what strength, after all, must there have been in Whistler's fire. To have come from Paris, from having been the colleague of Fantin, and Manet, and his flame of art to have survived at all in Sloane Street.[11]

His attitude to the British was highly ambiguous. He despised the 'Islanders,' while retaining a disgusted fascination with them, relishing in particular their incurable philistinism. Though his links with France were fraying, there was nothing to prevent him from going back to live and work in Paris, which he had left twelve years before. His French was excellent, and he was known and respected by many French painters and literati of the day.

It was a period when he was making a belated attempt to compensate for the gaping lacunae in his training as a painter, and France was the obvious place to resume the studies he had neglected as a student. In Paris he would also have escaped embroilment with his relatives, who were mostly in London. There is evidence that he may have been thinking of going back: in 1867 he wrote to a friend, George Lucas, in Paris asking him to look out for a studio for him there. In the event he stayed in England.

Had Whistler returned to Paris permanently, it seems unlikely that his mother would have gone with him or that he would have painted her in the way that he did — if at all. Why did he stay among the insufferable 'Islanders'? The most probable reason is the least flattering to the artist. Despite the fallow period before the painting of the 'Mother,' in London he was a notable and controversial painter, savouring, inflaming, and exaggerating his battles

with the artistic establishment. The pleasure he took in his pose as the ultimate artist confronting the philistines can be measured from *The Gentle Art of Making Enemies*, with its lovingly compiled quotations from critics who had misrepresented or ridiculed his work.

In Paris, where artistic debate and innovation were far more lively, this satisfaction would have been denied him. Nor can it have escaped Whistler's highly developed ego that in Paris he would have faced far stiffer competition as a painter than in London. A few names suffice to measure the extent of it: in England the greatest figures of the day were painters like the Pre-Raphaelite John Millais or the classically inspired Frederick Leighton, of whom Henry James wrote, 'In Mr. Leighton's plasticism there is something vague and conciliatory, it is as if he thought that to be more plastic than that would not be quite gentlemanly.'[12] In Paris Whistler's work might have been more sympathetically received. But he would have laboured in the shadow of Degas, Courbet, and Manet.

Meanwhile, his personal life — always unstable — was descending into chaos and farce. Shortly after his return from Valparaiso he broke with his long-standing and long-suffering mistress Jo. As usual he was short of money. During a brief excursion to Paris in 1867 he precipitated a major family crisis after physically assaulting his brother-in-law. The affair engulfed some of his friends, and eventually led to his expulsion from the Burlington Fine Arts Club. And in 1869 his half brother, George, who had helped finance his student days in Paris, died while returning from Russia.

His mother had lived with him intermittently since her arrival from America in 1863. By 1871 she was ailing. First

she had had trouble with her eyes, for which she was treated in Coblenz by a German specialist; then she succumbed to a rheumatic fever. By the standards of the day she was old but not ancient — sixty-seven that year. Yet her illness must have reminded Whistler of the suffering in her life, of the loss of three of her children in infancy, of the years she had spent in Russia, of the hard time in America after the death of her husband from typhoid in St. Petersburg — and of her own mortality. She was also his only close connection with his native country.

His behaviour in London had not made things any easier for her. The sight of the pale, devoted figure in black around his house must have stimulated a multitude of emotions, as well as his inner eye. With the American Civil War and the death of Prince Albert, the image of widowhood was in the air, and Anna Whistler had made something of a profession of it, always signing her letters 'Your widowed mother' or even 'Your afflicted but ever affectionate widowed mother.'[13] In 1866 she had moved with him from number 7 to number 2 Lindsay Row (97 Cheyne Walk today). It was there, in the bare second-floor room at the back of the house that he used as a studio, at a time of suppressed crisis in his life, that 'Arrangement in Grey and Black; Portrait of the Artist's Mother' was painted.

3

The Moment of Creation

'I was surprised when the next day he said to me: "Mother, I want you to stand for me. It is what I have long intended and desired to do, to take your portrait".'

Anna Whistler[1]

The closer we get to the exact moment of creation, the more obscure become the details of how the portrait was done. By far the most comprehensive account of Whistler's life and work is in the *Life of James McNeill Whistler* by Mr. and Mrs. Joseph Pennell. Compiled with the artist's help and published five years after his death in 1903, it was followed by a further substantial volume, *The Whistler Journal*, thirteen years later in 1921. Man and wife, the Pennells were the artist's Boswell, devoted partisans of their subject who religiously recorded his words, actions, and recollections as well as the progress of

his work. It might have been thought that in a total of seven hundred lively and detailed pages the Pennells would have found more space for the 'Mother' than they did.

It is true that their first meeting with the artist had been in 1884 — about thirteen years after he had painted the portrait. But his biographers were his compatriots, ardent champions of an American painter beleaguered by English critics, and Pennell himself was an engraver with a close and informed interest in Whistler's work. Surely they should have gone out of their way to extract from their hero and set down for posterity every scrap of information about his most famous picture — not least because they had first come across his work as art students at the Pennsylvania Academy of Fine Arts in 1881, at the exhibition where the 'Mother' had its first showing in the United States.

In explaining the origins of their lifelong interest in Whistler, they wrote at the very start of the *Journal* that 'most important to both of us was the fact that at the Pennsylvania Academy in 1881 Whistler's portrait of his mother was hung.'[2] Yet in their two compendious volumes, thickly strewn with detailed reflections on every aspect of his work, the Pennells devote a mere few paragraphs to the portrait — not all of them accurate.

There is no reason to suppose that the Pennells were party to any conspiracy to cover anything up. Whistler himself may simply have told them little about the portrait, and with their habitual deference, they may not have wished to press him. Although many people noticed that he was always stirred by any mention of the 'Mother,' this does not seem to have made him more

communicative about it, rather the reverse. Most of his recorded statements about the painting seem to have been elliptical or laconic to the point of evasion, such as his well-known remark when someone congratulated him on the work that 'one does like to make one's mummy just as nice as possible.'[3]

This attachment to his mother and respect for their privacy are emotions discernible in the intimate side of the painting. But he may also have had mixed reactions to its success. While he always welcomed praise for the portrait, he was ultra-sensitive to any intimation that he could never hope to equal or surpass it; excessive praise for the 'Mother' might imply that he had painted his best work in his early middle years and that, except for the subsequent portrait of the historian Thomas Carlyle, done in the same vein, and the 'Nocturnes', his art had been coasting downhill ever since. For all his braggadocio, Whistler was not without self-knowledge, and many modern critics would agree that his defensiveness about much of his later work was only too justified. (Sensitivity about an especially favoured work is not unique; Flaubert is said to have invariably lost his temper if anyone ventured to extol Madame Bovary in his presence.)

A more speculative motive for his apparent unwillingness to expand on how and when the 'Mother' was painted may have been nervousness about the techniques he had used. William Rothenstein has left a powerful evocation of the artist's feelings of insecurity about the fate of his works, describing how he once saw Whistler peering at the surface of one of his pictures late at night by candlelight, his hands trembling. Always ready

to indulge in grand-sounding maxims about art and the artist, he could be reticent to the point of evasion when it came to the working methods he used; even his students hesitated to ask him too much. 'There is no such thing as technique,' he once announced to them. 'You must be bold.'[4] Together with his alertness to the adverse implications of too much praise for the portrait and his affection for his mother, this haunting lack of technical self-assurance might help account for his failure to tell the Pennells more about the 'Mother,' even after its entry into the Luxembourg Museum.

Yet the most probable explanation of his silence may be the simplest. The picture had been painted on impulse, when he was alone with his mother, in the days of his greatest despondency. He may have had genuine difficulty in re-creating the moment. He may never have been able to retrace his steps or account for its appearance 'as the flower to the painter — perfect in its bud as in its bloom.'[5] His greatest achievement had been his most private and least self-conscious; the painting had simply happened to him.

<p style="text-align:center">★</p>

Everything suggests that Whistler painted his mother in the late summer or early autumn of 1871. Though the execution seems to have been unexpectedly brief and uncomplicated, the idea may have been maturing in his mind for some time. Proof of this intention is sparse and rests on just two pieces of evidence. Whistler did an engraving of his mother, though it is not certain that it ante-dated the portrait. Moreover, it has little in

common with 'Arrangement in Grey and Black.' In the engraving — a drypoint — Anna Whistler is shown standing, almost facing the artist, and the mood is much lighter than in the portrait — more Dutch than Spanish. It is not one of his most impressive engravings. Since its exact date is unknown, it is possible that it was connected with the genesis of the idea of a portrait. We know from his mother's letters that the original concept had been to paint her standing.

The second clue comes from an undated letter he wrote to Fantin-Latour, which talks of a portrait in preparation or perhaps already completed: 'I shall have a photograph of the portrait of my mother made and send you a copy. I am also thinking of sending it to Paris for the next Salon.'[6] No trace of any earlier version or of any photograph of it remains, and the Pennells have nothing to say on the subject. Moreover, on a closer reading, like nearly everything else to do with the picture, the letter to Fantin is replete with ambiguities. It is written in French, and in it Whistler says three things of importance.

The first is his advice to Fantin against destroying canvases with which he is dissatisfied. The reference is to Fantin's picture 'Le Toast,' a group portrait of his artist friends. Although the painting was intended as a tribute to realism (the original title was 'Hommage à la Vérité'), Whistler was featured wearing oriental dress and holding flowers, while Manet toasted a winged nude goddess portraying 'la vérité — notre idéal.' It was exhibited at the Paris Salon in 1865. Later Fantin cut it up, retaining only the head of Whistler, which he appears to have offered him as a gift.

In his letter Whistler suggests that the remnant be sold, preferably to an American; it would help make Fantin's name in New York and the United States, where 'they are much interested in painting now.' With his usual nose for publicity, Whistler went on to say that 'nothing could be more charming for me than to be presented to my compatriots by Fantin.'

In deprecating the habit of destroying paintings, he adds intriguingly:'I've done it so often myself and so regretted it.' Whistler was indeed a compulsive destroyer of half-completed or unsatisfactory works, stating at one point: 'To destroy is to exist.' His motives were probably a mixture of perfectionism and the usual doubts about his technique. The fact that he cautioned Fantin against wrecking his canvases would not be incompatible with the destruction almost immediately afterward of a first attempt at his mother's portrait. Whistler was not known for his consistency.

In the same letter Whistler talks frankly to Fantin about his problems with his art. He was 'tormenting himself a lot' but believed he had evolved a science of colour that he had 'reduced to a system.' This could be a reference to his method of tonal painting, which reached its highest peak of perfection in the 'Mother' and the 'Nocturnes'. He may have been experimenting with his new 'science,' using his mother as a subject. Suggestively the letter asks Fantin for two tubes of noir de pêche — black pigment derived from peach stones. Getting the darks just as he wanted them was to prove the major problem of the portrait.

The Pennells simply assert in passing that the letter to Fantin was written in 1871,[7] the year he did the portrait

we know today. On the surface that would make far more sense and dispose of the mystery of an unrecorded first attempt. There is no other sign that Whistler was working on a portrait of his mother in the late 1860s, and a lot of circumstantial evidence suggests that it would have been very difficult for him at that time. He had only just returned from the trip to Valparaiso and had set out almost immediately for Paris. His affairs were in even more turmoil than usual since he had just broken with Jo. He stayed with a friend in Bloomsbury for almost a year, part of which his mother spent in America. Nor is there any record of his having told anyone else that he was painting her.

In her numerous and normally detailed letters, Mrs. Whistler herself not only makes no mention of an abandoned attempt at a portrait but talks of the painting as a new idea. It could, of course, be that in her infinite loyalty to her son, she suppressed a failure. If a first, aborted portrait had existed, Whistler and his mother went to remarkable lengths to cover it up, but that seems intrinsically unlikely. More probably it was hardly more than a sketch, only given substance in Whistler's optimistic imagination as he considered the approaching Salon. It would be agreeable to think that a prototype of the 'Mother' or a photograph of it may one day emerge. Less excitingly, the dating of the letter could be revised yet again, possibly proving the Pennells right in their assumption that the letter to Fantin was, after all, written in 1871.

★

Work on the portrait was begun on impulse resulting from accident. In her letters Anna Whistler describes how a model failed to turn up to sit for her son and how he launched into the portrait the same evening:

> Poor Jemie ... is never idle, his talent is too eager, if he fails in one attempt he tries another, so I was not surprised at his setting about preparing a large canvas late though it was in the evening, but I was surprised when the next day he said to me: 'Mother I want you to stand for me. It is what I have long intended and desired to do, to take your portrait' ... If the youthful Maggie had not failed Jemie as a model for the 'Girl in Blue' in the picture which I trust he may yet finish from Mr. Grahame (sic), he would have had no time for my portrait ...[8]

The failure of the model to turn up for her sitting may seem like the purest chance. In fact, as the mother intimates, it had its logic. The model in question was Maggie Graham, the fifteen-year-old daughter of a Member of Parliament, William Graham. It seems she had had a bad time at the artist's hands. She was not the only one. 'Sitters to Whistler meant as much as a melon or brioche to Chardin', Jacques-Emile Blanche wrote. It was a case of 'nature morte applied to figures.'[9] While he worked, Whistler could be brusque, irritable, and self absorbed. If his models moved or otherwise interrupted him, he would rebuke or simply shout at them.

Children were not spared. Cicely Alexander, the model for 'Harmony in Grey and Green, Miss Cicely

Alexander', described how she would get tired and cross after hours of posing and finish the day in tears — which Whistler never noticed. Nor were his friends. Placed by Whistler painfully close to a burning fire, Stéphane Mallarmé was imperiously instructed not to move: returning home later, the compliant poet found his calves singed. The less docile Carlyle got impatient when Whistler worked with small brushes, and the artist was forced to appease him by pretending to use broad ones. Most trying of all for his models was his habit of erasing his work wholesale and beginning again, so that a sitter would see no profit after hours of painful stillness. Canvases were blotted, scraped down, or simply destroyed. Sickert estimated that 'perhaps thirty per cent, and I am putting it pretty high, of the perpendicular six-footers were allowed to remain in existence. I cannot remember how many of these I helped him to cut into ribbons on their stretchers.'[10]

It is likely that Maggie Graham's sittings had been unusually excruciating. The portrait was an important commission for Whistler, and it was not going well. (He had undertaken to deliver it by August of 1871, but it was never finished.) At one point it seems to have been near completion, but with his usual impulsiveness and perfectionism, Whistler scraped it down again. After all her misery there was nothing for the model to see. Maggie Graham had had enough.

Anna Whistler's letters suggest that the last-minute defection of he son's model put the artist in a sombre, taciturn mood: '... he does not relieve his trouble by talking of it ...'[11] His latest attempt at a successful 'society' portrait, for which he had already received a desperately

needed advance, had come to nothing. He was probably alone in his house with his mother — an anxious, frail black presence. It seems likely to have been a moment when the artist's feelings were precariously balanced between despair and creativity.

★

The late nineteenth century was the era of large, specially designed studios to which successful artists invited their clients and friends. A contemporary photograph of the London studio of Whistler's compatriot and rival John Singer Sargent shows it decorated with drapes and antiques, while the hugely successful French artist Meissonier worked in a mock Renaissance château he had built for himself in the centre of Paris.

Whistler's place of work in Lindsay Row was small, minimally furnished, and ill lit. This was not so much because of his limited means (though expense mattered) as from choice. The decor of the studio was basically as it appeared in the 'Mother': grey walls with black Japanese-style wainscoting, with a few of his own prints in thin, black frames (his own invention) on the wall. It had previously been a back drawing room. The window light would therefore have been less generous than in a purpose built studio and was lowered still further by the grey walls and the black door and dado, and by Whistler's habit of using curtains and shades to filter any direct illumination.

For Whistler, the studio itself was a tonal construct. Grey was the key; it was the background both on the

walls and on the paintings. When someone asked him why he always used grey priming on his canvases, Whistler had a simple answer; 'The sky is grey, and the water is grey and therefore, the canvas must be grey.'[12]

The minimal lighting was intentional. The lower the level of illumination, and the more it was dispersed to avoid any side light, the less risk there was that harsh shadows would throw the sitter into too much relief. He did not want the figures he painted to be a hump in the middle of the painting, or to bring them alive in paint by allowing light to glitter on broken, thickly impastoed[*] brushwork, or for them to stand out against their background. His aim — first fully realized in the 'Mother' — was to suffuse his figures in a 'tonal envelope' of the light he contrived around them. The crepuscular atmosphere he conceived for 'Arrangement in Grey and Black' was perfect not only for his mother but for London, where, as Whistler said some years later in the 'Ten O'Clock Lecture', his aesthetic credo, 'the evening mists clothe the riverside with poetry.'[13] He had always admired Van Dyck's ability to stand his figures within an airy yet undefined space.

In some later portraits he took his obsession with subdued lighting to extremes, placing his models in the darkest part of the studio, 'more or less in gloom,' according to one of his assistants, Menpes, with the canvas in a slightly lighter place. This insistence on the right light could be another trial for the sitter; sometimes, before a session could start, artist and model would have to wait for the exact shade of pearly grey to materialize in the studio. Shafts of brazen sunlight that

[*] Highly textured paint, usually brush or palette-knife marks are clearly visible — *impasto* (It.), dough.

could have interested the Impressionists were greeted by Whistler with horror: 'Would you, if you were a musician, get all the noise you could?'[14]

For other painters of the time, these working methods seemed highly idiosyncratic. In his book *Portraits of a Lifetime*, Jacques-Emile Blanche gives a vivid description of Whistler at work in one of his studios, describing it as an 'austere laboratory.'[15] Anything further from the Impressionists, with their predilection for open-air painting and vivid light with luminous shadows, is hard to imagine. 'Painting from nature', Whistler insisted, 'must be done indoors.'[16] He trained his memory for the 'Nocturnes' during dawn or dusk river expeditions but illogically was insistent on models for every detail of his portraits.

Anna Whistler did not often intrude into his studio. In fact by tacit agreement she always avoided disturbing him there since she once discovered the parlour maid nude 'posing for the all over.'[17] But in view of the hint in her letter that she tried unsuccessfully to comfort him, it is legitimate to speculate that she may have gone there after Maggie Graham let him down. If she did, the artist would have seen her stern, careworn profile and white coif against the grey and black geometry of the wall. (We know how susceptible he was to every transient impression: a later portrait of his second mistress, Maud, was inspired by seeing her against the black studio door.)

The idea of painting the studio itself — a fashionable subject at the time, which would have given plenty of scope to Whistler's amour propre — had already occurred to him but had come to not much more than an attractive, rather mondaine sketch. (The contrast with

Courbet's great masterpiece 'L'Atelier', painted whilst Whistler was in his immediate circle in Paris, must have rankled). The notion of painting his mother in such austere surroundings is less obvious than it seems. He could have easily manufactured a different, less empty setting or had her pose for him in some other room. His choice of the plainest available background was as crucial to the later success of the work as it was unconventional at the time. Bleak backgrounds on portraiture were not fashionable, and curtains, if included, were invariably draped, tasseled, and red, preferably accompanied by columns. When the picture appeared in public, contemporary critics — especially in England, where high colour, distracting decor, and anecdotal 'incident' were de rigueur — were baffled by the deliberate aridity of the setting. To them it seemed perverse; to us it seems to convey the atmosphere perfectly.

On the face of it, anything further removed from the Quaker-like simplicity we think of as the natural habitat of Anna Whistler than an artist's studio in Chelsea would seem hard to conceive. Yet there is a curious and not entirely fortuitous concordance between the two. The ascetic decor he chose for his studio was partly a result of Japanese influence, but it also reflected his attitude to his art. His mother herself had once compared his single-minded devotion to his painting with her own religious convictions, and the frugal, almost Shaker-like purity of the studio, relieved only by the wispy Chinese matting and the black framed prints, recreates a puritanical atmosphere out of foreign materials. Even the curtain (more conspicuous in the original painting than it has become today) strikes a cold note. Originally it was deep

blue, cunningly differentiated from the blacks and so frigid in tone that the English artist Aubrey Beardsley compared its silvery pattern to the thin, tingling notes of musical notation.[18]

<center>★</center>

Harmony was the leitmotiv of Whistler's art. Studio, paint and canvas — everything was consciously attuned to the atmosphere of the portrait as a whole. He later asserted that he sought 'the spirit, the aroma ... if you paint a young girl you should scent the room, a thinker, thoughts should be in the air, an aroma of personality.'[19] The surface he worked on was particularly significant; in this instance it needed to reflect not only the starkness of the room, and of his mood, but all the unfathomable memories and emotions aroused by the personality of this sitter.

It is known from those who saw the finished portrait, and confirmed by X-rays of the picture, that the canvas he began preparing that evening had already been used. It could hardly have been a matter of economy: Whistler was hard up, but not to the point of painting a portrait of his mother on a half-finished work. His choice of canvas seems to have been both impetuous and highly conscious, related to his concept of the portrait itself. The 'Mother' was not painted over another work but on the reverse side of one. It may be, of course, that in his eagerness to start work, he merely turned the aborted portrait of Maggie Graham around, having decided that it was the right size for his 'Mother'. One witness, Otto Bacher, who saw the completed 'Mother' in Whistler's

studio twelve years later, claims that there was a portrait of a 'child' on the reverse.[20]

T.R. Way, a painter who engraved some of Whistler's work, saw something slightly different: 'The Mother's portrait was, unless my memory plays me false, painted on the reverse side of an ordinary white primed canvas; and on this, before he had reversed it, he traced a cartoon of the 'Three Girls,' having pricked it through in the old manner, and then outlined the figures with a fine, red line.'[21] (Such pricking was used by the old masters, so that chalk could be rubbed through the pinholes to transfer the outlines from the drawings or cartoons. Whistler may have learned to use the technique during his studies of neo-classicism, or even in Gleyre's studio in Paris.)

Today there is no means of being sure who or what was on the back of the canvas. Eight years after Bacher had seen it, when the French government bought the painting for the Luxembourg Museum, Whistler had it relined with a new canvas before it went to France — probably because he thought it demeaning to send the picture with a botched work on the back. (His defensiveness may have been reflected in his famous 'Ten O'Clock Lecture' on his philosophy of art, in a passage excoriating 'art experts': 'Careful in scrutiny are they, and conscientious of judgement — establishing, with due weight, unimportant reputations — discovering the picture by the stain on the back ...'[22])

X-rays made in the Louvre reveal only a cluster of indecipherable strokes to the centre left of the picture. It would be gratifying to know exactly what they represent, though what was on the reverse is of purely

incidental interest. Far more important for his concept of
the portrait and the way it has come down to us today
are the reasons Whistler decided to paint on the back of
a canvas at all. When Bacher put this question to him, the
answer was simple but highly suggestive: 'Isn't that a
good surface?'[23]

For Whistler the aesthetic 'feel' of the portrait was
inseparable from the subject and of overriding impor-
tance; this had been a central tenet of the philo-sophy of
art for art's sake. In his book *Memories of James McNeill
Whistler* (1912) T.R. Way recalled that the artist was
extremely sensitive about the texture of the canvases he
used, constantly varying and priming them himself.
Sometimes they were of the coarsest sacking; at others,
as thin as calico. He once said that if he could see upon
the untouched canvas the completed picture, he painted
it. We shall never know why his eye alighted on the back
of a picture he had already begun, though he may have
been struck by the possibilities offered by the rough
grain of unprimed canvas, deciding perhaps that this was
the ideal surface for the 'puritan' image of his mother he
had in mind. Together with the Far Eastern feel of the
raw woven hemp and its painterly potential, perhaps it
also evoked subliminal memories of dark, coarse-
textured ancestral portraits from his New England
childhood.

The choice of canvas was central to the whole future
of the portrait. The effect of the thin, heavily diluted
paint he was to use on the bare, absorbent canvas would
be startling. (An American painter, Harper Pennington,
who also saw the unrelined painting, has confirmed that
the canvas was so permeable that it was stained right

through with oil from the front.)[24] In terms of the works of English painters at the time, with their polished, glossy, 'finished' surfaces, or of the sensuous, impastoed paint of the French, the very texture Whistler chose for his mother was a revolutionary gesture in itself.

Normally Whistler would have had one side of the canvas prepared for him (or would have prepared it himself) by coating the fibres in glue (size) with a large brush and then applying a layer of ground — in his case usually grey distemper. The effect of these two layers would be to flatten the fibres by filling the crevices between them, so making the canvas both smoother and less absorbent. This time Whistler appears to have done something different. In his determination to achieve the effect of rawness and bleakness, he appears to have used the reverse of a prepared canvas virtually unprimed. Across this parched and tactile surface Whistler dragged and scumbled* his often ink-like paint, sometimes dryly catching the upper threads. While it lasted, the effect must have been exquisite.

<div align="center">★</div>

By all accounts Whistler at work was a remarkable sight. His methods of painting seem to have been as idiosyncratic as his personal mannerisms. The duellist's stance, the rapidity of movement, the long brushes poised to dart at the canvas with swift, stabbing strokes — his spasms of brushwork are far more suggestive of modern 'action painters' than of his contemporaries. (To point the contrast, one has only to think of photographs

* Light brushing of an opaque colour over a previous layer of colour, making it show through irregularly.

of Cézanne, seated in a sober reflective posture before the easel.)

Whistler made few, if any, preparatory studies for most of his works. A later sitter, Comte Robert de Montesquiou, described how an initial sketch for his own portrait was done directly onto the canvas, in a wild fever of strokes, in less than two hours. But this did not mean that the portrait would be swiftly completed. Montesquiou also described how he began to feel the life draining out of him as, session after session, Whistler searched for perfection — touches that would sharpen the focus without releasing the figure from its 'tonal envelope,' lifting veil after veil until the portrait finally emerged. (Gainsborough's practice of starting a portrait in almost monochromatic shadow, slowly releasing more light as he built up crisper definitions and touches of colour, together with the use of long brushes and the inevitable ribaldries about failing eyesight, has recognizable similarities.)

The knowledge that the artist might at any moment be plunged into despair to the point of erasing or destroying the work before the model's eyes must have weighed particularly heavily on the sitter. It might have been of some comfort to Montesquiou to be told by Whistler whenever he faltered, 'Stand there for another moment and you will exist for eternity.'[25] But it was hardly an assurance that would have weighed with his devout mother. The fact that Whistler began to prepare the canvas in the evening (at the very least it would need to be reversed on its wooden stretcher) suggests that he was in a state of some excitement and anxious to make a start on the portrait the following day. There is no trace

of any preparatory sketches or drawings. Whistler seems to have set straight to work.

The failure of Maggie Graham to keep her appointment was only one of the apparent elements of chance that led to the painting of the 'Mother'. Another was the composition. Both at the time and later it was suggested that Whistler was influenced in his decision to paint his mother sitting by the Dutch matrons of Frans Hals or by classical models of matriarchs — the 'Agrippina' in the capitol in Rome, Canova's statue of Napoleon's mother at Chatsworth, or the Tanagra figures being excavated in Italy at the time. The echoes of classical statuary are powerful and contribute much to the feeling of serenity the portrait exudes. But these models cannot have directly influenced his original conception, quite simply because his first idea was to paint her standing up.

In her letter to her sister Anna Whistler had written that he had asked her to 'stand for him.' And for a few days stand she did, until her son took pity on her:

> I was not as well then as I am now, but never distress Jemie by complaints, so I stood bravely, two or three days, whenever he was in the mood for studying me ... his pictures are *studies* and I *so interested* stood as a statue! But realised it to be too great an effort, so my dear patient Artist who is gently patient as he is never wearying in his perseverance concluding to paint me sitting perfectly at my ease ...[26]

Most of his later portraits were of standing figures,

broadly in the manner of Van Dyck, or Terborch on an extended scale, and Whistler may at first have assumed that this would be the best way of investing his mother with natural dignity. No traces of his work during those first few days are visible today (unless the strokes in the X-ray result from an early, vertical figure, though that seems unlikely in view of the evidence that there were girls or a child on the back). In any case Whistler would have wiped them down, as he frequently did his abortive starts, with rag and turpentine. His decision to paint her sitting rather than erect seems to have been another example of hazard in the painting's history, arising not through any artistic reassessment on Whistler's part but simply because of his mother's health and his own sympathy for her — a sympathy he might have been less willing to show his other models.

From every point of view — the emotional charge of the portrait as well as its composition — the change was fundamental. Seated as she is, his mother carries an inimitable pathos, but also a certain grandeur, which it would have been harder to achieve had she been erect. This extraordinary combination of maternal frailty and authority enthroned, of the loneliness and vulnerability of age with regal solitude, might have been a good deal more difficult to suggest without the resonant emptiness around the figure. That again would have been harder to suggest in a vertical rather than a horizontal portrait.

This powerful ambivalence between naturalism and symbolism runs through every fibre of the painting. We sense that we are in the presence of a frail old lady, though our sympathy is restrained by her distancing, statuesque nobility. And yet there is no feeling of artifice;

every detail seems simple and true. The footstool is a good example of how Whistler felt his way toward this central, imposing balance between the iconic and the everyday. Once he took pity on his mother and decided to paint her seated, the stool was probably a simple necessity — not only as a place to rest his model's legs but perhaps as a foot warmer as well. There was a stove in the studio, but it might still have been chilly in late summer near the river, and sitters far younger than Anna Whistler had complained of being numb with cold after a long session with the artist.

It seems doubtful that Whistler used the footstool as an artistic contrivance; its presence in the portrait appears entirely normal. What is clear is that even such a detail as this has a determining effect on the whole construction of the portrait. By giving a decisive upward tilt to the mother's figure, the footstool helps create the illusion of her being balanced in space, strongly enhancing the 'other worldly' quality of the portrait that French critics (and especially the writer Huysmans[27]) particularly appreciated. Whistler clearly realized its importance for the structure of the painting: X-rays show that he was highly sensitive to its exact position and altered the angle of the legs several times, as he did the position of the chair and the line of the figure.

Had there been a more vertical tilt to the figure, without the stool, the geometry of the picture would have become severely grid-like: the mother's straight legs and upright torso would have echoed the flat fall of the curtain, the rectangle of the prints, and the harsh black line of the dado with too painful a symmetry. As a result, the portrait would have been impoverished in other

ways. We only have to think of the mother sitting with her feet squarely on the floor to see at once that this would have had the effect of 'grounding' both the sitter and the portrait: of bringing her down to earth, so weakening the 'elevated' feeling we get from the picture. Above all, Whistler sought to offset the soft angles of the figure against the strictly rectangular background, conveying the meaning of his subject through geometry and paint.

In his fervent defence of his artistic principles, Whistler always insisted that the subject of his portrait was almost incidental. It is one of the reasons he called it an 'arrangement.' Yet the most fundamental decision in the painting's composition — the posture of the figure — was less the result of some abstract artistic notion than a brilliant adaptation of his aesthetic aims to necessity and to his entirely natural consideration for his mother.

★

When painting his society portraits, Whistler was as exacting about his models' dresses as their posture. Sometimes he went to the lengths of insisting that their clothes should be made to his own specifications; for the portrait of Mrs. Leyland he supervised the design of the dress down to the placing of the bows; for Miss Alexander he insisted on having her dress washed and ironed anew for every day's sitting. In his 'Japanese' paintings a few years earlier, such as 'The Lange Leizen' of 1864, flowers, fans, porcelain and ladies in oriental

attire were arranged with the self-regarding eye of the interior decorator. Again, Sickert touches a tender nerve:

> Taste is the death of a painter. He has all his work cut out for him, observing and recording. His poetry is in the interpretation of ready-made life. He has no business to have time for preferences. The greatest artists in literary presentation, at the end leave us ignorant of their own opinion, or of the direction of their sympathies with the characters they represent. So here we have on the one hand Whistler tying Mrs Leyland's dress up with little ribbons, and locating her in a confused paradise of his own, and producing a very wreck of a painting, while Renoir, in Paris, makes a classic of a plump little lady, standing simply in her bourgeois salon, in her black silk Sunday dress, as it was sent home to her by her dressmaker.[28]

There is no excess of 'taste' in the 'Mother.' Here, as in so many other respects, the painting was a major exception. In Anna Whistler's clothes, as in her posture and the decor, there is a minimum of artifice and a complete absence of worldliness. After the death of her husband Mrs. Whistler habitually wore a black dress with a white coif, and her son posed her in her everyday clothes. The fact that her style of dress was directly descended from Dutch Protestantism probably appealed to her son's sense of tradition (reflected, in his own case, in his obsessional respect for the customs and uniforms of West Point), as well as to his eye.

Like the sedentary pose or the footstool, the

Velázquez-like tones of the dark dress against the greys of the wall were not manufactured for the occasion, except in so far as Velázquez and Japan had influenced the colouring of the studio itself; they were simply there. Nor was there anything deliberately archaizing about Anna Whistler herself. As Whistler's Chelsea friends noted with amusement but also affection, she was a genuine anachronism in their midst.

Thus the content of the portrait as well as the posture was uncontrived. With the exception perhaps of the pattern of the curtain, the only extravagant touch in the entire portrait is the handkerchief his mother holds. The splash of linen provided an excuse for a single piece of bravura: a virtuoso swirl of pure white lead pigment in the middle of the picture. Yet even this greatly remarked-on central flourish has a function, clinching the construction like a keystone. Like the centre of a classical tondo, it is the point of highest relief.

<p style="text-align:center">★</p>

Whistler's particular genius, closely allied to his wit, lay in seeing in a flash the potential of the occasion (he said deprecatingly 'I've had good luck — somebody always has said something that gave me the chance to say something I wanted to say in reply').[29] Baudelaire sensed very early the fugitive, impromptu aspect of his genius: 'A young American artist has exhibited a series of engravings that are as subtle and alert as improvisation or inspiration itself. Representing the Thames, a wonderful clutter of tackle, masts and rigging; a chaos of mists, funnels and billowing smoke; the profound and

complicated poetry of a vast capital.'[30] However, these flashes of insight were fickle and undependable — the eternal dilemma of improvisation.

He was both a slow and impetuous worker, an artist given to swift, false starts that rarely came up to his expectations and had to be erased again and again. The less confident he became of the direction he was taking, the more time he spent in producing anything that would satisfy him. 'Work is always so painful and uncertain. 'I am so *slow*,' he had written to Fantin-Latour a few years earlier. 'When I achieve a more rapid way of painting — when I say that, I mean to say something quite different, you understand. I produce very little, because I wipe it all out.'[31] Finishing a picture might take him many months, and a good number — such as the 'Six Projects' — were never finished at all.

The 'Mother' was different; in comparison with many of his other pictures, evidence of doubts, hesitations, or re-workings are relatively few. The main changes that can be seen today reflect Whistler's determination to prevent contours in the painting hardening into a closed outline. The back of the chair was made intentionally vaguer, and on second thoughts he brought the skirt down to the base of the picture to break the effect of an isolated silhouette. In the 'Mother' he was juggling two values against each other: while avoiding any suggestion of excessive precision in the profile, he was equally determined to sustain an overall geometrical rigour. It was probably for this reason that he added a second print (or part of one) in the top right-hand corner, after the paint was dry.

Though there is no conclusive evidence about exactly

when it was begun and completed, everything suggests
that the painting was done remarkably swiftly and surely.
The Greaves brothers were to claim that it was finished
in a matter of days, though perhaps weeks seem a safer
estimate. Again Anna Whistler's correspondence is the
best available evidence. Only too well aware of her son's
frustration over finishing his pictures, this time she
suggests that compared with his other work, his portrait
of her was brought to perfection with few of his usual
struggles:

> Jemie had no nervous fears in painting his
> mother's portrait for it was to please himself and
> not to be paid for in other coin, only at one or
> two difficult points when I heard him ejaculate
> 'No. I can't get it right. It is impossible to do as it
> ought to be done perfectly.' I silently lifted my
> heart, that it might be like the Net cast down in
> the Lake at the Lord's will, as I observed him
> trying again, and oh my grateful rejoicing in spirit
> as suddenly my own dear Son would exclaim, 'Oh
> Mother it is mastered, it is beautiful' and he would
> kiss me for it.[32]

The letter is dated November 3, 1871. The picture must
have been finished by October, when he proudly took it
with him on a visit to his friends the Leylands at Speke
Hall in Lincolnshire. (It was on the return journey that
it was nearly burned in a fire on the train.) Speke Hall
was the first place the picture was hung; appropriately
enough, it was displayed during his stay beside a
Velázquez — Leyland being a rich manufacturer and

collector. With typical immodesty, in a letter to his mother Whistler assured her she stood the comparison well.

Until it had to be sacrificed as surety for his debts, the portrait made more journeys with the artist, who kept it close to him. It is ironic to think of it hanging above the bed in Lindsay Row that his mistress Jo had been obliged to leave when Anna Whistler had arrived from America. For a long time he refused to sell it, even when in severe financial trouble.

Throughout his life, Whistler always spoke of this very personal picture as being in a separate category from his other work. Commending to Montesquiou a show of his work in Paris, which included some of his Italian pastels, he wrote: 'You can send all the beautiful women of Paris to see the little Whistlerian Pompeian ladies [*petites Pompéiennes Whistlériennes*]. There will also be my mother's portrait. And that is something different' ['Et cela, c'est autre chose'].[33]

His most honest portrait was his most private, his most easily accomplished, and by far his most successful. For once he was without disguise, painting for himself alone, and he took himself by surprise.

4

HIS MOTHER AND
OTHER WOMEN

'Asked how he had come to be born in Lowell, Massachusetts,
Whistler replied, "I wanted to be near my mother".'[1]
E. and J. Pennell, *Life of James McNeill Whistler*

The 'Mother' is quite unlike any of Whistler's other
portraits of women. Where they are nearly always
charming, romantic, decorative, and ultimately superficial,
'Arrangement in Grey and Black' is severe, architectural,
and dense with meaning. Beyond the simple image is a
complex weave of emotional threads. To a greater degree
than normal in the nineteenth century — or since —
Whistler grew up with and was sustained throughout his
life by women. From his earliest days he learned to rely on
them to organize his affairs, to protect and inspire him, to
minister to his moods and his genius, and to provide an

admiring audience. By contrast, his relations with men in his life, father and brothers included, were more distant.

His father, George Washington Whistler, a graduate of West Point, resigned from the army in 1833 and went to live with his second wife, Anna Mathilda McNeill, his dead wife's closest friend in Lowell, Massachusetts. It was here that James McNeill Whistler spent the first years of his life. At the time Lowell was a model town, a new manufacturing centre seen as one of the wonders of the modern world. The year before Whistler's parents moved there, it was visited by the President of the United States, General Andrew Jackson, and in his *American Notes* Charles Dickens describes it as 'an excellent place, full of neat rows of brick houses.'[2]

In this 'spindle city' of cotton factories and machine shops, young men and women worked twelve hours a day. The President's visit was the occasion for a celebration of industry: twenty five hundred mill girls, all dressed in white, paraded before him. The Whistlers' house had been built in 1823 for the first agent of the Lowell Machine Shop.[3] It was the finest in the neighbourhood, but it was also within sight of the machine shop and soon spoiled by nearby development. In his employment as keeper of locks and canals, then as an engineer of the Lowell–Boston railway line, Major Whistler was a symbol of the industrial ethos of the town. He is unlikely to have seen much of his new son, Jemie. The nature of the major's work also meant that the family was always on the move, first to Stonington, Connecticut, then to Springfield, Massachusetts, and then — in 1843 — to St Petersburg, where he had been appointed by Czar Nicholas I to supervise the construction of the Moscow–St Petersburg railway.

Whistler and His Mother

The closeness of young Whistler's relations with his mother is not entirely explained by his father's frequent absences or by Major Whistler's early death in Russia from cholera in 1849. Anna Whistler was an enormously capable and industrious woman as well as an intensely religious one. But to picture Whistler's upbringing, as is often done, as one of unrelenting rigour is a serious misreading of the relations between mother and son. Such an interpretation narrows and renders banal our reading of the portrait — an example of modern attitudes and pre-conceptions over-simplifying our view of the past.

From the start she seems to have shown a particular tenderness toward her 'Jemie,' explicable in the most obvious maternal terms. She had inherited a son and a daughter from Major Whistler's first marriage, and Jemie was her first child. The loss of three of her five sons by the time the family left Russia must have made him even more precious to her.

Moreover, Jemie was an exceptionally attractive child: small, animated, and remarkably beautiful (he was later to be called a 'pocket Apollo'[4]) with a talent for drawing perhaps inherited from his father. Anna Whistler's Bible lessons and gloomy Sabbaths may have been a trial to him, but her letters from Russia are full of maternal fondness and hints of little indulgences towards her 'saucy' child that belie the conventional draconian image of her. 'I cannot persuade James to put up his drawing and go to bed when it is light,' she once wrote.[5] A genuine matriarch would have had little difficulty in persuading him. The occasional delicacy of his health was another incitement to maternal affection. When his father sent him away to face the rigours of boarding school in czarist Russia, he

was soon back at home. And when he fell ill with
rheumatic fever, Jemie frequently missed school altogether
and stayed at home among the women.

The Whistlers lived well in St. Petersburg: twelve
thousand dollars a year, a fine house with servants, and
even some notice from the Czar and the court. The colour
and extravagance of what he saw of the aristocratic life —
a startling contrast with the 'neat rows of brick houses' of
Lowell — marked the artist's personality later in life. Back
in school in the US at fifteen, he was thought to have a
somewhat foreign appearance and manner. With his rather
fragile constitution and aesthetic inclinations, and the
adoring attentions of his mother and servants, in Russia he
must have felt something of a pampered young nobleman
himself.

Despite predictable misgivings about its dangerously
worldly associations, from the beginning his mother
encouraged his interest in art. Her gift to him of Hogarth's
engravings to distract him during an illness is said to have
proved inspirational for Whistler. It certainly affected his
judgement of the English artist; with his usual finality, for
the rest of his life he pronounced Hogarth the only great
English painter. The gift of his prints is a nice illustration
of Anna Whistler's predicament over her boy's aesthetic
interests. She no doubt saw 'The Rake's Progress' and the
rest as thoroughly improving material. For a young,
impressionable boy, however, the scenes of uninhibited
lubricity and Hogarth's voluptuous eighteenth-century
lines must have been inspirational indeed.

There is every reason that Whistler should have
become aware at an early age of his ability to charm
women, and to use them for his ends. At the same time,

he grew to admire them. Predictably it has been argued that his whole life was a rebellion against the domineering, bigoted matriarch whom (to the unreflective eye) his portrait seems to depict. It is more persuasive to trace some of his later tantrums, exhibitionism and general self-indulgence to a cosseted boyhood than to excessive severity, though neither influence is exclusive, and both may have played a part.

To judge by his behaviour in later life, any resentment against his mother's cramping pietism was submerged in the self-interested affection of a child who frequently got his own way in the end. However, he was also to discover, at least in his art, a need for some severity, and his self-criticism to Fantin-Latour is couched in words his mother might have used, when he refers to his painting as 'Canvases produced by a naughty boy (*polisson*) inflated with vanity at being able to display to other painters his splendid gifts — qualities that only demanded a strict education to make their owner into a Master, instead of a dissolute schoolboy (*écolier débauché*).'[6] The most obvious interpretation of his relationship with his mother is that it was an ambiguous one. Later in his life someone noticed that 'he never in any way complained of the old lady's strict Sabbatarian notions, to which he bowed without remonstrance, though he used to give a queer smile when he mentioned them.'[7]

★

Life for Mrs. Whistler and her sons changed dramatically following her husband's death and their return to America. She could have accepted the Czar's offer to stay

71

on in Russia. But as her Russian diary, with its record of Independence Day celebrations and home cooking shows, she was too much of a patriot for that (her son insisted that the fourth rather than July 11 was his birthday, the first of many future adjustments to his place and date of birth).[8]

During the few months that mother and son were separated when James was sent to London for his health, fine sheets crammed with Anna Whistler's minute and delicate script arrived once or twice a week from Russia (and were kept to the end of his life) with firm guidance for the fifteen-year-old boy. As well as exhorting him to renew his temperance pledge, give up thinking about gold mines in California, study French grammar and American history, and read Aunt Kate's improving book *Conquest and Self-Conquest*, she sent him drawing instruments and exchanged news from the St. Petersburg Academy with his stories of lectures on Hogarth, West, Fuseli, and Reynolds at the Royal Academy in London.

Her dilemma is clear: far from reacting like an authoritarian dogmatist, her response is perfectly under-standable today. She urges him: 'Beware of the influence of idle lads, my son. Reflect seriously Jemie, upon how little you have read, upon how much you ought to read. Do not suppose I would stupify (sic) you with study. I delight in your cheerfulness, my dear boy, I only want you not to be a butterfly sporting about from one temptation to idleness to another.'[9] ('My own dear Butterfly' became her somewhat despairing term of endearment later at such moments as his departure for Paris.)

Her letters occasionally show that Anna Whistler herself had something of a Whistlerian eye: 'I wished to

write my thoughts to you, dearest Jemie, for you enjoy beautiful scenery, and while I was taking dear Willie in a sledge to school crossing the icy plains of the Neva on foot the whole winter scene was so perfect I felt my mind elevated and refreshed. You know how I delight in the glories of the firmament, the rainbow hues of the clouds thro' which the bright sun was glowing, burnishing the windows of the Winter Palace upon which it reflected and every gilded dome and spire sparkling under its influence, I wished for my Jemie.'[10] Later in London she was to admit the attractions of an artist's life — tempering such worldliness by describing art as her son's 'natural religion.' But she made earnest attempts to deflect him from such a rash course. She wrote to her son in London shortly after his father's death: 'It is quite natural you should of all others prefer the profession of an Artist, your father did so before you, I have often congratulated myself his talents were more usefully applied and I judge that you will experience how much greater your advantage if fancy sketches, studies etc. are merely for your hours of leisure.'[11]

Back in the United States, Whistler's 'little prince' existence was over; instead of the easy life of St. Petersburg he found himself shovelling snow around the house in Pomfret, Connecticut, with the other boys. Despite these straitened (though by no means desperate) circumstances, his mother's affectionate indulgence toward him continued, and her son continued to take advantage of it. Sermons and Bible readings did not prevent him from misbehaving at school, and when he was ejected from West Point for laziness and indiscipline, family contacts were used first in an unsuccessful attempt to reinstate him, then to get him a job in the locomotive works at

Baltimore and finally a post in the U.S. Coast and Geodetic Survey in Washington. This he held down for less than a year.

As signs of excess and improvidence multiplied, his mother exhorted him to improve his self-discipline and even moved to Scarsdale, New York, to be closer to him. Particularly prophetic in view of the time he was later to squander in Paris as an art student and his life-long struggle to develop a reliable painting technique was his mother's letter warning him that he would never flourish as an artist without industry. But along with homilies, the moral importuning and the injunctions to frugality came his favourite sweetmeats and money. Whistler adored the home comforts, spent the money, ignored the advice, and continued to regard his mother with tolerant affection. When they lived together in London fifteen years later, the relationship was broadly the same.

<div align="center">★</div>

Although she would have preferred for her son the more respectable professions such as the church, architecture or engineering, Anna Whistler gradually resigned herself to his determination to make himself an artist. Considering his distinct signs of irresponsibility, the very last thing she must have wanted was for him to become an art student in Paris. Yet again she seems to have acquiesced without much of a struggle, prepared — as so often in his later life — to 'leave the decision to God.' Where Jemie was concerned, there seemed a streak of fatalism — maybe even of Calvinistic pre-determination — in her religion. 'What am I to do now for my Jemie but pray, believing?'[12]

she wrote when he left her, at the age of twenty-one, for Europe.

Needless to say his mother's prayers had even less practical effect on Whistler's conduct in Paris than in Baltimore or Washington. At no stage is there any evidence of tortured resentment at her moralizing, still less of his despising her; after all, he was still getting his way. In his personal treatment of his mother, there was always respect and occasionally deference.

The incongruities of the ménage of mother and son, in which Anna Whistler combined the role of manager of his chaotic household with that of a sort of resident conscience, have been extensively chronicled. The episodes that stick in the mind are the most revealing: of Whistler escorting her to Chelsea Old Church and leaving her at the gate with a bow; of her attempts to dissuade him from working on the Sabbath (when he lapsed and had an unproductive day at the easel, it was God's retribution); of her helping arrange parties for his libertine friends, then retiring to her upstairs room where she felt 'closer to her Maker'; of her instinctive disapproval for the Portuguese businessman-swindler, Charles Howell, who had intrigued himself into her son's affairs ('yet, you know, Mummy, to who else could I say play and he plays and stop playing and he'll stop?'[13]). And yet the fondest relationship she established among her son's friends was with Algernon Swinburne: poet, drunk and flagellant.

The most revealing description of Anna Whistler's feelings about living with her son comes in a letter she wrote soon after she took up residence. It shows both her determination to help him mend his ways and a glimpse

of her attraction, despite her sedate self, to the Chelsea art
world:

> While his genius soars upon the wings of ambition
> the every day realities are being regulated by his
> mother — for with all the bright hopes he is ever
> buoyed up by, as yet his income is very precarious. I
> am thankful to observe that I can and do influence
> him. The artistic circle in which he is only too
> popular is visionary and unreal, tho' so fascinating.
> God answered my prayers for his welfare by leading
> me here. All those most truly interested in him
> remark on the improvement in his home and
> health. The dear fellow studies as far as he can my
> comfort, as I do all his interests, *practically* — it is so
> much better for him *generally* to spend his evenings
> tête à tête with me, tho' I do not interfere with
> hospitality in a rational way, but I do all I can to
> render his home as his father's was.[14]

The steely tone that emerges occasionally in her letters
tends to be in response to female threats to his work or
reputation. In his student days she would implore him
from across the Atlantic to 'cultivate a purer taste, dear
Jemie,' when he sent her drawings from Paris that she felt
'caricatured only the depravity of city life' and which she
'thought best to purify by fire.'[15] Earlier still she had
intercepted letters from a 'West Point Belle,' replying
herself:

> Do not let it alarm you, fair stranger, that the
> widowed mother of James Whistler presumes to

advise you ... I judge not too harshly of the inexperienced in the world's allurements, not doubting present amusement is blinding you to future mortifications if persisted in. I did not lecture my son but depended upon his ready promise to end the affair — so natural in youth's teens! But so imprudent and culpable if continued. Probably you have no mother! ... I excuse the past in this flirtation of James, the temptation so irresistible at West Point ... I pray for God to grant a blessing upon my interposition, your delicacy, his honour are so precious.[16]

Their living together later does not seem to have been forced on either Whistler or his mother by circumstance. She was a refugee of sorts and not in the best of health but might equally well have stayed with her step-daughter, Deborah, and Deborah's husband, Seymour Haden. As we have seen, her presence in Whistler's house seriously disrupted his relations with Jo. Yet where his mother was concerned, the artist's legendary egotism seems to have been brought under control. Anna Whistler lived with her son because the arrangement appears to have satisfied a need on both sides. She was someone he could rely on to help him manage his daily existence without distracting him from his work. For her part, his mother could seek to moderate her son's excesses while nurturing his genius. He was later to keep his bankruptcy from her, as he shielded her from knowledge of his illegitimate son, 'an infidelity to Jo.'[17] Meanwhile, he continued to have Jo as a mistress, albeit lodged elsewhere. There were quarrels about her, but essentially the relationship between mother

and son in this highly incongruous ménage seems to have
been a very American mixture of surface moralism and
underlying pragmatism.

Those who met Anna Whistler at her son's house were
struck by his devotion to his mother and by her old-world
presence. One recalled her as 'Calm and dignified, with
something of the sweet peacefulness of the Friends
[Quakers].'[18] But when it came to the promotion of her
son's interests as an artist, pietism and pragmatism could
become inextricably confused. In a letter to his patron
Leyland she once wrote: 'You know, my dear Leyland,
how painful is this task to me, for though my experience
of blighted hopes in this world has taught me to expect
disappointment, I yet tremble as my sons encounter it, for
they have not the faith in God which is my support.'[19]

The letter was asking for an advance on a portrait
commissioned by Leyland. It was written at the request of
her godless son, whose religion, she now recognized, was
art. Insofar as she still felt any conflict between her own
beliefs and Jemie's vocation, Anna Whistler had obviously
resolved them in her own mind: 'God has given him
talent, and it cannot be wrong to use it.'[20]

★

It is easy to portray his attitude to his mistresses as a
random series of liaisons. Yet seen against a background of
his habitual irresponsibility and self-centredness, his
treatment of the women in his life, if not exactly a model
of propriety and selflessness, was a good deal more
defensible than his general behaviour. Someone who
knew him as a student in Paris decided that he had 'un

coeur de femme, et une volonté d'homme[21] — a penetrating observation (although his *volonté* frequently took the form of wilfulness, rather than willpower). Just as the women he knew often displayed what are conventionally supposed to be the essentially 'masculine' characteristics of rigour and self-discipline, so Whistler himself was well endowed with what were seen as some of the more negative 'feminine' traits. His mistresses, like his mother, managed his affairs in much the same way as might the sober and dutiful husband of a wayward and extravagant wife.

There was spite as well as wit in his comments on fellow artists whose successes he envied or on those who had crossed him. Examples of his feline vindictiveness are too legion to quote; perhaps the best instance was his inclusion of previous critical comments in the catalogue of the triumphant exhibition of his pictures at the Goupil Gallery after the sale of 'Mother' to the Luxembourg Museum. Magnanimity in victory was not a Whistlerian concept.

He could be as sneaky as a schoolgirl, as when he substituted the labels of nameless vintages for those of better known wines when he was short of cash. There was a strain of mawkish sentimentalism in his make up, as in some of his less successful pictures; in his later years he became extravagantly fond of children, paying Paris urchins to pose for poignant sketches. He was an absurdly vain and self-conscious dresser, and the decorative element in his art could be overpowering. It was not for nothing that he was once called the Beau Brummell of art (a description Whistler would have found flattering). According to the dandyist canon of Jules Barbey

d'Aurevilly, *Du Dandysme et de George Brummell*, which Whistler had read in Paris, vanity was the chief of dandyist virtues.[22]

Whistler's fondness for contrived simplicity of design easily descended to trickery and whimsical effect, as in his elaborately devised meals and menus, and the decor of his house. The 'Peacock Room' can only be described as gorgeous. The motif tells its own story, and it is easy to see why the real Prince of Dandies at the time, Comte Robert de Montesquiou, admired it so much.

In his personal behaviour the artist himself must often have seemed like a tiresomely self-regarding woman, made bearable only by his cascading wit. Fantin-Latour inadvertently put his finger on these aspects of his character when he described him as 'seductive, despite everything,' and wrote of his American friend:

> My love for Whistler is like that of a man for a mistress whom he adores despite the trouble she gives him.'[23]

That there was another, more profoundly attractive side to his personality is attested to by some of those closest to him. Like some sharp-witted cocotte, he virtually enchanted people, the poet Mallarmé being one of his most notable conquests, who went on to become a lifelong friend. The English painter Walter Sickert worked for many years for Whistler as a studio assistant. A man of robust good sense as well as aesthetic insight, who suffered at his master's hands and cannot be suspected of partiality, Sickert described Whistler's more captivating attributes: 'Sunny, courageous, elegant, soigné. Entertaining,

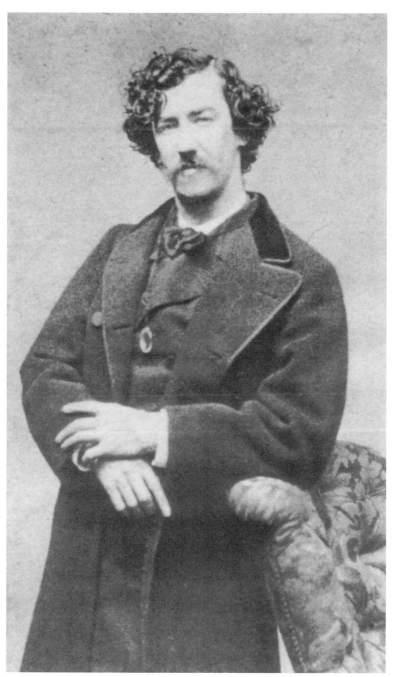

James McNeill Whistler by Étienne Carjat, Musée d'Orsay.

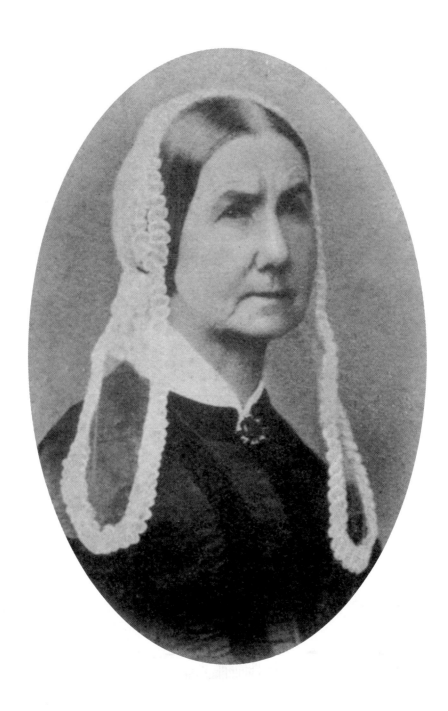

Anna Matilda Whistler moved to England and stayed with her son from 1863 first at number 2 and then 7 Lindsey Row.

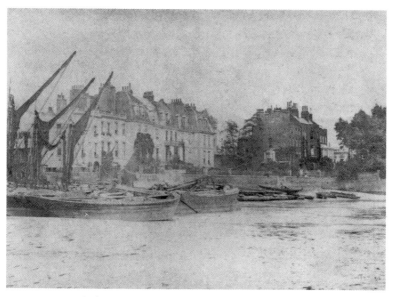

Lindsey Row in London (today Cheyne Walk).

7 Lindsey Row
(101 Cheyne Walk).

2 Lindsey Row (97 Cheyne Walk),
where the 'Mother' was painted.

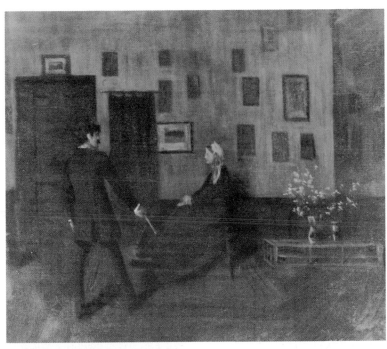

Whistler and His Mother, 1917, by
Walter Greaves, oil on canvas.
Gift Mr and Mrs Stuart P. Feld,
The Harvard Art Museum.

A nude binding up her hair, 1867, by
James McNeill Whistler.
Anna Whistler always avoided dis-
turbing her son in his studio after she
once discovered the parlour maid
'posing for the all over.'

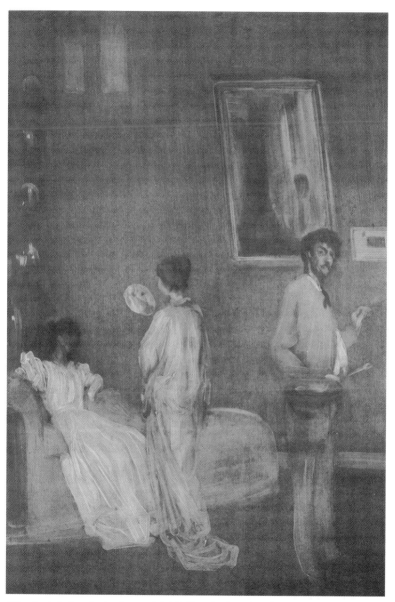

The Artist's Studio by James McNeill Whistler, sketch of a larger picture
never painted, Art Institute, Chicago. On purpose, the studio had minimal
furnishings and low light to avoid any side light. Its bare grey walls with
black wainscoting and door, Chinese matting and a few black-rimmed
prints, formed the background to the 'Mother'.

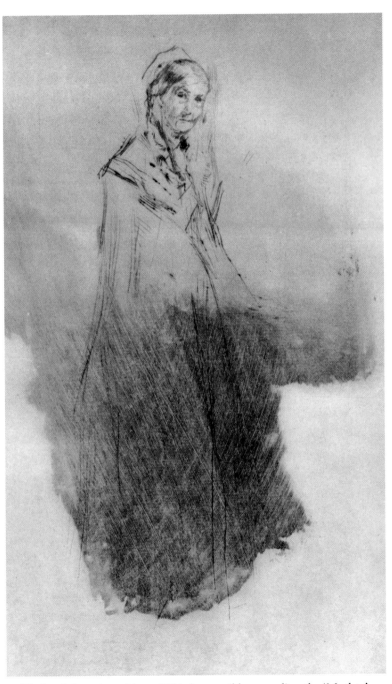

Undated drypoint of Anna Whistler, possibly preceding the 'Mother'.

Symphony in Flesh Colour and Pink: Mrs F.R. Leyland, 1873,
by James McNeill Whistler (Frick Collection, New York). Whistler
supervised the design of the dress down to the placing of the bows.

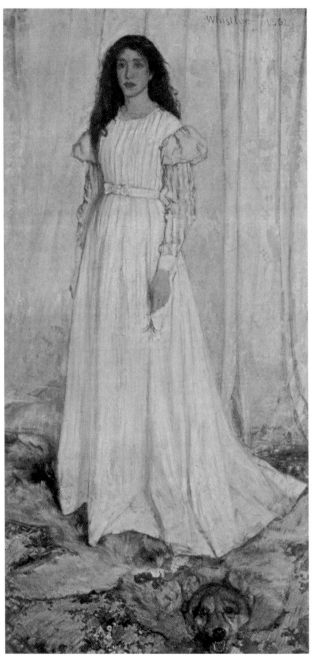

The White Girl, 1862, National Gallery of Art, Washington (portrait of Jo
Heffernan). Rejected by the Royal Academy, it was the sensation with
Manet's Déjeuner sur l'Herbe at the Salon des Refusés in Paris, 1863.

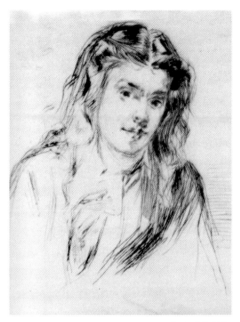

Fumette or La Tigresse, 1859,
by James McNeill Whistler.
A part-time model with a
sulpherous temper.

Maud Franklin, Pennell Collection, Washington. Not content to
be presented to Fantin-Latour as 'the daughter of a friend'.

Henri Fantin-Latour and James McNeill Whistler:
a section of Homage to Delacroix, 1862, by Henri Fantin-Latour.

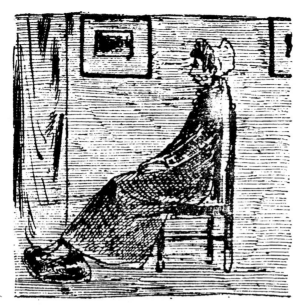

J.M.N. Whistler: Une pauvre dame abandonnée dans un appartement, dont les cheminees fument (*Revue comique du Salon,* 1872, by Draner). A poor lady left on her own in an apartment with smoky chimneys.

Whistler's Brother Ernie from Duluth, 1985, Ken Brown.

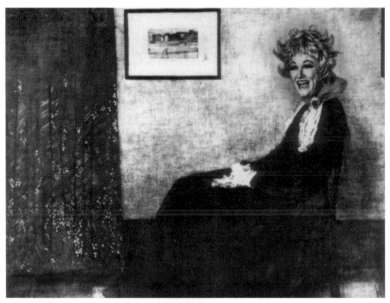

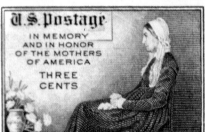

Whistler's Mother?
©1984 Alfred Gescheidt.

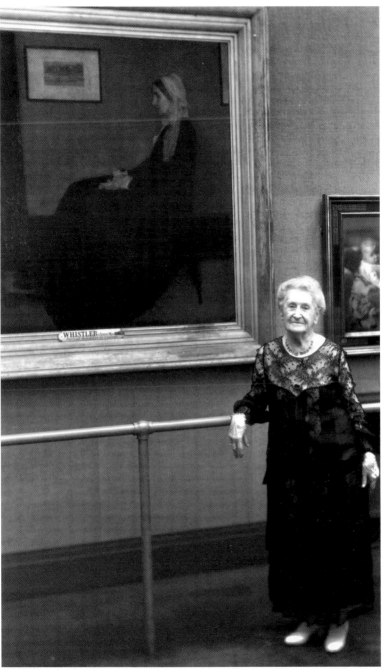

Wearing black satin with purple and white orchids, President Roosevelt's mother attended the departure of the 'Mother' from the US in 1933.

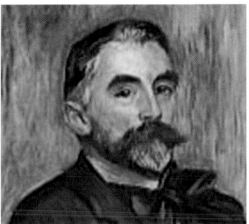

Stéphane Mallarmé.

Mortimer Menpes.

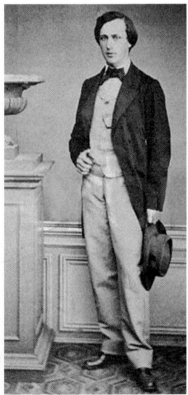

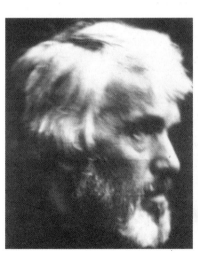

Thomas Carlyle.

Henry James.

Marcel Proust.

Robert de Montesquiou.

Walter Sickert.

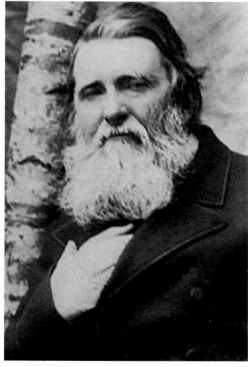

John Ruskin.

J.K. Huysmans

Algernon Swinburne.

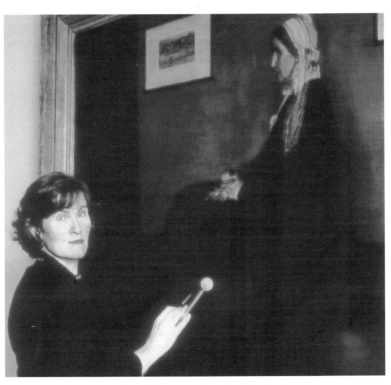

Sarah Walden restoring the 'Mother'.

serviable, gracious, good-natured, easy-going. A charmer and a dandy, with a passion for work. A heart that was ever lifted up by its courage and genius. A beacon of light and happiness to everyone who was privileged to come within its comforting and brightening rays. If, as it seems to me, humanity is composed of two categories, the invalids and the nurses, Whistler was certainly one of the nurses.'[24]

The Australian artist Mortimer Menpes, Whistler's assistant for many years, wrote in his book *Whistler as I Knew Him*, that he himself had been 'vigorously handled,' but nevertheless confessed to finding him 'in many respects a loveable, delightful man.'[25]

Despite this dangerous conjunction of charm and wilfulness, and a semi-bohemian style of life, Whistler was neither a promiscuous womanizer nor even much of a sensualist. In his relations with women, as in his drinking and eating, he was extremely exacting but, for a man of his passionate and impulsive nature, relatively abstemious. There was a strain of old-fashioned decorousness in his attitudes, which was accentuated with age: when he established his own school of painting in Paris at the end of his life, there were separate ateliers for male and female students and no nude models; the cause of his rupture with Jo was her posing for a licentious painting by Courbet.

Although he had a number of mistresses, his liaisons were remarkably stable. Today they might have been seen as a sequence of marriages, in the course of which Whistler showed a good deal more faithfulness than might have been expected in someone of his mercurial temperament. Other than his mother and sister, there were three main women in his life: his mistresses, Jo

Heffernan, Maud Franklin, and Mrs. Beatrix Godwin, whom he married late in life after the death of his mother. His relationships were fairly long-lasting: Jo was with him for eight years, from 1858 to 1866, Maud for fourteen, from 1874 to 1888, and Mrs Godwin from 1888 to her death in 1896. Each of them had three things in common: a practical intelligence, a long-suffering nature, and a devotion to his genius — qualities shared, it goes without saying, with his mother.

<p style="text-align:center">★</p>

Whistler's first recorded affairs were in Paris as a student and were so close to the model *vie de bohème* romanticized in Henri Mürger's book of that name, which Whistler had read in America, as to be almost a caricature.[26] The Pennells are predictably reticent about his sexual behaviour in Paris. But although he was an extremely good-looking young man, with his long, curly black hair and his dashing wide brimmed hats, and fond of dancing and female company, there is no evidence that he was particularly promiscuous or that he spent much of his time in brothels.

His principal involvement during his four years as a student was with a grisette from the theatre world, Héloïse, whose sulphurous temperament earned her the sobriquets of *fumette* ('combustible'), and *la tigresse*. She was a part-time model, among other employments, and it is clear from descriptions of her that Héloïse was a clever and characterful as well as an attractive girl, whose ability to quote chunks of the poet Alfred de Musset by heart earned Whistler's admiration. Her main defects were her

temper and her jealousy. Yet although she once destroyed his drawings in one of her rages, Whistler stayed with her for two of his four years in Paris. His second known mistress was a cancan dancer named Finette, who later performed in the music halls of London. The operetta world of Gerald du Maurier's *Trilby* records something of this *vie de bohème*.

★

Thereafter the women in his life show a gradual ascent in 'respectability' (if not physical attractiveness) from Jo through Maud to Beatrix Godwin. Jo (alias Mrs. Abbott), a striking red head whose dreamy Pre-Raphaelite looks are immortalized in 'The White Girl', was the daughter of an Irish workman who referred to Whistler as 'me son-in-law.' Socially she was the humblest of the three, though she was an intelligent women who understood the importance of art and painted a little herself. Perhaps the most interesting aspect of their relationship was their mutual loyalty. Jo touted his pictures around galleries for him, posed for him, begged money for him, and when once he was briefly unfaithful, she cared for his illegitimate son, using her own sister as a uniformed nanny.

In return, by standing by her in the face of the disapproval of his family, Whistler showed constancy of a sort, and when he went to Valparaiso, he even provided for her in an interim will. When they eventually parted, he had an undoubted grievance. Desperately short of money, Jo had agreed to pose during his absence in South America as one of the pair of naked sapphic ladies in

Courbet's lascivious picture 'Paresse et Luxure' (Idleness and Luxury) of 1866. Courbet's interest in her was not just as a model; the French artist had always been physically attracted to her, and Whistler may have suspected that they had had an affair — which seems more than possible. Courbet retained one of his magnificent portraits of her to the end of his life, in exile in Switzerland. Whistler had a double cause for jealousy.

Though a professional model, too, both intellectually and in terms of social aspirations, Maud Franklin was one step up from Jo. An auburn-haired women with a somewhat less self-sacrificial temperament than the Irish girl, she chafed under the constraints of her position and was not content to be presented to Fantin in Paris as 'the daughter of a friend' (he compromised by introducing her as 'Madame'). Yet Maud, too, stood by him through even more difficult years than he had experienced with Jo. They included the Ruskin trial, Whistler's bankruptcy, and, above all, the penniless days in Venice that finally damaged her health. The degree of his almost child-like dependence on her is well illustrated by a minor incident in his studio: while Whistler was completing a sketch, a bottle of acid spilled over the plate. Instead of acting to limit the damage, Whistler stood there aghast as the acid poured over a chest containing his clothes and called for Maud.

It was less than coincidental that when the final break with Maud came, the immediate reason seems to have been a less lurid repetition of the episode with Jo and Courbet. When Whistler began to use her more rarely as a model, she misjudged his level of tolerance by posing in the nude for a 'Venus' for a mediocre painter, William

Stott. Whistler, who could be puritanical about such things, was shocked and annoyed as much by the indignity of the connection as by the scandal.

Both Jo and Maud continued to have strong feelings for him after the break up of their affairs. When he died Jo came back from France, where she was living, to attend the funeral. Maud's devotion was transmuted into revenge: when he married Beatrix Godwin and was living in Paris, she went to live close by and called herself Mrs. Whistler.

His reliance on women grew throughout his life. Yet it was only after his mother's death in 1881 that he formed a truly emotional attachment. Mrs. Godwin, the widow of the great architect, was less good-looking than his mistresses but remarkably astute at managing his mercurial moods. She helped him in his work and acted as his private secretary, and he showed far more affection to 'Trixie' than to Jo and Maud. When she fell seriously ill, it came close to affecting his reason. His doctor brother, William, diagnosed cancer, but Whistler refused to believe it; the intensity of the artist's emotion drove William also close to a breakdown.

Insisting that his wife was afflicted with a temporary illness, Whistler made arrangements for her to 'convalesce' in Hampstead. His painting of her reclining on a couch at the Savoy Hotel around this time was entitled 'Siesta'; in fact, she was incapable of getting up. And when she died shortly afterward, it was observed that for once in his life Whistler was carelessly dressed (one black shoe, one brown). Trixie was by no means a fashionable beauty, but she had given him everything he needed most from a woman. Even Anna Whistler might have approved of her,

despite the undeniable fact that his hard-won contentment robbed him of any urge to create.

His immediate reaction to his wife's death was to seek female company: he telephoned Mrs. Pennell, the wife of his biographer, and went for a walk around the National Gallery. Thereafter, incapable of managing by himself, he was at once taken in hand by Mrs. Godwin's sister, the last of a long line of maternal figures.

'Arrangement in Grey and Black' was painted in mid-life. It would therefore be hard to defend the thesis that it represents a summation of the artist's feelings about femininity based on his experiences, as well as his relationship with his mother. Yet La Tigresse apart throughout his life the artist was drawn to 'good' women as well as intelligent ones. It would not be too far-fetched to see in the painting a monument to womanhood as well as motherhood.

<div align="center">★</div>

The 'Mother' was Whistler's most personal painting, as well as his finest. For anyone else but him, there would be no conceivable contradiction. Yet Whistler fiercely resented any suggestions that the portrait was chiefly or even partly an emotional homage to his own mother. He made an issue of artistic principle over the matter, which became the subject of a running controversy with friends and critics alike. However perverse or excessive this may have seemed, perhaps it was a natural defence mechanism against the very intensity of his affections. The remark in response to praise for the beauty of the portrait — 'Yes, one does like to make one's mummy just as nice as

possible' — may be seen among other things, as a typically evasive and humorous piece of understatement.

But the matter went deeper. Although it occasionally surfaced in petty or grotesquely extravagant gestures on Whistler's part, the conflict over the importance of 'content' and 'feeling' in the portrait of his mother went to the heart of his concept of painting. What was at stake was less the intimacy of his affections for her than his whole self-image as an aristocrat of art, pitted in permanent battle against the vulgar philistinism of the mob and the anecdotal sentimentalism at the core of English taste.

In 'The Ten O'Clock Lecture,' delivered in London in 1888 and reproduced in *The Gentle Art of Making Enemies* a year later, Whistler spelled out, or rather proclaimed, his aesthetic creed. He insisted that painting was 'the poetry of sight' and should be entirely independent of subject matter. Themes were unimportant; what mattered were 'celestial harmonies.' Art should stand alone without 'emotions entirely foreign to it, (such) as devotion, love, pity, patriotism, and the like.'[27] Significantly he gives his portrait of his mother as the prime example of art misunderstood: 'Take the picture of my mother, exhibited at the Royal Academy as an "Arrangement in Grey and Black." Now that is what it is. To me it is interesting as a picture of my mother; but what can or ought the public to care about the identity of the portrait?'[28]

It was not a position calculated to appeal to the English art establishment of the day, as the first reaction of the Royal Academy showed when the picture came up before the hanging committee in 1872. A 'Confounded

"arrangement" or "symphony" or something of the kind,'[29] one of the committee is said to have remarked before rejecting it. Whistler would have been happy with that; he liked his adversaries to behave according to the character he assigned to them. But he reacted violently when his friend Swinburne challenged his theories in public, using the 'Mother' (for whom in life Swinburne himself had had some affection) as part of the argument.

In his commentary on 'The Ten O'Clock Lecture' entitled 'Mr Whistler's Lecture on Art,' Swinburne praised him for the 'Mother' and his portrait of Carlyle that came immediately after — but in a way Whistler found intolerable. Describing Whistler's 'arrangements' as 'lovely and effective,' Swinburne teasingly adds that it would be quite useless for the painter to protest that his portraits did not appeal to the emotions as well as to the aesthetic sense, and he talks of the 'intense pathos of significance and tender depth of expression (in) the portrait of his own venerable mother.'[30]

Anyone else but Whistler might easily have forgiven Swinburne for discerning traces of filial affection in the portrait. But the article impugned the artist's aesthetic code; his religion of art had been traduced. In a reaction which would have been more normal had Swinburne insulted Anna Whistler, he immediately severed his relationship with the poet and selected the passage from the article which referred to the 'Mother' for reproduction in *The Gentle Art of Making Enemies* under the title 'An Apostasy.' It would be interesting to know what Mrs. Whistler herself would have made of the exchange between the two men about her portrait.

Swinburne was even more right that he supposed.

Present in the portrait are not only 'pathos' and the 'tender depth of expression' but everything Whistler himself vehemently denied was there: devotion, pity, love, and patriotism. It was quite natural that they should be; these were the emotions the artist must have instinctively associated with his mother. Not only did he admire them, but in his own peculiar way he shared them.

Meeting him for the first time in 1891, when Whistler was fifty-six, the uncannily perceptive writer Huysmans saw in his frail, fine, angular little body and sapphire eye 'something of the meticulous old maid.'[31] And in 1902, the year before Whistler's death, an American who was watching him at dinner in Paris noticed that with his grey, pink-cheeked profile and little slippers he looked uncannily like his mother.[32]

5

THE PORTRAIT AS PATRIOTISM

'We lack the deeper sense. We have neither taste nor tact, nor force. How should we have them? Our crude and garish climate, our silent past, our deafening present, the constant pressure about us of unlovely conditions, are as void of all that nourishes and prompts and inspires the artist as my sad heart is void of bitterness in saying so. We poor aspirants must live in perpetual exile.'

<div align="right">

American expatriate artist in
'The Madonna of the Future', by Henry James[1]

</div>

Name and place of birth are two of the simplest facts people can be asked. Most will give a straightforward reply. Whistler blurred both. It is symbolic of the uncertainty he cultivated around his identity that during its triumphal tour of America in 1933 and 1934 the 'Mother' should have travelled twenty thousand miles around his native land with the artist's name misspelled on the picture's label (MacNeill instead of McNeill). Even more telling is that it should have been his middle name that caused the difficulty. 'McNeill' did not feature among Whistler's Christian names. It was his mother's family

name, which the artist substituted in later life for the prosaic Abbott (the surname of the husband of General Whistler's elder sister): 'as my mother's eldest son, I have the real right to bear her Highland name of which we are all proud.'[2]

With his indifference to factual accuracy and weakness for romantic resonance, he could equally well have pillaged his father's name: George Washington Whistler had the necessary ingredients, and James Washington Whistler would have sounded well. Instead he chose McNeill, a name that combined Celtic mystique with Southern aristocratic pretensions, the McNeills being Scots who went to Wilmington, North Carolina, after the Battle of Culloden. It would greatly have amused the artist to have known that the great American collector Charles Freer worried that the use of his assumed middle name on his will might invalidate the document.

It was not only his name that he conjured with. Notoriously unreliable about his birthplace, he variously claimed to have been born in St. Petersburg or Baltimore — both more appealing to the romantic imagination than the industrial new town Lowell, whose 'taint' he consciously tried to expunge. He carried his evasion to coquettish extremes, refusing to tell the French critic Théodore Duret, where he was born at all.[3]

Yet like it or not, Whistler was an American and a New Englander, by birth and character, if not always by inclination. However profound his frustrations with his motherland, he was 'an American artist, residing temporarily abroad,' as he attested on the documents he signed that exempted his pictures from import duties when at last they were bought by American collectors.[4]

Consciously or inadvertently, in the 'Mother' Whistler epitomized his native land in the minds of his countrymen; more than that, it was the painting that most closely confirmed his own identity. Its differing critical reception in the three countries were he spent most of his life — England, France and the United States — is enormously revealing, telling us much about artistic taste in those countries at the time and about Whistler's relationship with each, as well as a lot about the many-faceted nature of the portrait itself.

<div align="center">*</div>

In its lengthy obituary on Whistler on July 18, 1903, *The Times* of London carried only a passing mention of 'Arrangement in Grey and Black.' In common with other publications, while supposedly summing up his life and achievements, it concentrated more on his personality than his painting. And when it got around to his pictures, there was a note of prudent detachment: 'As to the general reception of Whistler's works in those days, it cannot be said that they roused any strong feelings on one side or another. The "insults and abuse" of which Mr Pennell speaks, and which had really been "hurled" at the Pre-Raphaelites fifteen years earlier, were not forthcoming. Some artists were greatly interested, some shook their heads, and the public — who of course do not count — were mildly puzzled.'[5]

In a way *The Times* was making a fair point: Whistler and his biographer had both dramatized the painter's differences with the artistic establishment. After all, some of his prints had been acquired by the British Museum in

his lifetime, and some of his early pictures — notably 'At the Piano' — had been greatly admired in London. *The Times* obituary writer was right about the 'puzzlement' Whistler inspired; in their response to his work — as to his person — the dominant reaction of the English was less that of hostility, as Whistler and his champions liked to claim, than of bemusement tinged with condescension (of which there was a touch in *The Times* obituary itself). The 'Mother' in particular was a profoundly un-English painting: impatient as a race of ambiguity or paradox, the English liked clarity in their art, and it was not at all clear to them what this picture meant or what school or country it belonged to.

The same was to some extent true of Whistler himself, with his dandified French side, his Russian aristocratic insolence, and his American flair and vivacity. To Continentals in particular it was obvious that whoever he was, even after thirty years in the country, there was very little of the Englishman about him. Théodore Duret, an indefatigable champion of his work and one of his most perceptive artistic biographers, was at pains to underscore the full extent of the physical and temperamental differences with the Islanders: 'Brown, thin, wispy, quick-featured, impulsive, capricious, making gestures and talking loudly, everything was far removed from British phlegm. Only his language was of the country, but when he opened his mouth his accent set him apart.'[6]

He was as touchy about his nationality as about everything else (as someone once said of him, the way to get Whistler to do what you wanted was to treat him as a very sensitive foreign power). Time and again he jeered at the notion that he was an English artist, boasting that

there was not a drop of Anglo-Saxon blood in his veins. He would have been gratified to know that the pallbearers at his funeral included three Americans, a Frenchman, an Irishman, and a Scot, but not a single Englishman.

Life in England seems to have suited him for a number of reasons. As his work attests, he had a genuine appreciation and understanding for the landscape of London, if not for the English countryside, which — unusually for a foreign-born painter at that time — he scarcely attempted to render on canvas. Another incentive to life in London was that intellectually and artistically, despising the English was a far more attractive pastime than living up to the French. There was nobody in London who could reduce him to apprehensive reticence, as Degas did (George Moore noted acidly that in Degas's company Whistler was remarkable for his flashes of silence). With his inflated sense of status, the social snobbery of England had its perverse appeal for him too. Fantasizing one day about a knighthood, he reflected how agreeable it would be to hear the fishmonger presenting his bills with the words 'Your little account, Sir James.' Mortimer Menpes, one of his most sympathetic and amusing disciples, explained that 'Whistler had no democratic instincts ... His only excuse for the masses was that they were a blot of colour to be painted ...The master was a Tory. He did not quite know why; but, he said, it seemed to suggest luxury: and painters, he maintained, should be surrounded by luxury.'[7]

One side of him was almost pathetically anxious for official as well as public recognition, which was consistently denied him. He was never elected to the Royal Academy and could not put this down to

chauvinism: other Americans were members (earning his ferocious antagonism for not championing his cause), and in the eighteenth century the Pennsylvania artist Benjamin West had become its president. In terms of the honours bestowed on him, the summit of Whistler's achievement was a short-lived period as president of the Society of Painters. It was an undistinguished institution, and even here his appointment caused some resignations. With his flair for publicity and American optimism, he tried to build up the society's image, redecorating its rooms and securing a royal charter for it — but no knighthood for himself to strike awe into the fishmonger.

It is an extraordinary thought that an artist of his talent who lived in England for three decades was never given a commission to work on a public building. Even the Greaves brothers were invited to decorate Streatham Town Hall, his wife, Beatrix, remarked with some feeling. An even more striking fact is that at his death there was not a single painting by Whistler in any of the major public collections in England.

His behaviour, of course, didn't help. He was seen as an occasionally amusing eccentric, but essentially as an upstart and an interloper. His legendary effrontery and the praise he showered upon his own work were hardly calculated to ingratiate him with the artistic establishment. 'They were pearls I cast before them' he once claimed, 'and the people were — well, the same people.'[8] His grandiose theorising about painting was not in the British tradition either: in the eyes of the English Americans in Europe were there to learn about culture, not to preach about art. The Pennells' assessment was that Whistler was regarded in London as

clever (a negative quality in English eyes) but with a transatlantic impudence.

Mixed in with the sense of perplexity about his work and instinctive resentment at this flamboyant personality, there was a faint whiff of class condescension in some of the comments made about him. Ruskin's jibe about 'Cockney impudence'[9] may not have been entirely fortuitous and may have stung Whistler rather more than the financial slander that gave rise to the trial. But perhaps the most revealing piece of criticism ever made of him in England came from the *Daily Telegraph*. In a comment on his pictures in 1881 the newspaper wrote that it would be happy to bestow praise on him 'If Mr Whistler would leave off using mud and clay on his palette, and paint cleanly, like a gentleman ...'[10] Naturally, Whistler responded with scorn: 'the English employ insolence to cover emptiness'[11] was one of his many uncomfortably accurate observations on the Islanders.

To an extent, the emptiness, the insolence and the bumbledom of the English were welcome to him: they confirmed his own prejudices and were essential to his pose as the scourge of the philistines. Yet had he been lionized as he would have liked by the English social and artistic elites, it seems certain that he would have relished the twin roles of social and aesthetic snob. Whether, as a fully adopted Englishman, he would have painted the 'Mother' how and when he did becomes an intriguing speculation.

Despite all his friends and contacts he remained an occasionally bitter outsider. His political opinions were always erratic, but in the case of England there was a palpable note of revenge. Stagily reactionary in his views

('Emperors abound now. It was all very well when they could cut off a man's head'[12]), he affected to find the English decadent and effeminate. When the Boer War came, he rejoiced in every British defeat. While Henry James was suggesting that England should expand its overseas conquests, Whistler was expressing the hope that the Boers would dig the grave of the Empire. His partisanship of the Boers and running critique of the performance of Britain's military elite ('whipped cream,' as he called them) as seen by a 'West Point man'[13] were not designed to win him friends in high places. But by the time of the war, largely as a result of the sudden blossoming of his reputation that followed the sale of the 'Mother' to the French government, he needed them less.

<p align="center">★</p>

The problems he encountered in getting the portrait exhibited at the Royal Academy are well documented; in the end it was only through the intervention of an old family friend on the committee, Sir William Boxall, that it was accepted (Sir William threatened resignation). In retrospect, an outright refusal to hang the portrait might have been more gratifying for Whistler. In general, there was a disconcerting lack of outrage about the English reaction to the painting; like some members of the Academy's hanging committee, several critics failed to recognize it as a proper picture at all. Reviews at the time were scant and ambivalent, reflecting the general sense of mystification about what the artist was up to, which *The Times* was to speak of at his death. In the circumstances it was natural that the critical notices the portrait attracted

at its first public showing in England were neither lengthy, fulsome, nor especially vituperative.

There was some praise for its more obviously appealing aspects, such as the face (at the time, when the picture was still icily cool, the colours of the face must have stood out as a more evident touch of warmth and painterliness). But at a period when anecdotal detail was all-important (other pictures in the Academy's 1872 exhibition bore titles like 'Naebody Coming to Marry Me,' 'Hearts are Trumps,' and 'As Jolly as a Sandboy'), it was immediately noticed that Whistler's painting failed to tell a proper 'story.' Warily noting that the likeness of the room and the old lady were 'probably' true and intimate, the *Examiner* nevertheless decided that 'it is not a picture, and we fail to discover any object that the artist can have in restricting himself almost entirely to black and grey.'[14]

Everybody found it hard to place the picture in any tradition, and nobody discovered any specifically transatlantic flavour. The Academy's reviewer came closest when he saw in the portrait a vision of a 'typical Huguenot interior.' It was one of the reasons he disapproved of it, since it failed 'to rouse pleasurable sensations by line, form or colour.' To his eyes, the portrait was a depiction of 'life with its sources of joy sealed or exhausted.'[15]

Significantly, the very qualities that were to enthuse the most sensitive French critics — the vaporousness of the tones and the slightly ethereal feeling — went entirely unnoticed or were deplored by English commentators. Far from being intrigued by the portrait's studiously reserved atmosphere, the art critic of *The Times*, who devoted only ten lines to the picture in his second review

of the academy exhibition, merely commented that the head lacked solidity — a revealing judgement when one thinks that the head was the most 'solid' aspect of the painting.[16] The *Illustrated London News* was of two minds: unlike *The Times*, it found subtlety in the face, while disliking the 'almost negative' colouring of the flesh. Summing up the general underlying feeling of incomprehension, the *Illustrated London News* critic asked: 'Why should the greys and blacks be so unmeaning and so drearily smokey?'[17]

More positive appreciation came from one or two artists, with a particularly astute comment from Carlyle — surprisingly, in view of his general lack of visual sensibility. His verdict — that the portrait had 'a certain fitness'[18] about it — was far less banal than it seems. To the stygian Scot the unusual sobriety of the painting must have been a recommendation in itself. But his choice of the word fitness to describe it was strikingly appropriate, in view of the classical connotations of the term and the elements of classicism in the portrait itself.

Rossetti may have been unconsciously alluding to a parallel aspect of the painting — its moral strain — as well as reflecting the utilitarian ethic of the Pre-Raphaelites when he said that it was a picture that would 'do good to the times'[19] (the fact that his comment was addressed to Anna Whistler may have made him more deferential about it). G.F. Watts, by then a grand old man of English painting, wrote to Whistler to say that he could not refrain from congratulating him, though he knew how little importance the artist would attach to his opinion.[20]

Ultimately Whistler's deeper aesthetic instincts seemed destined to clash with English attitudes, tolerantly

described by Bernhard Sickert: 'The centuries of Puritanical forebears, I suppose, are the cause of the comical mode of approach of the most intelligent Englishmen to any question of art. They appear to tackle the matter as a kind of mathematical problem with clenched fists and bent brows, determined to understand or die in the attempt.'[21] Ruskin, whose extraordinary perception could have allied him with Whistler in happier circumstances, fell into this Victorian mould, writing in *Modern Painters*: 'I have now given up ten years of my life to the single purpose of enabling myself to judge rightly of art ... earnestly desiring to ascertain, and to be able to teach, the truth respecting art: also knowing that this truth was by time and labour definitely ascertainable.'[22] It was his Oxford rival Walter Pater, whose writings on the Renaissance were thought so hedonistic that parts were withdrawn for fear of corrupting his students, who finally embraced the theme of art for art's sake, to the disapproval of the English, while influencing Proust, an admirer of Whistler, in France.

Nearly twenty years after its first cool reception at the academy, when Whistler's reputation was already growing among American collectors, the importance of the portrait finally began to be recognized in England. When in May 1889 the 'Mother' was exhibited together with 'Carlyle' and the portrait of Rosa Corder at a loan exhibition in Bloomsbury, at least one critic — that of the *Evening News and Post* — lost himself in superlatives: 'The celebrated "Portrait of my Mother" occupies the place of honour at the exhibition, and is the finest portrait of this century, if not indeed that has ever been painted.'[23] It was 'nothing short of a national misfortune,' he added,

that the picture was not on permanent exhibition in England.

Then at last, two years later, after the Luxembourg Museum had acquired the painting, the English woke up to the full extent of their loss. The *Pall Mall Budget* of December 10, 1891, openly lamented the disappearance of the portrait from the country, thundering away in a front page editorial accompanied by a large engraving of the artist that only the painter's most unreasonable opponents could regard it as creditable to England's artistic culture that the 'Mother' should have left the country, never to return. From Whistler's point of view, one of the most satisfactory aspects of the publicity that developed around the sale to France must have been the debate over the artist's nationality. In the words of *The Pall Mall Gazette*: 'It is worth noting that Parisian critics and newspapers perpetually remind their readers that Mr Whistler is not an Englishman, but an American. Indeed, from the accounts of him that have appeared in France during the last few weeks one would not even faintly surmise that from about 1858 onwards he lived and worked chiefly in England. He had previous to that date lived for four years or thereabouts in France.'[24]

By 1892 Trixie was writing from Paris marvelling at the change of tone in the English newspapers since the 'Mother' had crossed the Channel: 'It is as though he were a different person.'[25] Had she compared what British and French critics had said about it, she could have added that it might have been a different picture.

★

The critical reception of the 'Mother' in France was fundamentally different from that it had received in England or would get in America. Where the English had for long reserved final judgement, puzzling in an uneasy, earth-bound way about both content and style, and where Americans were later to see a strong material presence and a sentimental symbol of their nationality, the French imagination saw something indistinct yet obscurely significant: a certain dreaminess and mystery, even a delicious decadence. What for the London critic was a half-empty picture filled with 'dreary smokiness' was for the French a canvas rich in shadowy suggestiveness.

Such profoundly differing appreciations of Whistler's work were not entirely new. The French had often seen a visionary quality in his paintings. As early as 1863, when Whistler exhibited 'The White Girl' in the Salon des Refuses, Courbet called it *'une apparition du spiritisme,'*[26] and the famous French critic Fernand Desnoyers delighted in the rewarding ambiguities he detected. For him, everything about the girl appeared strange, like a portrait of a 'spirit or medium.'[27] Her expression was at once charming and tormented, vague and profound. Already the French had also perceived something spectre-like in Whistler's art, but what intrigued and delighted them repelled the English: in 1859 the art critic of the *Daily Telegraph* had found 'At the Piano' 'an eccentric, uncouth, smudgy, phantom-like picture of a lady at a pianoforte, with a ghostly-looking child in a white frock looking on.'[28]

The theme of other-worldly ambivalence recurs in descriptions of the 'Mother.' The writer and critic Huysmans, chronicler of the first campaigns over the

Impressionists and champion of Delacroix, Turner, and Goya, discerned a pleasing contrast between the portrait's realistic intimacy and its immaterial qualities: the mother as mother was substantial enough, but it was as though she were 'on the wing towards a distant dreaminess.' Huysmans also saw and appreciated — as no Englishman had — the extraordinary beauty of the darks, which he likened to 'black Chinese ink.' He also praised 'the delicate (*leste*) and profound relationship between the darks and the grey, and the lightly-loaded canvas, showing its grain here and there.'[29]

The view of Whistler as dreamy aestheticist was taken to predictable extremes by his friend Comte Robert de Montesquiou. In his poem 'Moth', dedicated to the artist, Whistler was described as a 'magician of the crepuscular,' the eyes of whose sitters 'started from the depth of the blacks,' and who conflated morning and evening in 'brilliant, chimerical arrangements.'[30] It was this sort of reaction to the 'Mother' and other paintings that helped make *le whistlérisme* a cult in France. Jacques-Emile Blanche, though himself an admirer of the artist, was later to denounce the cult's excesses. Writing in 1905 after an exhibition of Whistler's work in London, Blanche regretted that the fin de siècle literati had presented Whistler to the French as 'a sort of Mallarmé of painting, a necromancer in his ebony tower, in the middle of a garden where the sun never penetrates.'

To Blanche's way of thinking it was unfortunate for Whistler that his Parisian success had come at a time of 'general languor' in painting, when the artificial, the esoteric, and the bizarre were in vogue: "Whistlerism" and "Mallarmism" are formulas which enchanted the period

of our youth, preciosities which dignified our disdainful persons ... The "Portrait of the Artist's Mother" acquired by the Luxembourg is a work which pleased because of the morbid element certain snobs thought they found there.'[31] Blanche must have had Montesquiou, Huysmans, and Mallarmé in mind, though their sensibility to Whistler was shared by many others, including Proust. The painter Elstir in *A la Recherche du Temps Perdu*, was based on Whistler himself, as well as on Paul Cesar Helleu, a young French artist and admirer of the American painter.

Nevertheless, Blanche agreed that Whistler had surpassed himself in the 'Mother,' adding his own touch of mystification by describing the portrait as 'a great landscape of the soul' and — more happily perhaps — as a 'human nocturne.'[32] Even after Whistlerism had become a respectable taste in England and America, 'Arrangement in Grey and Black' excited few such imaginative flights among the Anglo-Saxons.

Fascinating as they are as a commentary on French as opposed to more prosaic aesthetic sensitivities, these were largely the responses of a literary sect. The assessments of French art critics when the portrait was first displayed in Paris at the Salon in 1883 had sometimes been more down to earth. Like many other pictures, the 'Mother' received its share of mischievous comment and witty caricature. In a series of spoofs on famous paintings of the time, the 'Mother' was captioned 'a poor old lady left alone in a room with a smoking chimney.'[33] and the *Union Médicale* suggested that it must surely have been a posthumous portrait.[34]

On the whole, though, reviews by art critics were at once more perceptive and enthusiastic that they had been

in England. A particularly prescient piece in *Le Jour* noted both the abstract qualities of the portrait and the 'strange savour' of its tones.[35] The *Gazette des Beaux Arts* praised its sense of unity.[36] *Quinze Jours au Salon* saw in it a 'penetrating charm.'[37] The critic of *Le Rappel* wondered what the portrait had to do with England, concluding that it was only the fog-like atmosphere, though unlike the fog bound English themselves, he saw great virtue in the 'infinite fineness of its greys.'[38] The same writer noticed affinities with the French painter Pierre Puvis de Chavannes, one of whose works was later to hang next to the 'Mother' in the Louvre. (It is true that Puvis de Chavanne's *Pauvre Pêcheur*, though generally more blond and Italianate, has something of the haunting sadness of tone and colour of the 'Mother'.)

The generally positive reception at this first display in France clearly helped pave the way for the purchase of the 'Mother' by the French government eight years later. When the purchase was announced, the French press were unanimously enthusiastic. Welcoming the picture to France, *Le Figaro* praised its 'modernity,' noting wryly that it would hang not far from the 'somewhat old-fashioned' works of Whistler's former teacher, Charles Gabriel Gleyre.[39] The *Chronique des Beaux Arts* exulted in the acquisition, comparing the patina of the surface with that of a Rembrandt, a Titian, or a Velázquez. (Viewed in the light of the probable condition of the painting at the time, the remark become less flattering.) *Le Gaulois* hailed the purchase of the painting as a 'great artistic event,' adding, 'in correction of other newspapers,' that Whistler was neither an Impressionist nor an Englishman, but an American 'with his own, absolutely personal school.'[40]

★

Le Gaulois was right. Yet apart from this casual comment, the French were as slow as the English to discern anything particularly American in the painting. Only later — notably in a vigorous book on Whistler by the critic Louis Gillet — was the theme given its proper weight. The book, called *An American Painter: Whistler* and published in 1907, attracted the notice of the *Boston Evening Transcript* on July 20 that year. In it Gillet argued that Whistler's boycott of his own country and refusal to countenance any talk of a 'national school' were misleading: in his personality as in his painting, the artist was 'furiously American,' the 'finished type of the Yankee of Irish Race.'[41]

Gillet argued that although Whistler charmed the French by the gracious side of his character, he had never been completely at home in Europe, disliking both England ('the country of cant') and Germany (once epitomized by the artist as the people who called gloves 'hand-shoes'). As an American Whistler was a 'citizen of the world' — and so nowhere at ease. Gillet saw Whistler not as an anti patriot but as a cosmopolitan in spite of himself, a condition thrust on him by the state of his own country; 'That colossal republic is in a very strange condition. It has no idiom. It aspires to possess the universe, and does not possess its language. What would have become of an artist in such a country?'

For Gillet Whistler was unclassifiable — a 'fantastic' and 'capricious' individual. Yet it was impossible to look at the 'Mother' or 'Little Miss Alexander' without thinking of

the word puritan. The Frenchman found Whistler's art devoid of all sensuous elements, the figures essentially 'abstract,' and concluded — in a highly prophetic statement — that 'any more decisive example of what American may be in painting cannot be found.'[42]

Among the first to see the Americanness of Whistler's work was a better-known Frenchman, Auguste Rodin. Writing to the Lowell Art Association in 1908 promising a copy of his (in the event unfinished) memorial to the artist, Rodin was probably not merely indulging in national politeness when he said: 'The work of Whistler is one of the first and most integral manifestations of American art.'[43]

Could the artist have painted the 'Mother' — or anything like it — if he had stayed in his own land? Or was it only as a self-exile from the 'vast far-offness' of America, as a restless cosmopolitan, that Whistler could re-capture the peculiar spirit of the place — a spirit Henry James once described, in a phrase that could almost have been used about the 'Mother', as that 'thin, empty, lovely, American beauty?'

Ironically, despite the far stronger stylistic affinities of his writing with Whistler's painting, James was more deeply attracted to Sargent's work and to the man. Whistler's own disgust with his fellow American's slick and vapid brushwork ('almost like the work of a bad boy, and I do not know whether he ought not to be taken out and whipped for it!'[44]) reveals the very narrow line he was attempting to walk in his own work — between mysterious suggestiveness and a clean technique; evocative and resonant tonal painting and the search for immediate, dramatic effect.

Henry James's appraisal of Whistler mellowed considerably over the years. A disdainful comment in 1878 ('Mr. Whistler's productions are pleasant things to have about, so long as one regards them as simple objects — the spectator's quarrel with them begins when he feels it to be expected of him to regard them as pictures'[45]), developed into a recognition four years later of Whistler as 'a votary of tone; his manner of painting is to breathe upon the canvas. It is not too much to say that he has, to a certain point, the creative afflatus. His little black and red lady is charming; she looks like someone, and if she is a shadow she is the shadow of a graceful personage.'[46] By the nineties he was writing: 'To pause before such a work is in fact to be held to the spot by just the highest operation of the charm one has sought there — the charm of a certain degree of melancholy meditation.'[47]

James was reflecting the dramatically improved critical reactions to Whistler after the purchase of the 'Mother' by the French government, and was particularly incensed by British attitudes to the artist over the Ruskin libel trial: 'If it had taken place in some Western American town, it would have been called provincial and barbarous; it would have been cited as an incident of a low civilization.'[48] He acquired an eye for Whistler's esoteric style well before it was generally taken seriously; in 1882 he writes 'Mr Whistler, of course, is extremely peculiar, he is supposed to be the buffoon, the laughing stock of the critics. He does the comic business once a year; he turns somersault in the ring,' but then most perceptively he goes on to say: 'It is a misfortune for Mr. Whistler that he once gave the measure of his talent, and a very high measure it was. The portrait of his mother, painted some years ago, and

exhibited this year in New York, is so noble and admirable a picture, such a masterpiece of tone, of feeling, of the power to render life, that the fruits of his brush offered to the public more lately have seemed in comparison very crude.'[49]

What Whistler would have produced had he felt able to stay in America, or had gone back there after a period in Europe, is clearly an unanswerable if. Although he never returned there after leaving for Paris at the age of twenty-one, there is no evidence of any thoroughgoing revulsion against his native land. His antipathy appears to have been exclusively aesthetic and was nourished by resentment at America's failure to see in him one of its most gifted prodigal sons. Had America fêted him in the same way it did his fellow expatriate John Singer Sargent (whose work Whistler saw as meretricious), there seems little doubt that Whistler would have hurried home to bask in the glory denied him in London.

As it was, he felt his rejection keenly. In his artistic battles in England he got no support at all from his countrymen: 'It did not matter whether I was in the right or the wrong — I was one against the mob. Why did America take the side of the mob — and get whipped?'[50] It was worse than that: if anything particularly offensive reached him, he would say, he knew it came from America. He despised the philistinism of his country as much as he did that of England: 'Nouveaux riches take a long time to grow up to the portraits we make of them.'[51] And if he ever went back, he once said, it would only be to sail around Baltimore Harbour before coming straight back to Europe.

Despite all his bitterness, however, as Gillet contends

Whistler himself remained American to the core. It was not just that he never lost his accent, sang American songs when his work was going well, served buckwheat cakes and other American specialties to his guests, admired the writings of Bret Harte, or enjoyed parading his exotic, transatlantic origins as a form of distinction, as a means of marking himself off from the crowd. His whole character bore the imprint of the New World.

His flamboyance reflected a thoroughly American blend of self-confidence, self-publicity and sheer gall — in a word, 'boosterism'. But he was also a creature of contradiction: along with his reverence for tradition and social snobbery went a studied usurpation of Old World conventions. His almost excessive worship of France, his maudlin glorification of 'art', and his caricatured dandyism and Bohemianism were different sides of the same coin — manifestations of excess, and irrepressible American exuberance. Alongside all this ran the deeper and more sober side of his character: his pietistic commitment to his work, a certain insecurity and isolation as an individual and as a painter, and the strain of moralistic Puritanism in some of his pictures as well as in his personality were all American qualities too, which in one way or another are brought together in the 'Mother.'

Yet it took nearly thirty years for America to recognize itself in the portrait. Even then, its readoption of the artist and his major work was based on a series of ironies. Only after it had been blessed by France did America take any notice of the portrait at all. The French, who performed the aesthetic consecration by accepting it into the Luxembourg, valued it for qualities to which most Americans were blind. And when Whistler's countrymen

did fall in love with his 'Mother,' they did so for reasons that would have appalled the artist himself.

★

The first America saw of the portrait was when it was included in an exhibition of Whistler's Venice prints at the Pennsylvania Academy of Fine Arts in 1881 — exactly ten years after it was painted. Hung in a back corridor, the picture attracted no attention. The show appears to have been a failure; in Pennell's words, 'it wasn't even made fun of.'[52] The following year it was shown at the Society of American Artists in New York, also without any great acclaim, though at least the society elected Whistler a member. He was still insolvent at the time (he had to get the 'Mother' out of hock to display it in America) and could have used the fifteen hundred dollars that was asked for the picture in Pennsylvania — it was said that he would have let it go for as little as five hundred. Yet there were no takers, in either Pennsylvania or New York, where it was offered at the reduced price of twelve hundred dollars. (Ten years later the French government got it for a thousand.)

The timing of the 'Mother's' first appearance in America was unfortunate; had she been introduced to her countrymen only a few years later, the reaction might have been different, and Anna Whistler might have been enthroned in New York or Washington, D.C. today. By the mid eighties American collectors such as Vanderbilt had begun to buy Whistlers, and the French purchase of the 'Mother' in 1891 put the final seal of approval on his work. For Americans, the effect of the purchase on

Whistler's reputation was decisive. A manufacturer of railroad cars, Charles Freer, the fruits of whose later patronage of the artist may be seen in Washington today, was among the first to congratulate him.

As Whistler's reputation rose, the question of his national provenance began to be important. In an extraordinary eloquent outburst of patriotism and anti-British sentiment, an American critic in London, who signed himself G.W.S., exulted: 'The honour paid by the French Government to American art in the person of Mr. Whistler is not only a high honour; it is in many points unique.' Noting that the French had got the portrait cheap, and assessing its real value at five thousand dollars, the writer calculated the proportion of honour to cash at about six to one.

No English artist, he reminded his readers, had been treated with such distinction by those arbiters of artistic taste, the French. In a robust display of American democratic republicanism and in a fine piece of polemical writing, G.W.S. proceeded to belabour the English as philistines and snobs. In tones of mordant sarcasm he recalled the decision by the organizers of an exhibition of Victorian portraiture a few months before to 'sky' Whistler's portrait of Carlyle in an obscure corner, while giving greater prominence to 'superlatively bad' pictures of the Queen and her family. He continued his comprehensive assault on English society, the royal family, and English official art:

> The moral is perfect. It matters little in England whether you paint well or ill: perhaps, on the whole, you had better paint ill. The essential thing is that

you should paint badly enough to be liked at
Windsor, and get a commission for a likeness of the
Queen or some of her very numerous descendants.
Thus and not otherwise shall you be well hung at
the Victorian Exhibition in the New Gallery. But if
you happen to be a great artist, and paint the
portrait of a great writer of books, you shall be hung
with contumely. Could there be a better epitome of
the recent history of art in England, and of the
relations to those in authority to those not in
authority, nor under their patronage? One work of
Mr. Whistler is received with high honour in the
Luxembourg on its way to the Louvre; and at the
very moment another work of his, worthy to rank
with the first, is hoist with equally high disrespect to
the ceiling of that gallery in London which was
supposed to be the most open minded and the least
in awe of the deadening influences which make the
Royal Academy a byword on the continent.[53]

The spirit and sentiments are so close to Whistler's style
and views that it is hard to believe that the article did not
reflect some personal briefing by the artist himself, who
was not in the habit of overlooking the way his most
famous pictures were hung.

A similar note of national pride was struck in a
discussion of the 'Mother' in the New York illustrated
monthly for artists *The Art Interchange*: 'He is as much a
Yankee as you or I. The United States Custom House says
so; Whistler says so, for he exhibited in the American
section of the World's Fair; and lastly, his pictures say so, for

no John Bull would ever have dared to paint them, even if the gods had made him able to do so.'[54]

Whistler saw and enjoyed all this, not to speak of the fame and money the purchase of his pictures by Americans brought him. The Carnegie Institute in Pittsburgh was the first American museum to buy one of his pictures — his portrait of Pablo de Sarasate — for five thousand dollars. Two years before his death he was delighted to learn that the drawings he had made at West Point were now hung in a place of honour. Especially satisfying to both him and the Pennells must have been the award in 1899 of the Temple Gold Medal by the Pennsylvania Academy. It was there that the 'Mother' had first been shown in 1881, in the exhibition of his work that had not even been laughed at. And when he was dying, among his last words were queries about what artists were doing in America, and about the treatment of his pictures in Pennsylvania and New York.

★

'I, James NcNeil Whistler, do hereby certify ... that it is my purpose to return ultimately to the United States ...'[55] a customs form signed by the artist proclaimed. Despite many planned journeys, he never did. To the disgust of the Pennells, although Freer and Vanderbilt were among the pallbearers, there was no official American representation at his funeral. This did not prevent his death in 1903 from being fulsomely marked in the American press. A front page article in the New York Times on July 18, 1903, described him firmly as an American artist, asserting — somewhat excessively — that his genius had 'greatly

dominated European art of the present generation.'[56] In another commentary on him four days later the same newspaper described him as 'in person and speech a typical American of the Southern rather than the Eastern sort,' who had done more than any other to 'force Europe to recognize the power of this country in the arts.'[57]

At this stage of the rebirth of his reputation, however, there was still some uncertainty about his spiritual nationality and artistic status. In yet a third piece on Whistler two weeks later, the *New York Times* carried a curious report by a correspondent in Paris claiming that the artist was more French than English or American, with a gift for 'frantic French self-advertisement' (a neat inversion of national perceptions).

More seriously, he quotes with apparent approval a harsh attack on the artist by the little-known French painter Louis Anquetin to the effect that Whistler was essentially a brilliant juggler, an *escamoteur*, who cleverly evaded the real difficulty of painting in order to produce an impression of durability and solidity that the years would not countersign. 'He was an extremely clever trickster,' the correspondent concluded; 'his painting is a kind of inspired thimble-rigging, in which he constantly deluded a public which he despised as to the real position of the little pea.'[58]

Closer to Whistler's birthplace, the *Boston Evening Transcript* displayed few doubts about his qualities as a painter, insisting that the 'Mother' was one of the most 'unquestioned and unquestionable' masterpieces of the last half of the nineteenth century. Perversely, however, for a New England paper, it failed to underline the obvious Puritan symbolism of the portrait, deciding that there was

'nothing distinctively American in his art, as there was nothing distinctively American in the man. He belonged to no country.'[59] This did not stop the newspaper from vigorously upholding the public purchase of his parent's house at Lowell. While agreeing that Whistler had never referred to his Lowell days and that the town ran the risk of being 'sneered at as a city seeking to shine in a reflected light,' the newspaper endorsed the setting up of a museum in the house as 'a sign of a new spirit or of the concentration of aesthetic endeavour.'[60]

When the house was opened in 1909 as an art centre, the artist's treatment by his country gave rise to a revealing altercation between Joseph Pennell and the governor of Massachusetts, Curtis Guild. Pennell, who had been unable to attend the opening, sent a letter of congratulation, which was read out, including the following passage:

> Jealousy of great work and fear of a strong personality are the only reasons that can be assigned for the un-American attitude of some Americans towards Whistler, and, indeed, towards other American artists and authors who have remained in Europe. It is rare in America to find so patriotic an American as James McNeill Whistler, and the mere fact that he lived his own life in his own way as an American in the heart of England proved that he had a courage and determination far beyond the conception of detractors ... It may of course be asked why Whistler kept up his Americanism if America did not want him. Certainly it did not want him for years. Many people in America do not now. But it might occur to them that, as it would

have been easy at any moment for Whistler to become a distinguished citizen of any country in Europe, he only remained an American because he was one and wanted to remain one. In no other country would a great artist be insulted by his compatriots because he did not live within the boundaries of their frontier.[61]

Governor Guild responded with the necessary dignity: wisely declining to be drawn, he smoothed the susceptibilities of his audience with the not unappealing contention that the appreciation of art and of service to humanity had no more enduring home than the United States.

★

By 1932, when the 'Mother' came back to America for the first time since its display in Pennsylvania and New York half a century earlier, it had become widely familiar through prints. (Graves, son of the printers with whom the picture had been in custody, relinquished the copyright in 1892 so that it could be lithographed by T.R. Way). Brought to America by special permission of the Louvre at the initiative of the New York Museum of Modern Art for inclusion in its American painting exhibition, the 'Mother' subsequently toured the country with all the pomp and circumstance of a visiting dignitary.

The tour was widely seen as a diplomatic as well as an artistic event: in announcing that the Louvre had agreed to break its rule against lending works of art, A. Conger Goodyear, the museum's president, said that the 'return of

the painting at this time is an act of international goodwill on the part of the French Government and a reaffirmation of the artistic solidarity of France and the United States.'[62]

From November 1, 1932, to February 6 of the following year more than a hundred thousand people saw the portrait in New York. After insistent requests 'by telephone, cable and letter'[63] from museums all over the country, the Louvre agreed to extend the picture's stay into 1934, the centenary of Whistler's birth. During its year and a half tour it was seen by a total of two million people in San Francisco, Los Angeles, St. Louis, Cleveland, Columbus, Toledo, Baltimore, and Kansas City and at the Century of Progress exhibition in Chicago, where it remained for five months. Of the thirty cities that asked to exhibit it, eighteen were disappointed.

The American press was peppered with stories recording its triumphal progress. As has since become the custom in newspaper commentaries on major works of art, there was at least as much interest in the security arrangements with which the canvas was surrounded as in the painting itself. In Chicago — where in 1893 at the world's fair Whistler had shown some of his work in the British section — the *Boston Evening Transcript* reported that the portrait was escorted from Union Station to the Art Institute by a platoon of federal troops. 'General Parker Commander', it grandiloquently added.[64]

Such extraordinary precautions were seen as a mark of honour in themselves. Wherever the painting was shown, its security was assured by armed guards. A heavy rail protected it from the crowds, together with a hidden contrivance designed to set off a loud gong if the portrait moved a fraction of an inch. Perhaps for the first time in

the history of display of paintings, photo electric cells were used to form a wall of invisible light; trespass across it caused a siren to sound.

The 'Mother' was allowed to be shown only in completely fire-proof buildings. Wild rumours about how much the portrait had been insured for were only stilled when The *New York Times* reported that the French government had originally placed a figure of a million dollars on the painting. This had been negotiated down to five hundred thousand by the Museum of Modern Art, which feared that such a high premium would be too much for smaller museums, particularly during the Depression.

Some of the security measures bordered on the idolatrous and the farcical. According to the *Art News* of October 21, 1933, a detailed photograph was taken of the picture at each museum on the day of arrival and departure, the genuineness of the photograph being vouched for by the affidavit of museum officials and its complete authenticity assured by its being photographed together with a local newspaper published on the day it arrived and on the day it left. 'Whistler's Mother is an honoured and carefully guarded guest in the land which might have been her home,' the *Art News* concluded.[65]

Appropriately the portrait was in Boston for Mother's Day. The use of the picture on a three-cent stamp to publicize the occasion ('In memory and in honour of the mothers of America') had helped draw the crowds around the country. It also led to a highly revealing squabble between artists' organizations and the authorities.

Half a century earlier, in response to criticism in England that the picture was too empty, Whistler had

facetiously suggested adding a Bible and a glass of sherry. In his own country his sardonic proposal came close to being fulfilled. The designer of the stamp clearly thought that the portrait as it stood was a little too bleak for popular taste and in need of a little sentimental embellishment. The sight of the mother staring grimly into the void already seemed a little disturbing to the twentieth-century mind. For whatever motive, in reproducing the picture for his stamp, the designer decided she needed something to look at. He therefore trimmed off the bottom of the picture to make the space around the mother seem less arid and added a bowl of flowers in the corner.

There followed a furious protest to the federal government by the American Artists Professional League, whose chairman sent a telegram to the postmaster general complaining about the 'mutilation' of the picture. The addition of the flowers had the effect of 'totally changing its composition' and was a 'serious transgression of professional ethics and one which damages the reputation of the artist.' Cannily he used the event to press for a copyright law to protect the 'helpless position of the artist-creator' everywhere.[66]

Other artists' organizations joined in the furore. Complaining about the cutting off of the figure below the knee, the obliteration of the curtain and prints in the background, and the introduction of the 'stupid' pot of flowers, the president of the Allied Artists of America exploded: 'Why, in Heaven's name, didn't they let well enough alone? What a chance they missed, when it is a well known fact that this painting by Whistler is cherished

more by the American people than any other work of art by an American artist.'[67]

The American Artists Professional League was not content to let matters rest there. Convinced that the picture could have been kept within the dimensions required for a postage stamp without disfigurement, it insisted: 'A way of solving such a problem of design is to be found in Edward B. Edwards "Dynama-Rhythmic Symmetry".' Readers were accordingly invited to submit sketches for the 'appropriate unmutilated use' of the 'Mother' on a postage stamp.[68]

There is little doubt what Whistler's own reaction to this episode would have been. Once he had asked his friend the painter William M. Chase how things were going in America: 'Do you find there, as you do in London, that in houses filled with beautiful pictures and superb statuary and other objects of artistic merit, there is invariably some damned little thing on the mantle that gives the whole thing away?'[69] For one and a half years America swelled with pride at the presence in the artist's homeland of a statuesque picture by the first world-renowned American master. But by putting that one little bowl of flowers in the corner, it had come dangerously close to missing the entire point of the picture and to giving the whole damned thing away.

The portrait's eventual exit from the United States was a solemn state occasion. At a final one-day exhibition in New York, the president's mother, Mrs. James Roosevelt, officiated, and the gallery was turned into a motion-picture and broadcasting studio. In her address to the American people, the president's mother included the words 'I am sure Whistler would have been proud of the

homage paid him by his fellow countrymen. I know it would give his mother great happiness to see her son appreciated and honoured by his native land.' For the French cameras, she added a few words in French, and the French consul general suggested, in his reply, that the picture had brought the French and American peoples a little closer 'on the basis of art.'[70]

The president's mother is reported to have worn black satin, with purple and white orchids.

★

This hugely successful tour of the United States was unmarred by very much serious critical comment on the picture as art. Then, as earlier, responses verged on the mawkish. 'And the son being a great master, the picture becomes the noblest tribute to motherhood that painting can show, and to everyone who has known the blessing of a good mother, the most wonderful interpretation of his own devotion, if he has the eyes to see it,' wrote Charles H. Caffin in the *Story of American Painting*.[71] As a piece of simpering sentimentalism, this would seem hard to beat, though others ran him close. 'And now as the evening shadows gather,' intoned an anonymous author, 'about to fade off into the gloom, the old mother sits there alone, poised, serene: husband gone, children gone — her work is done. Twilight comes ... She was his wisest critic, his best friend — his mother.'[72] Such reactions are a long way from Montesquiou and Huysmans. Whistler's likely response to them hardly bears thinking about.

It goes without saying that, amongst the enthusiasm, no one showed much interest in the condition of the portrait

or in the even more recondite question of how the state of the 'Mother' might have influenced critical reactions to it. (Only in later years was there evidence of any American awareness of the importance of this side of things; during a large exhibition of Whistler's work, including the 'Mother,' in 1954, one informed critic acknowledged that the painting was 'marred by the curiously negligent attitude towards technical considerations which has reduced a number of Whistler's important painting to shadowy, cracked ruins.'[73])

In 1934 the mood was one of patriotic celebration of the country's most internationally famed artist, tinged with shame that America had not had the foresight to acquire the 'Mother' itself. Virtually every newspaper report quoted with awe the fact that the portrait could have been had for about a thousand dollars fifty years earlier. Amid all the hullabaloo, however, there were occasional cynical comments on the public's idolization of the portrait. The artist would have turned in his grave, one disrespectful critic asserted,[74] at the sort of popular adoration his work had received, which was due merely to mob curiosity, fired by advertising for Mother's Day.

Even American specialist art journals and the literature of museums where the portrait was displayed commented almost exclusively on the 'human content' and national symbolism of the picture — the very aspects Whistler himself had specifically abjured in *The Gentle Art of Making Enemies*. Both expert and public reactions were overwhelmingly emotional, rather than analytical. Apart from predictable reference to its glorification of motherhood, there was little attempt to dissect the source

of the picture's appeal or to disentangle its 'European' from its American qualities.

Conceivably the condition of the picture when it was exhibited may have had something to do with this apparent indifference to the supreme matter of its style. As will be shown in the later chapter on its restoration, by this time the portrait's radical nakedness was clothed in the respectabilizing accoutrements of age; a juicy patina and golden glow of old varnish. Indeed this may have added to its popular appeal. As the only acknowledged American old master, sanctified by admission to the Louvre, it looked the part. It had become that impossible thing, an American antique.

Had the 'Mother' been closer to its original condition — starker, barer, more earthy and empty-looking, with the grainy canvas texture Huysmans had noted — some of the two million Americans who saw it could well have been disconcerted. The subject would still have been emotionally satisfying, but like the English critics half a century before, some might have harboured a suspicion that with its raw, cold, scraped surface and paint like 'Chinese ink,' it was not really a 'finished' picture at all — and certainly not one they would have expected to see in the hallowed halls of the Louvre.

<p style="text-align:center">★</p>

After 1934 the portrait came back to America three times: in 1953 — 54, in 1963 — 64, and in 1986. Inevitably perhaps, reactions on each occasion were progressively more muted. There seemed nothing new to say about it; the portrait had passed into ancestral folklore, like a family

picture on the wall that is so familiar to everyone that nobody really looks at it anymore. Younger members of the family may be a little unsure who was depicted in the first place, but not curious enough to ask. As an image the portrait lived on, but as a picture it was dead and embalmed. Like the Bible, the 'Mother' was widely referred to or pillaged for pictorial quotations but rarely read in the original.

Only in cartoon form has the picture enjoyed a second life — a tribute, of a sort, to its hold on the public imagination and to its power. Only a very restricted number of pictures are familiar or potent enough to be successfully caricatured, and the 'Mother' must surely hold the record. Naturally enough the cartoonists' treatments of such pictures reflect our contemporary preconceptions and preoccupations. Judged against this admittedly subjective and transient yardstick, the most revealing thing about the attitudes of present-day Americans to the 'Mother' is that she has lost her motherly attributes.

The affectionate side of the picture, which was so obvious to earlier generations, has drained from the modern perception. To the children of the sixties Anna Whistler is no longer a mother: she is a matriarch, a figure of almost risible severity, a symbol of defunct values. Considering Anna Whistler's unquestionable indulgence toward her egotistical son and the tolerance of egotistical forms of individual behaviour in the second half of this century, there is a certain irony in this view of her.

Rationalizing cartoons and caricatures is a hazardous business, with its risk of ponderous exegesis or the laborious over interpretation of the ephemeral, the casual, and the light hearted. Yet unlike the 'Mona Lisa', whose

sensuous, teasing smile lends itself to playful, sexual jokes, it is difficult to caricature the 'Mother' without making a serious and occasionally complex point, however inadvertently. Even at their most trivial or outrageous, cartoons of the 'Mother' are often instructive and sometimes disturbing.

Not all are as funny as they are meant to be. A second glance at the caricature of Anna Whistler as a zany, liberated woman, as in Alfred Gescheidt's 1984 composite photograph 'Whistler's mother?' and the humour fades rapidly. In exchange for what seems to us the painfully constricted, joyless puritanism, with its intimidating sobriety and gaunt moralism, we get wildly exuberant, 'life-enhancing' laughter, as perpetual youth is super-imposed on the sombre reality of age and approaching death. But in exchange other, more positive and arguably 'life enhancing' qualities of the original have gone too: the impression of endurance in the face of isolation and adversity, of selfless devotion to the family, and, above all, of a comforting faith.

Mothers must now be jolly, youthful companions, and we might even see the hilarious blonde emancipated lady as a good deal more diverting than with the Bible quoting 'Mother.' Yet the laughter soon becomes an importunity, making one feel that the relentless merriment might turn out to have its moralizing aspect too.

Examples of moralizing in reverse include Richard Bober's 'Stories My Mother Never Told Me', in which Anna Whistler is converted into a ferociously grumpy mother with a repulsively weird child, with a skull dangling suggestively from the brim of his hat. The artist seems to be making a heavily ethical point by typically

trenchant twentieth-century means; an allegory perhaps of nineteenth-century bigotry giving birth to twentieth-century freakishness and violence.[75]

Other, lighter veined caricatures of the 'Mother' contain definite echoes, if not of nostalgia for puritanism, at least of sardonic contrasts with our current condition. To modern eyes perhaps the most troubling aspect of the 'Mother' is her loneliness, reflected in her pictorial stranding in space. She had her religion, but her statement that she was thinking of God while her son painted her may be hard to accept today, and our all-consuming scepticism makes it even harder to conceive that her faith would really have been as intense or consoling as she states. As a result, we pity her, while simultaneously feeling frightened for ourselves and our own isolation in the world. By desacralizing her portrait, we simultaneously laugh off disturbing thoughts and revenge ourselves for her moral importuning.

To an irreligious world with neither time nor inclination for the practice of contemplation, the mother in the portrait seems to be gazing into nothing. Because of our experience of seeing lonely old people seated with a vaguely disapproving but transfixed and immobile gaze before the ungodly screen, cartoons showing the 'Mother' watching TV can make a disturbingly convincing joke, which blends rapidly into poignancy. The addition of the TV becomes an act of kindness to the old lady; it makes us feel better now that she has something to do. Instead of the bowl of flowers today she can have something animated to rest her old eyes on. Yet it is not just the incongruity of the TV that robs the 'Mother' of her iconic status; she is diminished as a person, deprived of the

127

dignity of solitude together with the focus of her life — faith.

Extensions to the television theme are irresistible: Ken Brown's 'Whistler's Brother Ernie from Deluth', 1985, slouches with his remote controlled TV and his newspaper in easy permanent touch with the 'real' world. In fact, of course, he is staring into a void, too, and this time the joke is not on the 'Mother', but on Ernie.

At the lower end of the scale cartoons of the portrait become swiftly less amusing, while retaining some residual meaning. It would be particularly tedious to over analyse 'Arrangement in Grey and Black with Creep (Whistler's Weirdo)'; it is far too close for comfort to the sort of parody that might easily have appealed to Richard Bober's appalling 'child.' And unlike the others, it tells us nothing whatsoever about the portrait (one of the reasons it does not raise a smile) but something about late twentieth-century America.

Here the desacralization is crude, witless, and ugly, its significance explicable only by reference to the sociologist's lexicon: rejection of authority, age, family, God, national allegiance — it scarcely matters what. There are many others like it. All that can be said is that the portrait is such a powerful nexus of symbols that it can sometimes invite a single, annihilating riposte. Something that has to be challenged, explained, mocked or destroyed so frequently must have its own renewable sources of strength.

6

The 'Mother's Road to France

'How can it ever have been supposed that I offered the picture
of my Mother for sale ... certainly I should never dream of
disposing of it.'[1]

<div align="right">Whistler, 1884</div>

'Is it for that that you sold your Mother?'[2]

<div align="right">Fantin-Latour to Whistler in 1891,

pointing to the Légion d'Honneur

on the artist's lapel.</div>

Conceived on a sudden inspiration, executed in secret,
nearly burned in a railway accident, used as surety for his
loans and almost sold for a hundred pounds, rejected by
Whistler's own country, then paraded through its
museums like some sacred effigy — few great paintings
have had such a colourful existence as the 'Mother.' One
of the most fascinating episodes in the life of the portrait
was its transfer from the safe keeping of the artist's
English creditors to the Luxembourg Museum in Paris
and thence to the Louvre. It is a story of brilliant
intrigue involving painters, writers, bureaucrats,

politicians, and a future prime minister of France. The successful denouement shaped the rest of Whistler's life. The prime mover was the poet Stéphane Mallarmé. Introduced to each other by Monet, Whistler and Mallarmé, the leader of the French symbolist movement who had written his ethereal *L'Après-midi d'un Faune* the year before the 'Mother' was painted, formed an ardent friendship, one of the closest of the artist's life. In many ways they were very different people. Despite his poetic vocation, Mallarmé lived a humdrum life as a *père de famille* (patriarch) and a schoolmaster. The French Impressionist painter Berthe Morisot, who was untouched by Whistler's paintings, writing, or charm told Mallarmé that she found it hard to understand their mutual attraction: 'You who are so calm and so much a master of your moods, how is it that you get on so well with Whistler, with his touchiness, bellicosity, and withering irony?'[3]

Their characters were indeed entirely different, yet their artistic temperaments converged. Both were perfectionists, Mallarmé driving his editors to distraction in the same way that Whistler drove his sitters to despair. In 1866, before they had met, Mallarmé was defining what he was aiming at in his poetry in terms that Whistler might easily have applied to his later style of painting. 'Words,' wrote Mallarmé, must 'reflect one upon the other to the point where they no longer appear to have their own colour, but seem to be merely transitions in a scale.'[4] Whistler and Mallarmé shared a mystily elevated concept of their function as artists and the consequent incomprehension of the public. As Whistler once wrote grandiloquently to the French poet, 'You are alone in

your art as I am in mine.'[5] Even their signatures were similar. Whistler's butterfly began as J. M. W., before it became elaborated into an oriental design; Mallarmé's was an almost equally exotic arrangement.

Fortunately for Whistler, the immaterial aloofness of Mallarmé's poetry was combined with the hard headed practicality of a man of the real world. For years after they first met, Mallarmé acted as the artist's Parisian dogsbody, translating the 'Ten O'Clock Lecture'[6] into French, assisting Whistler in his endless disputes and litigation, helping sell his engravings, keeping accounts for him, and finding him accommodation in Paris. In manoeuvring the 'Mother' safely into the Luxembourg, Whistler relied heavily on the French poet's mixture of diplomatic finesse and business acumen.

Though they had several friends in common, including Swinburne and Montesquiou, it was not until 1886 that the two became acquainted. Through exhibitions in the Salon and the admiration of his friend Huysmans for Whistler's painting, Mallarmé was already aware of the artist's work. Theodore Duret — French critic, friend of Mallarmé, and indefatigable champion of Whistler — had personally attended the 'Ten O'Clock Lecture' in London in 1885 and was struck by the similarities between the aesthetic codes of the poet and the artist. The following year the *Revue Independente*, which was sympathetic to the Symbolists, printed a luxurious issue featuring both Mallarmé and four of Whistler's drawings.[7]

It was Monet — whom Whistler had helped through his presidency of the Royal Society of British Artists to exhibit his work in London — who finally brought the

two together. In the words of Henri de Regnier, who was present, Mallarmé was instantly touched by Whistler's magic wand. The poet's offer to translate the 'Ten O'Clock Lecture' into French sealed the friendship. (It turned out to be a laborious process; Mallarmé had problems with Whistler's elliptical style. How, for example, was he to render 'Art is upon the town' into French? Hardly by *L'art fait le trottoir*, the poet reflected, settling eventually for *L'art court la rue*. After a number of tortuous reformulations, Whistler was delighted with the result.)

As his intimacy with Mallarmé developed, Whistler, after a long gap, began to go to Paris more frequently. His London existence, always unsettled, was becoming stormy again. In 1888 he resigned his high-handed presidency of the Society of British Artists. In the same year he ended his friendship with Swinburne. After fourteen years with Maud Franklin, he broke with her, married Beatrix Godwin, and spent his honeymoon in Paris. And in 1890 *The Gentle Art of Making Enemies*, the chronicle of his injuries at the hands of the Islanders, appeared.

Problems with his fellow countrymen were mounting, too. His experience at the hands of the organizers of the American section of the Universal Exhibition in Paris in 1889 must have left him feeling even more rootless and *dépaysé* than usual. Having submitted 'The Yellow Buskin,' his portrait of Lady Archibald Campbell (but not the 'Mother,' which was still in the hands of his creditors) for display at the exhibition, together with the 'The Balcony' and twenty-seven lithographs, he was peremptorily invited by

General Bush C. Hawkins, in charge of the American section, to withdraw ten. Predictably enough Whistler withdrew everything in a fit of spleen, exhibiting instead under the British flag.

Embarrassingly for the artist, the British took even less of his work than the Americans offered to display, and Whistler's rancour increased when Sargent — also in the British section — obtained a medal of honour. It can have been of little consolation to be assured by Mallarmé, who had agitated discreetly on Whistler's behalf, that had he exhibited in the American section, he would have got the medal. (In later years he always exhibited in the American section of an international exhibition when there was one.)

It was a stage in his life when everything was drawing him closer to France: if neither the English nor the Americans saw his full worth as an artist, the French did. To his intense satisfaction, after the Universal Exhibition at the end of 1889, he was nominated a Chevalier de la Légion d'Honneur for his services to painting. Thereafter Mallarmé redoubled his encouragement to him to live in France, to the extent of seeking out rented accommodation for his friend 'James McNeill Buffalo Bill Whistler' (the real Buffalo Bill had just enjoyed a great success performing at the centenary celebrations of the French Revolution). The place he found, he wrote to London, was 'made for you.'[8] Determined to entice him across the Channel, he enclosed a plan he had drawn of the house.

★

The idea of selling the 'Mother' to the French

government originated in London, the brain child of D. Croal Thomson, a dealer who headed the local branch of the Goupil Gallery. By the end of 1891, when he put his plan to Whistler, the sale of the portrait of Carlyle to the Glasgow City Council earlier in the year for a thousand guineas (the equivalent of twenty-five thousand francs or just over five thousand dollars) had created a stir in England. Soundings of the French Ministry of Fine Arts and the administration on the possibility of buying the portrait for the Luxembourg proved positive. Whistler was more than ready to see the 'Mother' in a French public gallery, and, above all, the Louvre, for which the Luxembourg Museum was seen as a waiting room. But his suggested price — seventy-five thousand francs, or three times what he had got for Carlyle — was a problem. (For purposes of rough comparison, Manet's 'Olympia' brought only twenty thousand francs).

As Croal Thomson delicately put it, the Luxembourg had a small budget for the purchase of paintings by living artists, and it was 'not in their administrative tradition' to pay high prices. Should there be any signs of reluctance on the part of the French Government even when Whistler had reduced his figure, Thompson suggested that a pressure group of artists and writers could be organized to press for the purchase of the portrait. Alternatively, a public subscription could be raised, as had recently been done in the case of the 'Olympia.'

Seventy-five thousand francs had been a characteristically extravagant opening shot; enthralled by the idea of seeing his major work in a French museum, Whistler was in no mood to make difficulties about the asking

price. He needed as much as he could get (his new wife's notions about how they were to furnish their house in Chelsea were almost as expensive as his own), but the prospect of seeing his portrait in the Luxembourg was far more important to him than money. Almost equally tempting to him, as his letters to Mallarmé make clear, was the opportunity to confound his English and American critics.

It was decided that some public pressure on the French authorities would be necessary: immediately and enthusiastically Mallarmé assumed the role of campaign coordinator. Trusting his judgement and delighted by the poet's devotion to his cause, from then onward Whistler relied almost entirely on Mallarmé's advice. Over the next few months there followed an exchange of letters between artist and poet which resembled nothing so much as a particularly devious diplomatic intrigue.

The 'Mother' was rescued from Whistler's creditors and displayed in the gallery of Messrs. Boussod & Valadon in Paris. Meanwhile, Mallarmé plotted with Whistler the organization of a press campaign and the raising of a subscription. One of the first fruits was an article in *Le Gaulois* of November 4, 1891 by the friendly critic Gustave Geoffroy. The portrait was already known to the French, having gained a third class medal at the 1883 Salon. Now that it was back in the country again, here was a chance, Geoffroy wrote, to prevent it from leaving France and to acquire for France's main museum of contemporary art a work not just by one of the masters of modern painting but by 'one of the greatest masters of all time': 'Are there not in Paris enough people capable of ... rendering to the London

artist the homage that he deserves, and to make a gift to France of a chef d'oeuvre by Whistler, just as they did last year of Manet's chef d'oeuvre?'[9]

Even Whistler found the article a little overpowering in its advocacy. Hypersensitive as ever to points of pride, he would have preferred a more discreet approach to the authorities. Fortunately one of Mallarmé's numerous contacts was the newly appointed head of the Fine Arts Ministry, Henri Roujon. Roujon was out of the capital at the time, and at first Mallarmé agreed that things should await his return to Paris and his assumption of his appointment. In fact Roujon's return was delayed through illness. At this stage Mallarmé's tactics was to soft-pedal the public campaign and wait until he got back; once Roujon had worked himself into his job and was in a position to make decisions, things would move forward of their own accord.

Meanwhile, Mallarmé sent the ailing Roujon a study Duret had made of Whistler (which just happened to include a reproduction of the 'Mother') 'as reading matter to distract him.' From his letters to Whistler it was obvious that the poet was greatly enjoying the conspiracy: 'I'm sure you see my game clearly enough'[10] Mallarmé wrote to Whistler at this point. Whistler did. Replying from London he asked Mallarmé to use his 'Machiavellian tact'[11] to cool Duret's ardour. In the meantime, he himself would see what he could discover from his friend the Comte de Montesquiou, whose portrait he was painting, about the mood of the authorities.

Mallarmé then switched tack. On further consideration he was afraid of interminable bureaucratic

foot-dragging at the Ministry of Fine Arts. Roujon was still unwell, and might find it difficult to make such a flamboyant gesture as the purchase of a foreign painting right at the start of his incumbency; there could be resentment among French artists. As a result, if he bought the picture at all, Roujon might be able to offer only a paltry amount. And if the acquisition by the state were delayed or a miserly price paid, the éclat would be diminished. Mallarmé knew his Whistler.

A more attractive idea had now occurred to Mallarmé. Antonin Proust, the former chief of the Ministry of Fine Arts, had unexpectedly offered to put himself at the head of a group of distinguished people who would buy the portrait for the nation, a procedure that would have nothing in common, Mallarmé hastened to assure Whistler, with the 'vulgar and mediocre' approach of a public subscription. Such an 'illustrious committee' with Antonin Proust at its head would have a more 'artistic, select, and elevated' flavour. Everything was in hand, he wrote to Whistler, and going miraculously well, 'though nothing is astonishing where you are concerned ... I have become your notary, since for you even in this task, a poet is necessary.'[12]

In a footnote to the letter Mallarmé floated yet another stratagem: by a combination of both approaches, they could get the best of all worlds. The government could be prevailed upon to ask Whistler to sell the portrait, and if the offer was insufficient, Whistler's admirers could group together to present it to the state. Whistler was undecided. Ravished by the idea of an 'illustrious committee,' but equally attracted by the prospect of a formal request from the government for his

picture, he was afraid of falling between stools. For a while he oscillated, though one thing was certain: he had firmly decided not to make difficulties over the price. Even if he was paid only what he had received for the Carlyle, there was 'a certain dignity'[13] in the figure of one thousand pounds (five thousand dollars). Just as importantly, it would prevent his English enemies claiming that he had been obliged to give the 'Mother' away, or that the French had bought it only because it was cheap.

Whistler was beginning to relish the intrigue as much as Mallarmé. Meanwhile, in yet another letter, which crossed with one from Whistler, the poet came up with yet another scheme. On further examination the notion of an 'illustrious committee' seemed less attractive than before. There was a risk of the membership's duplicating the Manet committee, whose purpose had been rather different: to force the government to buy a controversial canvas — a painting of a naked woman on a couch attended by a black servant and a cat. The 'Mother' hardly fell into that category.

Mallarmé's new ploy was ingeniously simple: the ministry would ask Whistler for the portrait for the Luxembourg, and the artist would reply that he was content to let the government fix the price. 'We mustn't hide from you that it might be miserable, derisory even,' he cautioned Whistler, 'in our judgement, something like 5,000 francs [one fifteenth of Whistler's starting figure of seventy five thousand].' To sweeten the pill, Mallarmé's letter stressed that a request for the 'Mother' directly from the ministry would be 'without precedent and infinitely flattering.'[14]

Whistler immediately agreed, overflowing in gratitude toward the poet — and ratcheting up his demands. While perfectly content to let the ministry fix the price of the painting, he wanted an official promise — or as close as Mallarmé could get to one — that the portrait would one day go to the Louvre. Apart from the glory that would come to him from such an 'artistic triumph in the Capital of Art' (one of his favourite apophthegms was that what was not worthy of the Louvre was not art), Whistler frankly confessed that he was thinking of the effect of such a public undertaking on England, a country where he had suffered so many years of 'insult and ribald misunderstanding.'

'You understand,' he wrote, 'that for here (London), it would be the final blow.'[15] Mallarmé's reply was prudent. He could well understand the impact on the English opinion but gently reminded Whistler of the custom whereby pictures could be accepted by the Louvre only ten years after the artist's death. [16]. Meanwhile, Whistler had also broached the subject with Duret, who had assured him that the portrait would eventually go to the Louvre: 'But let's not talk about this at present — given that none of us wishes to survive you and personally see the painting in the Louvre.'[17]

On November 20, 1891, the minister for public instruction and fine arts, Léon Bourgeois, accompanied by the leader of the Radical group of deputies, Georges Clemenceau, visited Messrs. Boussod & Valadon to see the 'Mother.' Fortunately for Whistler, the future prime minister and leader of France in the First World War was a highly cultivated man, passionately interested in the arts: hearing of Monet's illness, he once left the

Assembly in mid debate to comfort him. There is no
evidence that he had ever met Whistler, but he became
a staunch partisan of the 'Mother.' According to
Mallarmé's dutiful report of the viewing, Bourgeois was
enthusiastic. But the visit to the gallery was redundant;
he had already signed the letter to Whistler the previous
day.

> Monsieur,
> For a long time I have been desirous of seeing one
> of your works in the Luxembourg Museum, and
> my attention has alighted particularly on the
> portrait which is at present exhibited at the
> premises of Messrs. Boussod & Valadon, Boulevard
> Montmartre. I would be most obliged to you,
> Monsieur, if you would be kind enough to tell me
> whether, as I have been assured, you would be
> prepared to release it to the French government.
> Should you agree, I would very much hope that
> any conditions you might impose would not be an
> obstacle to the success of my project and that the
> empty space in the Luxembourg can at last be
> filled with one of your canvases that has rightly
> earned most notice among the public.
>
> With distinguished salutations,
> Léon Bourgeois,
> Minister of Public Instruction and Fine Arts[18]

The allusion to the price was appropriately indirect —
a grey-toned allusion. Records show that the original
draft of the letter had been less reticent. No doubt at

the initiative of one of the ministry's bureaucrats, the second paragraph included the sentence: 'You will be aware that the resources assigned to me are extremely modest and that works of art acquired by the state are mostly bought at less than their true value.' This was struck out by Bourgeois in deference to Whistler's sensibilities and in the knowledge that Whistler had been adequately primed by Mallarmé about what he could expect.

Whistler was in ecstasies. The following day he wrote at once to Mallarmé to tell him that the ministerial letter had arrived, 'Its beautiful seal, with the armorial bearings of France, floating in an absolute lake of red wax in the middle of the envelope. Imagine my joy ...' He found Bourgeois's letter perfect: 'courteous, charming, full of dignity ... and highly flattering to me.' He looked forward to meeting the poet again in Paris, 'for now that France has taken the 'Mother' forever, it seems to me that she should adopt the son as well.'[19]

In the middle of his rhapsodies of gratitude to Mallarmé ('Your astonishing rapidity of judgement ... your refinement of tact') Whistler received yet another letter from the poet confirming that he had already heard from Duret: that his friends in Paris were taking soundings about the possibility of his promotion from a chevalier to an officier of the Légion d'Honneur. The only thing still lacking in this cascade of honours from France was any assurance that the 'Mother' would definitely go to the Louvre.

In his best diplomatic style, Mallarmé's letter blurred the issues beautifully: 'There has been some talk of it ... although one draft of the letter mentioned it, everything

gets obliterated passing through so many hands in the offices, and perhaps it has been omitted. It must have seemed so self-evident to them.'[20] With an ingenious eye to the painter's sensibilities to English opinion, Mallarmé suggested that given that entry to the Louvre was such a forgone conclusion in France, Whistler would be quite justified in including 'this detail' for the benefit of the English press.

Whistler immediately settled down to compose his formal reply to the minister. The result was almost a caricature of orotund extravagance:

> Monsieur le Ministre,
> I am extremely happy and exceedingly touched by the honour you extend to me in proposing to purchase one of my works for the Luxembourg Museum. The picture you have chosen is precisely the one which I would most ardently wish to see as the object of such a solemn consecration. I therefore waste no time in making you aware that there can be no question of any obstacle of the kind foreseen in your letter arising, since I put myself entirely in your hands, M le Ministre, as to establishing the said conditions, in the light of the resources placed at your disposition by the state, to cover such circumstances.
>
> This flattering evidence of sympathy, crowning the gracious honours which come to me from France, is too precious for me to wish to examine, on this occasion, anything else but these honours themselves.

I beg you to accept, Monsieur le Ministre, the assurance of my highest consideration.

James McNeill Whistler, 21 Cheyne Walk,
Chelsea, November 23, 1891[21]

A copy went to Mallarmé. After telling him how much he and his friends had savoured the terms of his reply to Bourgeois, especially the last sentence, the poet came down to brass tacks: "When we were talking of the figure of 5,000 francs, we were not far out; in fact the Ministry can offer 4,000." He recommended immediate acceptance 'without wasting an hour,' hinting that any delay might cause unspecified problems. 'Send me a telegram on receipt of this letter, in the simple terms: "Yes, I accept 4,000 francs".'[22] Unwilling to reveal the exact figure to all and sundry in the post office, Whistler simply replied: *'Accepte la somme dictée.'*[23]

The minister's final signature on the purchase was obtained the same evening, and M. Bourgeois was prevailed upon by Mallarmé to send a second letter to the artist 'to satisfy his legitimate pride.' After confirming the purchase, Bourgeois went on: 'Once again I must express to you my great satisfaction at being in a position to enrich the state collections with one of your most precious and celebrated works.'[24]

Again the ministry had laboured hard to find the right tone; the sentence had been redrafted four times. As his second reply to Bourgeois of December 9 showed, Whistler had still not run short of fulsome superlatives and Gallic excesses of style; it spoke of the 'glorious destiny' of the portrait, thanked the minister for

the 'gracious expression of his sympathy,' and expressed his 'respectful gratitude for this distinguished privilege.'[25]

Le Figaro of November 27 was first with the news. As it happened, however, almost everything in the report was wrong. According to its correspondent, Whistler was 'an English Impressionist,' whose portrait of Carlyle had been bought by Edinburgh University, rather than the Glasgow City Council, for thirty-five thousand francs (it was twenty-five thousand), since when the artist had refused to sell any of his pictures for less. The reaction of the French press as a whole to what Mallarmé assured the artist was the 'artistic event of the moment'[26] was more accurate and uniformly enthusiastic. Whistler was complimented both on his 'gift' of his mother's portrait and on his nomination as an officier of the Légion d'Honneur. Among all the salutations, one passage in the *Chronique des Beaux Arts* procured him particular pleasure: 'The splendid portrait of his mother by M. Whistler has just been placed in the Luxembourg Museum. It is a work that is destined to attract admiration throughout eternity, a work on which the consecration of the centuries seems to have placed the patina of a Rembrandt, a Titian or a Velázquez.'[27]

Although Degas's comments on the 'Mother,' made as he and Mallarmé walked home together after a soirée held in honour of the painting, at which Montesquiou's poem 'Moth' had been read aloud, are not recorded in detail, the great French artist was said by the poet to have been particularly admiring.[28]

★

In England the younger members of the Chelsea Arts Club gave Whistler a banquet to mark the sale of the portrait. Here was a chance to show magnanimity in victory over the Islanders; Whistler did not take it. 'It is right at such a time of peace, after the struggle, to bury the hatchet — in the side of the enemy, and leave it there.'[29] The 'enemy' was indeed in confusion: among more official opinion, the loss of the painting to France was greeted with a mixture of dismay, contrition, and chauvinistic resentment, the *National Observer* accusing the Royal Academy of being asleep for half a century. Whistler's promotion in the Légion d'Honneur aroused less comment. Mallarmé's role in the showering of honours on the artist was noted, but then, as the *Man of the World* wrote on February 3, 1892, 'Mellarmé (sic) and Whistler were bound to get on together. The first is to poetry what the second is to painting. It is impossible to deny that they both have talent, though both are also occasionally incomprehensible.'[30]

In Whistler's description to Trixie in London of his reception in Paris and the ceremony of his promotion to officier of the Légion d'Honneur, the contrast with his treatment in England comes again and again to the surface. In France 'they are all happy for me. They are glad that I am here amongst them. They share my joy and pride ... They have no idea about it in England, where they will pretend not to understand what it means, or where they will try to ensure, in their usual way that it is forgotten. But here it is a great honour — especially for Art ...'[31]

Seizing the commercial moment, in March 1892 the Goupil Gallery in London organized a retrospective

exhibition of Whistler's work. The show was an unprecedented success, and the painter had the mixed pleasure of watching the prices of his works rise overnight — mixed because some had found their way into the hands of his critics. For Whistler, who now spoke of France as 'my new country,'[32] revenge against the Islanders must have been sweet indeed. He indulged himself to the hilt, insisting that previously adverse criticisms of his work were appended to each item in the catalogue, and contemplating sending Ruskin a season ticket to the exhibition at which 'The Falling Rocket' — the cause of the Ruskin trial — was sold for eight hundred guineas (or about four hundred dollars).

Life in England was never the same again. London seemed dull and dreary, he wrote to Sydney Starr, now that no further fighting was necessary. Two months after the exhibition, after thirty years in England, he moved to Paris.

<div align="center">★</div>

The two months at the end of 1891 were the high point of Whistler's life. Besides assuaging his appetite for the official praise the English had starved him of, he had revelled in every moment of the manoeuvres with Mallarmé. When it was all over, he wrote wistfully to the poet about the end of the episode. His 'genie of the lamp' had given him all that he had asked; now he was afraid the genie would evaporate, 'enveloped in its blue smoke.'[33] But there was one last satisfaction to come: the 'illustrious committee,' whose services had not in the event been called upon, refused to disband without a

celebration in the artist's honour. It was the perfect last act, the artist exulted, one of 'royal graciousness: the Illustrious Committee, the great poet-Minister, and the Banquet.'

A year later there was a disagreeable coda to the story. Visiting the museum with Mallarmé after a reordering of the rooms to give greater prominence to recent acquisitions, Whistler discovered that the 'Mother' now shared a room with a portrait of Gladstone by an undistinguished Scottish artist, McClure Hamilton. He was furiously indignant. (Hamilton himself records that on discovering the painting, Whistler had exclaimed: 'Why drag in Hamilton? Who is he, anyhow?'[34]) Whistler claimed to have had it out with the director of the museum, Léonce Bénédite, telling him that 'if this goes on I am afraid I must take my Mummy from your Hotel.'[35]

Bénédite's reply is not recorded, though it seems unlikely that he himself in any way undervalued Whistler's portrait, on which he later wrote an eloquent and perceptive appreciation, describing it as 'this noble image.'[36] In a sense the decision to buy and display McClure Hamilton's painting was an indirect tribute to the 'Mother.' The purchase had proved to have been a diplomatic as well as an artistic event. It was the only painting from England in the museum, and its acquisition in preference to works by such artists as Sir Frederick Leighton or Sir John Millais had caused considerable resentment in London. In acquiring McClure Hamilton's portrait of the famous British prime minister, Bénédite was clearly trying to soothe official British susceptibilities.

That was not how Whistler saw matters. Once again the Whistler-Mallarmé publicity machine went into action. On December 20 the *Journal* carried an article commenting on the reorganization of the Luxembourg. Noting that a special room had been set aside for foreign artists, the newspaper suggested acidly that while Whistler, Sargent, and Alfred Stevens were worthy of such treatment, 'Mr John McClure Hamilton, who has produced a mediocre portrait of Gladstone, clearly knows nothing about painting.' While it was perhaps understandable that the French government should wish to possess a picture of the great statesman, to display it among the rare chefs d'oeuvres in the Luxembourg was 'excessively ingratiating.'[37]

True to his aesthetic code, in which content was entirely subordinate to art, Whistler was furious at the thought of his portrait sharing a room with a mediocre canvas, even if the subject was the greatest British prime minister of the century (he was an admirer of Disraeli, as it happened). Even in Paris, after all his triumphs, his crusade against official English art was unrelenting.

<p style="text-align:center">★</p>

It is tempting to wonder how far the extraordinarily devious campaign organized by Whistler and Mallarmé was in fact necessary to secure the purchase of the 'Mother' and how far their joint machinations were a deliberate mystification, an example of the over refinement characteristic of some of their works. At one point in their exchanges Mallarmé came close to confessing to Whistler that come what might, the

purchase of the portrait was a *fait accompli*. Had the whole affair been left in the hands of Boussod & Valadon, the Paris headquarters of the Goupil Gallery, the outcome would probably not have been very different; Whistler might even have got a slightly higher price.

Together the artist and the poet transformed a relatively straightforward exercise into an exquisite cabal — a small work of art in itself. As Whistler wrote to his friend at one of the most deliciously intricate moments in the affair, 'You know how to extract poetry from the situation.'[38] In its veiled manoeuvres, subtle intrigues, and ambivalent approaches, there is something of both Whistler's painting and Mallarmé's verses. The induction of the 'Mother' into France had been accompanied by an appropriately ingenious piece of theatre.

7

Origins and Influences

'His whole work was the adoring homage of the New World
to the Old. His career, the second rape of Europa by a Southern
gentleman in impeccably laundered ducks.'

Walter Richard Sickert[1]

'If ever mortal painted an idea, that man was Roderick Usher.
The paintings over which his elaborate fancy brooded and
which grew touch by touch into vagueness at which I
shuddered the more thrillingly ... By the utter simplicity and
nakedness of his designs he arrested and over-awed attention.'

Edgar Allan Poe, 'Fall of the House of Usher'[2]

For lack of a settled tradition of their own, previous
American expatriate painters — and Whistler himself in
his earlier, more decorative work — had frequently
assumed the borrowed clothes of European sophistica-
tion. In the eighteenth century Benjamin West did
imposing historical scenes (albeit in contemporary dress)
and grandiloquent portraits, while John Copley
combined a natural honesty with gentility and fashion.
By contrast, 'Arrangement in Grey and Black' appears

almost provincial in its simplicity. Yet in its origins and influences, structure and psychology, it was by far the richest and most sophisticated canvas an American artist had ever produced.

When one considers Whistler's cosmopolitan background, this may seem less surprising. Added to that was his intuitive intelligence, ready to pluck ideas from unexpected sources and remould them for his purpose. Sources of inspiration were probably as diverse as they were unconscious, ranging from Baudelaire and Barbey d'Aurevilly to Poe and Walt Whitman, from classical statuary to Japanese prints, from Velázquez to Courbet, and from American primitive paintings and silhouettes to photography.

It is hard to pin any of these influences down directly, and the artist himself has given us little help. Whistler was not a thinker but an aesthete, whose life was given over to the search for beauty. Nor was he much given to the rational analysis of painting, his own or other people's. Instead he absorbed influences through impulse. He once told the curate of the Fine Arts Society, Ernest Brown, that he would lay the eggs if Brown would provide the incubator.[3] The image is peculiarly appropriate: Whistler was less an intellectual of painting, as he has frequently been called, than an unconscious incubator of influences.

Sharp-witted, impetuous, and shamelessly eclectic, he simply saw the point of things quicker than others and instantly made them his own. Menpes tells a revealing story of how people laughed at the American portrait painter William Chase for adopting Whistler's straight-brimmed hat. It was, of course, the other way around;

Whistler had stolen the fashion from Chase. 'Ha Ha, what have we here?' he had exclaimed as soon as he caught sight of Chase's headgear. 'This is good. I like the lines of this hat.'[4] In less than a week he had made it his own and got himself credited with its invention.

Whistler had a genius for constructing something new out of borrowed or unexpected materials: Chase's hat, the word 'Nocturne' (a neologism adapted from music by his friend and patron Frederick Leyland, which the artist applied retrospectively to his paintings of Valparaiso Bay), and his recognition of the painterly potential of the river Thames. Newness was important; he never stole directly from the past. Unlike many other expatriate Americans, he was never crushed into conformity by the weight of European history or by the unmatchable legacy of European painting.

There was a limit to how much he knew or cared about either. At no point in his life did he display any serious interest in the past, or go to the trouble of reading widely on the history of art or of undertaking systematic cultural pilgrimages, any more than he felt bound to widen his knowledge of his own country or what was going on there in painting by revisiting America. He simply absorbed, used, or discarded whatever came his way. As for Americanness, he drew on it like an essence.

In anyone else this lack of cultural depth might have been a handicap. Somehow Whistler turned it into an advantage. Just as he sometimes succeeded in converting a shaky technique into brilliantly innovative effects, so his disinclination to immerse himself in the study of the past liberated him from the oppressiveness of its styles

and left him free to innovate on the basis of what was going on around him. This is why the 'Mother' is both a highly original painting and an inspired fusion of a dizzying profusion of influences.

★

However much Whistler may have seen himself as the new man of painting, he did not come into the world naked. Chief among the influences he must have absorbed with his milk was the Puritan ethic. Applied to Whistler — insolent, affected dandy, scapegrace and bankrupt, painter of society portraits — the very notion of puritanism seems almost laughably incongruous. In terms of painting, however, seen as a virtue, the word begins to make better sense. In his search for 'pure' art, everything extraneous — sentiment, opulence, literary content, expression of feeling itself — had to be avoided at all costs. Depth, roundness, sensuous impasto were banished, while colour itself came to seem to him not just an extravagance but a vice.

Ever since Greek art, the human form had formed the measure of reference for all the arts; the classical column itself, based on rounded human proportions in space, is the obvious example. The 'Mother' was stretched across the surface, with a minimum of depth, modelling, or shadow. The result is a flatness and angularity that falls easily into geometry and abstraction (an effect paralleled in 'Battersea Bridge,' with its gaunt uprights and horizontals).

The seeds of this radically distinct style were probably widely scattered. In contrast to the European conception

of man as the measure of space, the Far Eastern, and particularly the Japanese approach, was fundamentally different, and instinctively attracted Whistler. The possible influence of classical friezes in bas relief, where roundness and flatness were combined, has already been noted. Brief as it was, his experience of map making may also be relevant here. The mother sits in a frame of fixed transversals: the curtain, the dado, and the prints. Her skirt spreads over them like a continent across a map maker's grid. Lines and outlines are what matter; it is they, rather than illusionist modelling or shadow, that define both background and subject.

A more specifically American influence may have been primitive American portraits and silhouettes. Silhouettes had enjoyed great popularity after their introduction by an exiled French marquis. As an adolescent interested in drawing, Whistler is likely to have noted dozens of them in American homes. It was a style of portraiture that accorded easily with American primitive painting, which went on through the eighteenth into the nineteenth century.

These were simple, serene portraits, constructed of humble artistic materials in thin, almost monochrome, flat paint. The sitters were painted full face or in profile. The result were honest utilitarian records for posterity in tune with the Shaker principle 'Beauty rests on utility.' The thought of these mournful or expressionless countenances hanging on bare walls above meagre furniture, with only a Bible for company, easily recalls the 'Mother.' It is tempting to think that there may have been an example in Anna Whistler's American home.

Primitives and silhouettes blended easily into the stiff,

self-conscious images of early photography, in which Whistler, like every other artist at the time, was known to be interested. An acknowledged rival to painting, photography was often also a more or less acknowledged tool, as well as a formative stylistic influence. Whistler's letters mention the use of photography for enlarging a cartoon onto canvas. This may have been an exceptional incident, although Sickert's later fascination with photographic enlargement could have stemmed from such experiments, in which Whistler's assistants were involved.

Individual historical photographs have been singled out as possible direct inspiration for the 'Mother,' including certain prints of Queen Victoria in profile and a theatrically posed image of a mother in vigil over a dying child (Henry Peach Robinson's 'Fading Away' of 1857). But it is not evident that these were very much more significant than any of innumerable examples of white-bonneted widows in mourning to be found in every family album.

It is true that the 'Mother' alone of Whistler's work has the still, arrested air of early photography, whereas a characteristic of his other portraits is the effect of movement, accentuated by his blurring technique. To what extent this was influenced by the first photographic errors, which were quickly taken up for their own interest, is questionable, though Degas certainly explored such effects. The work of Nadar, the great portrait photographer and eminent figure in the circle of intellectuals around Baudelaire in mid-century Paris, epitomizes the constant cross-fertilisation between painting and photography.

Whistler's remark that if painting were only about imitation of nature, then photography would produce greater art, suggests the sort of impulse it gave to his more abstract ideals. There is some evidence that photography may have affected his work in other ways. He was acutely aware of the distortion of tone certain colours can produce in black-and-white reproduction, and just as he sought a 'fair', 'flat', 'ivory', or even 'golden' tone in etching, so in photography he foresaw the importance of retaining the unity of the painting in print. He wrote to Croal Thomson of the Goupil Gallery in 1892 criticizing some proofs: 'The portraits are all too hard and purple black — they ought to be fairer and more golden brown — The two firework pictures are ... wonderful proofs of the completeness of those works.'[5]

Apart from neoclassicism and the Pre-Raphaelites, the only specific English influence may have been the gifted but short lived painter Charles Keene, a close friend of Whistler, who once described him as the 'greatest English artist since Hogarth.'[6] An etcher and illustrator for *Punch* magazine who was admired by Degas and Fantin-Latour as well as by Whistler, Keene produced some time in the mid-sixties an etching that portrays Mrs. Edwards, a noted connoisseur of etchings (and frequent hostess to Whistler), dressed in full black skirt and white bonnet and shown in profile, in contemplative mood, a closed book on her knee. The relationship of the mood and composition to the 'Mother' is too obvious to need description.

Despite French enthusiasm for the 'Mother,' direct French sources are hard to detect. Fantin-Latour's 'Liseuses,' showing young girls in black, alone with their

inner thoughts, their eyes averted from the spectator, carries echoes of Keene. Corot's presence can always be felt behind Whistler's search for honesty of tone; the older painter's advice was 'against uncertainty, place a certainty,'[7] and he became the revered ancestor of much tonal painting through to Seurat. Courbet influenced Whistler's attitude to the world almost as much as his painting; he was his model for the artist's confronting and scandalizing the bourgeois. It is not by chance that his influence is most strongly visible in Whistler's early self-portrait. Courbet's 'Winnowers' 1855 — isolated figures against a flat, screen-like wall, bears the mark of the Japanese inspiration that affected Whistler himself. Although Courbet's vigorous brush strokes are echoed in the wall behind the 'Mother,' the overall style of the portrait is still worlds away from what any Frenchman was doing at the time. By comparison, the impact of Japan is more immediately discernible.

<p style="text-align:center">*</p>

To assess the influences that may have contributed to the artist's conception of the portrait, and to a great extent to his conception of himself, it is essential to look at the impact of mid-century Paris on the twenty-one year old Whistler. These were really formative years of his life. Much of his subsequent behaviour and outlook can be traced back to a handful of books he read at the time. First among them was Henri Mürger's *Scènes de la Vie de Bohème* (though he read it in America, it was the book that brought him to Paris). Then there was Barbey d'Aurevilly's *Du Dandysme et de George Brummell.*

And finally there was Baudelaire's immensely influential essay on Poe. Whistler was never a great reader, and these three works formed almost a programme for his life.

Published in 1850, Mürger's book is best known today through Puccini's opera La Bohème, which it inspired. It is a love story set among penniless artists living in the Parisian garrets first made familiar by the book, and its racy, journalistic style and carefree characters, who live for art and either become great masters or die in misery, swept the whole of Europe. Its impact upon the young Whistler in America is not hard to imagine. In a preface that amounted to a manifesto for a philosophy of life, Mürger wrote: 'Art, rival of God, is the equal of Kings.' But art was not stuffy academicism, and his Parisian Bohemia was a place where 'the most eclectic styles converged in an astounding idiom of life.' Bohemia was the enemy of the puritans, the mediocre, and those lacking 'the audacity of their talent.' This latter in particular was a fault Whistler was never to experience.

★

Barbey d'Aurevilly's book was a study of the English Regency dandy Beau Brummell, who had died in 1840 in a French asylum.[8] It appeared ten years before Whistler arrived in Paris from America and had an extraordinary and lasting impact on French artists and intellectuals. When he read it, Baudelaire commented that it left him nothing else to write about dandyism, and its influence spanned the rest of the century to Proust. It clearly had a profound effect on Whistler, too.

It is not too much to say that this short book of a hundred or so pages sums up his philosophy of art and life. Reading it today helps resolve the central paradoxes in Whistler's personality. Briefly put, these paradoxes were between puritanism and vanity, stylishness and profundity, the frivolous and the serious. Brummell emerges from the book as far more than a beau and a fop; indeed, Barbey gives him quasi-metaphysical depth. Far from being vacuous or superficial, he was a work of art in himself, a response to the needs for refinement and caprice of an over conventionalized and horribly bored English society. His frivolity was not contemptible but majestic; his egotism not immoral but awesome. In him, lightness of wit went along with 'negligent penetration.' He shone with a mysterious reflection from the surrounding penumbra.

Some of the scenes in the book could have come straight out of the Pennells' account of Whistler's own life. Brummell, whom Byron affected to believe was greater than Napoleon, left his regiment rather than set foot in Manchester, just as it was inconceivable that Whistler should have been born in Lowell. Brummell dismisses a disgruntled creditor by claiming to have given him recompense enough by leaning from the window of his club to greet him as he passed. When one of Whistler's landlords sought rent for an apartment, the artist told him not to worry since he would be charging him for the decorations. Sartorially the parallel is too obvious to need labouring, and Brummell might well have appreciated Whistler's meticulously cultivated streak of white hair.

Style in all its forms was not a mere accessory to life

but its essence; style ruled the world. Infinite attention to style was itself a kind of puritanism — the purity of art for itself alone. Nuances of style required puritanical application, whether Brummell's sanding down of cloth to achieve a gauze like effect and his preference for exquisitely muted colours in his clothes, or Whistler's rubbing and scraping of his canvas in a search for tonal perfection.

Barbey is undismayed by Brummell's eventual indigence and decline in an asylum at Caen. The butterfly exists to be broken, its nobility lying in its transient perfection. With all due reservations, something similar could be said of the aims of Whistler's art. In Victorian England life was not easy for such exquisite beings. With his dandyist philosophy, it would have been even harder for Whistler to have survived life in his own utilitarian country than in London.

It is a thought that must have crossed his mind when he read as an art student in Paris the famous essay on Edgar Allan Poe that Baudelaire had published in 1852. One passage in particular must have struck him as a warning against any temptation to pursue his career as an artist in his native land: 'For Poe the United States were nothing but a vast prison in which he ran about with the fevered restlessness of a creature born to breathe the air of a sweeter scented world — nought but a great, gas lit Barbary — and his interior, spiritual life as a poet, or even a drunkard, was no more than a perpetual effort to escape the influence of the antipathetic atmosphere. What a pitiless dictatorship is that of democratic societies ...'[9]

Whistler himself was aware of his affinities with the

great American writer. When Mallarmé told him that the character of Poe had become clearer to him since he had known the artist, Whistler replied by reflecting romantically that he knew he was always alone: 'alone like Poe must have been, with whom you have found a certain resemblance.'[10] The resemblance was apparent in large and small ways. Like Poe, Whistler tried to give himself a more resonant lineage by falsely claiming to have been born in Baltimore. Physically Poe had a singular personal beauty. Born in Boston, Poe saw himself, like Whistler, as an aristocratic Southerner by nature. He attended the U.S. Military Academy at West Point, and, like Whistler again, was expelled for indiscipline. Just as the writer had a romantic impulse to take part in the Greek War of Independence (he never got there, in fact), so Whistler set sail for Valparaiso. And Poe, like Whistler, had an unusually close relationship with his mother.

This mother-son devotion is not exactly unusual, and its intensity in the case of these creative individuals may be simple coincidence. Yet it is a curious fact that four of the major American artists and writers of the time — Poe, Sargent, Whitman, and Whistler himself — all retained till late in life what by European standards must have seemed a remarkable dependency on their mothers. In terms of the iconography of 'Arrangement in Grey and Black' and the possible emotional and intellectual influences distilled into the portrait, by far the most pertinent case is that of Poe.

Baudelaire was sufficiently struck by the extent of the devotion of Poe's mother to her son to include in his essay a long and evocative passage on the subject, which

Whistler can hardly have read without being conscious of his own case. (Poe was in fact orphaned as a child and Baudelaire is describing his adoptive mother, the mother of his child bride.) Read in retrospect, the picture Baudelaire draws seems like an idealized version of Anna Whistler: a model of maternal ardour, Poe's mother was also a 'tireless minister to his genius.' She hawked his poems and articles around publishers' offices, and, when he was struck by sterility (or afflicted by drink), 'never suffered one syllable to escape her lips that could convey a doubt of him or a lessening of pride in his genius and good intentions of her darling.' And when Poe was close to the bottom after his wife's death, his mother 'lived with him, took care of him, watching over him and defending him against life and himself.'[11]

Baudelaire, who felt neglected by his own adored mother after her remarriage, went on to erect a verbal monument to Poe's:

> This woman seems to me to be great, greater even than a mother of antiquity ... It is clear to me that this Mother [Baudelaire's capital letter] — a flame and a beacon lit by a shaft of light from the highest heaven — has been given as an example to the races of the world, too little heedful as they are to devotion, to heroism, to all that goes beyond duty. Was it not only justice to inscribe at the head of the poet's works the name of the woman who was the moral sun of his life? His glory will embalm the name of the woman whose love could dress his wounds and whose image will forever float above the martyrology of literature.[12]

It would be wrong to push the analogy beyond its natural boundaries: Whistler's circumstances were far less severe than those of Poe, and Anna Whistler was not averse to a bit of moralistic nagging. But there were sufficient parallels for this idealized concept of motherhood, with its references to antique images of heroic matriarchs and to the immortalizing of the memory of the poet's mother in his work, to have left its echo in Whistler's highly impressionistic and retentive mind. What is certain is that some passages from Baudelaire's essay can be read almost as an appreciation of the 'Mother' nearly twenty years before it was painted.

Walt Whitman, who featured on Whistler's exiguous reading list, had a similarly elevated concept of motherhood. In a forward to a collection of his letters to his mother after she died, he wrote of the 'reality, the simplicity, the transparency of my dear, dear mother's life', apostrophising her in verse as 'my matron mighty, my sacred one, my mother.' Though clearly of a livelier temperament than Anna Whistler, according to her son, Mrs. Whitman, too, was 'very eloquent in the utterance of noble moral axioms.'[13]

Clearly we do not know how intently Whistler read Whitman's poetry; Pennell only records *Leaves of Grass* as having being read aloud with Swinburne and Rossetti. But his verses must have been linked in Whistler's mind with the atrocious suffering of the Civil War, from which Anna Whistler was a refugee, as well as with patriotism. Imagery of maternal suffering and stoicism abounded in Whitman's work ('A wall of

weeping widows ...'). For the poet, the mother was the obvious symbol of America:

'America'
Centre of equal daughters, equal sons,
All, all alike endear'd, grown, ungrown, young or
old
Strong, ample, fair, enduring, capable, rich,
Perennial with the Earth, with Freedom, Law and
Love
A grand, sane, towering, seated Mother,
Chair'd in the adamant of Time.[14]

Less than ten years after Commodore Perry had opened up Japan to the West in 1853, a shop specializing in Japanese and Chinese art and artefacts opened on the Rue de Rivoli in Paris. 'Among the initiates' the French critic Champfleury wrote in 1868, 'the purchases of a young American painter drew a great deal of attention. Almost every day he treated himself to some lacquered or bronze piece, or some sumptuous Japanese dress. Although the American had his studio in London he was seen there as frequently as if he lived at Neuilly.'[15]

The effect of Japan on the evolution of European painting was compared at the time with that of antiquity on the Renaissance.[16] Some even held that it had revolutionized the Western optic.[17] The impact was certainly immense. As in the Renaissance the first stages of the revolution were sometimes imitative, superficial, flirtatious, or decorative. The items of orientalia Whistler had shipped off to London were used to colourful effect in pictures like 'Princesse au Pays de la Porcelaine'. The

kimono Whistler posed in for Fantin's group portrait 'Le Toast' has presumably come from the Rue de Rivoli, too. More important for the 'Mother' was the second stage of the Japanese ferment: the point where Japanese influence was stylistically absorbed into the artist's bloodstream. Of longer-term significance than the fans, ceramics, and oriental bric-a-brac that charmed him in his Japanese period was his discovery as a student in Paris a few years before of a book of Hokusai's prints at the workplace of the famous printer and engraver Auguste Delâtre (whose services Whistler used).

Juxtaposing Japanese prints with 'Arrangement in Grey and Black' is the easiest way to appreciate how Whistler unconsciously incorporated some of their stylistic peculiarities into the picture: the flat, blank background; the firm, straight lines, filled-in contours, and blocks of colour, with a minimum of variation within each (only the face of the 'Mother' is modelled in European fashion); the absence of perspective, the decisive fall of the curtain, and the audaciously cut-off print to the right (a Japanese idiosyncrasy). His actual tools — the long brushes, table palette and 'sauce' pots of colour made up in advance — and the chosen hour recall Eastern implements and painting processes, as does his habit of laying his pictures flat to hold their washes. The blotting or wiping of unsatisfactory areas emphasized the weave of the canvas and its flat surface, as Eastern painting denies recession and perspective.

Unlike his other pictures, whether the flamboyantly oriental portraits or even some of the 'Nocturnes' (where sprigs of plum blossom occasionally linger at the edge of the picture), in the 'Mother' the stylistic

importation was unobtrusively effected, subsumed within the mood of the portrait. There is no feeling of affectation or incongruity, and the tonal intricacies of his paint softened and made acceptable the stark Japanese contours. Just as the straight-brimmed hat he had 'borrowed' from William Chase looked even better on Whistler, so his ingeniously eclectic eye somehow contrived to make Anna Whistler look even more her American self within a Japanese-influenced framework.

It was Menpes who said of Whistler that 'the people who talk so glibly about Whistler never having copied anyone do not realise how great an artist he was. When the Master saw a good thing he accepted it.'[18] Having seen Whistler at work in his studio and visited Japan, the 'bushman' (Menpes was Australian) had cause to know. Whistler was so jealous of Menpes's visit that he ignored him when he returned. Eventually, however, he questioned him closely about his impressions, becoming particularly excited when Menpes described how the Japanese master Kyosai mixed his tones in little blue pots: one for the flesh, another for the drapery, and so on, so that a black dress would be one broad beautiful tone of black. 'This Kyosai must be a wonderful man, for his methods are my methods,' Whistler protested. 'No' Menpes said gently. 'That is the method of Kyosai.'[19]

8

TECHNIQUES

ASPECTS OF INSECURITY

'Today we all have genius. That's taken for granted. What is certain is that we no longer know how to draw a hand.'

Renoir to Vollard, 1920[1]

'He knew how much he could not do, nor was he ever confident even of the things that he could do; and these things, therefore, he did superlatively well, having to grope for the means in the recesses of his soul.'

Max Beerbohm[2]

The 'Mother' was painted at a moment of flux in the history of painting. The techniques of the academics had reached a point of sterility. Across Europe by the middle of the century everyone — the Pre-Raphaelites in England, the Macchiaioli in Italy, the new schools in Germany and Denmark, the realists and Impressionists in France — was groping in different ways for the road back to 'honest' painting.

Whistler belonged to no school or tradition: artistically

as well as emotionally he saw himself as an outsider and an innovator. A relentless eclectic, he was in contact with many of the major currents of his time. Partly as a result, his art was often a great soup of influences, occasionally spiced with dubious technical condiments. Sporadically he produced something strikingly individual and genuinely new: his prints, his vision of London, the Venice pastels. Always more at ease in etching (he carried etching plates in his pocket rather than a sketch book), in painting, his failures and half successes far outnumbered his lasting achievements. Perhaps only in the 'Nocturnes' and 'Arrangement in Grey and Black' did he approach a precarious perfection.

Whistler's training as an artist was as erratic as it was unconventional. No other painter at the time could claim to have been educated for his craft in Russia, Paris, West Point, and the U. S. Coast and Geodetic Survey. The start was promising enough. As the youngest pupil at the Imperial Academy in St Petersburg he learned to draw heads from nature and to copy classical busts; despite his youth, he came out top of his class of twenty-eight. His principal teachers in the life class were Messrs. Vistelius and Voivov. At this early stage of his training he seems to have shown both enthusiasm and application, desolate if he was forced to miss a lesson and studying on Saturdays under the guidance of an older student at the academy.

A highly impressionable child, from his time in Russia Whistler must have perceived painting as a noble profession. The great Russian artist of the day — Karl Pavlovich Briullov, an Italian-influenced painter whose most famous picture was the 'Last Days of Pompeii' — was rich and revered by the czarist court. The young

Whistler was captivated by his posthumous portrait of the Czar's daughter in her imperial robes. The earliest seeds of Whistler's romantic conception of the painter as a hero, later to mature in the Bohemian setting of Paris, may have been sown in St. Petersburg. The notion of the artist as a self-willed genius, as careless of the demands of formal training as of the prejudices of the vulgar mass, translates all too easily into a self-image.

The fact that Whistler's most impressive technical achievements are in the field of etchings highlights his lack of rigorous instruction in the use of oils. Unlike many other young artists at the time, he never worked in any painter's studio as an apprentice. Even in drawing and engraving, between St. Petersburg and Paris the only systematic training he received was as a cadet at West Point and as an employee at the Coastal and Geodetic Survey in Washington D.C. At West Point, like his father, he excelled in draftsmanship, studying under the mural painter Robert W. Weir and gaining high marks in a field disdained by many of his more military-minded colleagues. Even so, he appears to have been a talented rather than a diligent student.

His map-making and topographical work at the Coastal and Geodetic Survey (albeit decorated with Whistlerian doodles in the margins) was a sound, practical discipline, which helped reinforce his knowledge of engraving techniques. Throughout his life he seemed most at home when working with the gradations and tonal variations between black and white, dark and light.

It may be that the very act of printing on to fresh paper purified the image in a way he could not always achieve on canvas. After a hard day at the easel he once turned to

his assistant saying, 'Let us cleanse ourselves, Menpes. Let us print an etching.'[3] His habit of scraping down unsatisfactory work is also based on an etcher's attitude of mind, where miscalculations can be expunged with acid, a clean, smooth plate recovered, and a new start made. His very facility in manipulating tones in etchings may have had a damaging effect on his painting, giving him an uncanny ability to conjure away any intractable passages by submerging them in suggestive shading. However his engrained etcher's instincts were arguably fertile catalysts in painting, as Sickert recognized: 'Into French art culture is imported a grain from the mechanism of a scientific craft as practised in America. It flowers.' But it cannot be denied that Whistler relied disproportionately on his first skills, never submitting to any discipline of equal rigour in painting.

In their description of his studies in Paris, the Pennells hotly defended Whistler against charges of laziness, notably from a fellow student, the English artist Sir Edward Poynter: 'It would be nearer the truth to say that he never stopped working ... The women he danced with at night were his models by day.'[4] It is true that he produced some excellent engravings at this time. But the overall impression that he was more intent on living the life of an art student than in studying art is inescapable, and it was confirmed by Whistler himself when he later lamented his failure to make good use of his time in Paris. His elder half brother George, who was supplying his allowance, wanted him to study at the École des Beaux Arts, where he would have worked under the influence of Ingres. Instead he enrolled in the studio of Charles Gabriel Gleyre, an undistinguished academic painter. For

an American determined to savoir the Bohemian life, it was a more attractive option. The atmosphere at Gleyre's studio, where Whistler was an infrequent attender, was engagingly informal: there were a good many foreigners and no examinations, plenty of comradeship and horseplay, and few obligations. From time to time Gleyre would call in and stroll around among his students, commenting on their work in a lordly way.

Considered with the 'Mother' in mind, However, Whistler did learn two things of value from the time he spent in Gleyre's studio. Insistent on the importance of line over colour, Gleyre believed the pigment mixtures should be pre-prepared on the palette so that the maximum attention could be given to the draftsmanship — a system of painting Whistler later adopted, and sometimes claimed as his own invention. (When he later rejected Courbet for Ingres, he announced in a letter to Fantin-Latour in the vehement tones of some Savonarola of painting that colour was a 'vice' and a 'whore'[5] — evocative remarks when applied to the intense sobriety of colouring in 'Arrangement in Grey and Black').

The second major lesson he learnt from Gleyre was the primacy of black as the base tone. Together the two techniques were to become the basis of his search for tonal harmony in his style. Already in Paris there were occasional hints of his predilection for thin paint: once, when he was copying paintings at the Louvre for money, a friend commented on his reproduction of a work by Ingres that 'it wasn't a bit like Ingres, for it was done in a thin, transparent manner, with no impasto and hardly enough paint to cover the canvas.'[6]

Whistler stayed in Paris for four years. Despite the

Sarah Walden

limitations of his formal studies, his talent showed
through. With help from Gustave Courbet, who described
him as 'my English pupil,'[7] he acquired a sound enough
grounding in the techniques of painting to qualify as a
minor French artist — a not inconsiderable standing
when one considers who were the major ones at the time.
Perhaps a little too generously, Degas later said that some
of Whistler's pictures of this period could have been
mistaken for his own; together with Fantin-Latour 'we
were all on the road to Holland.'[8]

The best of Whistler's early work — such as 'At the
Piano' — was done while he still had one foot in the
French camp. Though in thick paint and with heavy
shadows, and showing the influence of Courbet's realism,
'At the Piano' already suggests the highly individual style
of 'Arrangement in Grey and Black': the predominance of
blacks and whites, the firm lines of the construction, the
strong silhouettes, the pictures and the dado. The rather
dreamy, mysterious quality of 'The White Girl', which in
one form or another was echoed in much of his later
work, was the first evidence that he was straying from the
French path into Pre-Raphaelitism and beyond.

It was only when he settled in England that Whistler's
development faltered, as he became increasingly side-
tracked into the obscure, second-hand fantasies that
characterized English art at the time. Sickert's analysis is
harsh: 'Whistler's too tasteful, too feminine and too
impatient talent had need for its development to remain
in the severe and informed surroundings of Paris, the
robust soil where his art had its birth.'[9]

Fortunately his years in France had inured him against
the worst excesses of English provincialism — 'the lilies

and languors of the Chelsea amateurs' in Sickert's words, though it also made him painfully aware of his own attraction toward unwholesome tendencies. The death of Ingres in 1867 may have reminded him of how far he had wandered from soundly based painting — 'beautiful Latin security.' By the end of the sixties he was lamenting his wasted opportunities in Paris, seeking to re-educate himself, and wishing he had studied under the great French master. As Degas said, 'Everyone has talent at 25. The problem is to have it at 50.'[10] When he painted the 'Mother', Whistler was thirty-seven — exactly the mid-point between the two.

★

His exotic but incomplete apprenticeship to his craft was a major limitation in his development. As a technician of painting, throughout his life he was racked by an all-too-justified sense of insecurity. Unable to achieve the effects he was seeking with the necessary permanence and precision, he became a master of atmospheric evasion. Even in prints, where he excelled, his uncertainty is evident. Hands tend to be obscured by shadow or safely hidden in clothing, and the outlines of figures are indistinctly conveyed. Some of this was deliberate sketchiness — an echo of Rembrandt. But in painting the technique could easily descend into facility and escapism. As Bernard Sickert (like Walter, a painter) caustically remarked of one of Whistler's followers, if a figure had no feet to speak of, people were supposed to accept it as 'atmosphere.'[11]

For all their felicity (Vuillard copied the technique in his oil sketches on brown paper) the Venice pastels of the

eighties are an example of Whistler's accomplished evasion, their allusiveness as much a reflection on the artist's limited means as of his inventiveness and vision, of his brilliance in drawing success from the jaws of near failure. In painting, Whistler's technical deficiencies are more obvious. A glance at the masterful modelling of the backs of Degas's women (the French artist had studied classical statuary and developed in the shadow of Ingres) suggests how far Whistler always remained from ease or control.

Close examination of 'The White Girl' and 'Wapping' shows how far he was forced to struggle with his materials. The area around the heads has been churned up where the artist repeatedly scraped away the paint in his attempts to get the drawing right. Even now, Jo's head in 'Wapping,' meant to look dreamy, looks gauche and murky with reworking, although Whistler was pleased with the final version. As part of his theory that works of art should spring ready formed for the painter's hand, Whistler seems to have done a minimal, if any, preparatory sketching or compositional or anatomical studies, especially in his later career.

He became increasingly astute at disguising his shortcomings, skilfully transforming uncertain areas of paint into witty suggestions of form or artistic 'atmosphere.' The highly indeterminate space behind the chair in the 'Mother' is not simply the result of a series of pentimenti (changes by the artist). Nor is its imprecision entirely deliberate. It is a perfect example of the artist's skill at avoiding the issue in as 'creative' a manner as possible (X-rays confirm that he had trouble with this passage of the painting). The germ of the solution lay deep

in his etcher's reactions, and the hint of successive, semi-erased almost abstract shapes has a twentieth-century feel. Two years later he was nearly reduced to tears in his attempts to get the legs right in his portrait of Leyland. Minimalist shorthand eventually solved the problem of the hands. Bernhard Sickert marvelled at Whistler's ability to 'pull off' masterpieces 'in spite of his neglect of rudimentary laws ... Sometimes the final qualities were happy accidents ... the dress of Miss Alexander was scraped down and the result so satisfactory it was thus left.'[12]

Sometimes constructive improvisation could be brilliantly successful. At other times the aesthetic blur it produced could smack of mere taste or cleverness in the eyes of his critics. However just, there was a distinctly defensive element in Whistler's frequent excoriation of other painters for their tricky brushwork or sleight of hand techniques. Deeply resentful of Sargent's success, he said that his work betrayed the 'cleverness of an officer who cuts up oranges into fancy shapes after dinner'. But where his own work was concerned, Whistler was occasionally startlingly frank: surveying a gallery of new paintings in the Royal Academy one day he commented to Menpes: '... there is a certain smart handling, a certain superficial cleverness and facility. Do you know, Menpes, I couldn't do that?'[13]

When his guard was down, Whistler's instinctive respect for any form of virtuosity, however meretricious, emerged despite himself. It was the touching side of an artist whose courage in pursuing the uneven struggle in the face of his own shortcomings was remarked on by Sickert. It slipped out once when he was attending an exhibition with Menpes: 'How foolish that trick of the

brush is,' he remarked contemptuously to the 'bushman,' then added in the same breath: 'But how do you think he does it?'[14]

Criticism of Whistler's technique was widespread. People who had no comprehension of his aims saw him as a conjurer, a trickster, or quite simply a charlatan. Burne-Jones said that Whistler 'had great powers at first which he has not since justified. He has evaded the difficulty of his art'.[15] Grudgingly conceding that he was a 'clever fellow,' the Pre-Raphaelite Millais nevertheless thought that he was 'a great power for mischief amongst young men, a man who has never learnt the grammar of his art'.[16]

As some of those who saw him at work on his pictures confirm, his methods of painting were not designed to absolve him from these accusations. When he fumbled a passage, he used to take off the superfluous paint with blotting paper, conveniently obscuring the passage in question. The result was to clean the raised knots of the canvas, giving it an agreeably grainy look. Seen in the light of some contemporary techniques of painting, Sickert's comment was prescient: 'Here we have a superficial appearance that can be produced by anybody'.[17]

Whistler was a master at making a virtue of necessity. When it worked, of course, it was beautiful. Whether one sees the technique as an example of mere serendipity or as an illustration of Whistler's improvisatory genius, there is no doubt that in certain areas of 'Arrangement in Grey and Black' the flat, arid surface that blotting, scouring and scraping off helped produce fitted the subject and mood of the painting to perfection. It is even possible for us to interpret this restless rubbing, cleansing and renewing as

an expression of his high ideals, his perfectionism, his 'Puritanism'.

★

In addition to being an inadequately trained craftsman, for someone who was thought of as an 'intellectual' painter Whistler was patchily informed about the Old Masters and seems to have taken surprisingly little trouble to familiarize himself with their works or techniques. There is no evidence that he read at all deeply or travelled widely to explore in any detail the construction of the paintings he admired. Instead he relied on his powerful instinct and artistic intelligence to assimilate what he needed with minimal effort. He showed scant interest in the works of the Renaissance: even during his stay in Venice, he never managed to see at first hand the greatest pictures of his idol, Velázquez. Nor, unlike the widely travelled 'bushman' Menpes, did he follow up his interest in Japanese art by visiting the country.

Apart from museums and exhibitions in France and England, his main fund of visual experience came as a student from a visit to Holland, where Frans Hals and the Dutch engravers made a lifelong impact on his work. He had seen the works of the revered Velázquez in the Hermitage in St. Petersburg, in the Louvre, in the National Gallery, and at the vast Manchester Old Master exhibition in 1857. But his interest in the Spanish painter does not appear to have been compelling enough to draw him to the Prado. He intended to go once, with Courbet and Jo, and promised to bring Fantin-Latour a detailed report on certain paintings. In the event the trio got as far

as Biarritz. He saw photographs of 'Las Meninas,' but never the original. And when he copied his paintings in the Louvre it was not to learn, but to eke out his allowance.

One might have expected Whistler, as a cosmopolitan and an American, to have been more enterprising in his travels and interests. (The contrast with Degas, who spent years studying from the antique and the Renaissance and a long period in Italy, is telling.) Needless to say, the slightness of his knowledge did not prevent him from passing definitive judgements, as erratic as they were sometimes revealing, on great artists. And in a man of his legendary self-regard, artists were frequently assessed, not so much on their own merits as by reference to himself.

Hogarth's paintings were elevated to the first rank, perhaps less because of their intrinsic quality (though his sureness of line certainly endeared himself to Whistler), than because his prints had inspired Whistler as a child. And naturally enough his views on major painters of the past reflected the aims he was striving for in his own work. Indeed, it is possible to read many of his judgements about them as an unconsciously articulated recipe for the 'Mother.'

He was not attracted to the Italian school in general; Raphael he once dismissed as the 'smart young man of his time',[18] and repeatedly expressed his distaste for 'hard, bright Italian skies,' against which details could be seen a mile off. Yet Canaletto, with his clear blue skies and infinity of anecdotal detail, attracted his highest praise. There was no 'uncertainty' here, and Whistler liked the 'crisp, clean way' the tones were put on — though of course the work of such a master 'was as little understood

as mine'[19]. 'Clean' painting — widely defined to include Velázquez's tonal relationships as well as Canaletto's unerring eye — always attracted Whistler. Hals and Manet had his approval for similar reasons, though he reacted with scorn when Manet gave up his blacks for an Impressionist palette.[20]

Despite his tour of the Netherlands he recoiled from some of Rembrandt's portraits, describing one as 'gummy,' with 'a fat juicy quality about it I don't like.'[21] To the Whistlerian eye, Rembrandt's heavy build-up of impastoed paint may indeed have seemed 'unclean' and unpuritanical. But his especial horror was reserved for Turner, whose pictures were simply 'not big work. The colour is not good. It is too prismatic. There is no reserve'.[22] He particularly disliked the simple-minded symmetry of Turner's suns, his lack of anatomical knowledge, and what Whistler discerned as his fudging style (the last two phobias no doubt reflecting the artist's concerns about his own work). Terborch's flesh painting he found attractive, particularly 'the pearly tones of the shadows,' and while he admired his use of blacks, he implied that the Dutchman didn't understand them as well as he himself.

However flippant or ill founded, such comments are strong pointers to what he was aspiring towards in his own tonal painting, especially in the 'Mother.' This was not the work of a 'smart, young man' but of a middle-aged painter in the throws of an artistic crisis. It was not 'gummy' in its use of paint, but stark and spare. It was also a feast of darks. Its tones were 'certain' yet at the same time beautifully 'reserved,' their ambiguities as clean yet supple as those of Henry James. (With considerable foresight

Pennell once suggested that Whistler thought of himself as a 'Puritan in a period of meretricious technique.')[25]

Alongside Whistler's disrespectful 'New World' pronouncements on some of the greatest masterpieces of European painting went a conscious yearning for Old Master status for his own. Like Reynolds, though in quite a different style, he sought to achieve an instant 'Old Master' surface in his paintings through dangerously experimental techniques — one of the reasons he was hyper-sensitive to the opinion of posterity. Anticipating criticism of one of his later and less successful portraits, that of the famous violinist Pablo de Sarasate, he said, 'Wait till the Sarasate is as old as the Mother, with a skin of varnish on it that has mellowed ...'[23] Sickert remarked that Whistler wanted to give his pictures from the beginning the suave, smooth, exquisite surface the great works had acquired with time.[24]

The paintings were frequently put out in the garden to dry and to 'ivory'. He wanted a hard yet saturated surface. At a time when interest in France was growing in light, unvarnished surfaces, sometimes close to a pastel technique, as in Millet, late Degas, Toulouse-Lautrec, and others, Whistler's unique combination of Japanese screenlike textures with saturating varnishes and a dark tonality is as unexpected as it was unparalleled. As his frequent requests to revarnish his paintings showed, varnish was important to Whistler.

While he desperately sought to get away from established styles and do something 'new,' his vision of what he wanted to achieve in his painting was frequently contradictory. On the one hand was a distinctly American predilection for the 'broad,' the 'simple,' and the 'scientific':

the bold conception executed in a flourish 'in one wet', ie before the paint was dry On the other, he was attracted by 'European' ambiguities and obscurities: tonal nuances, intricacy of surface, haziness of outline. With his undisciplined and fragmentary training and impetuous painting style, Whistler lacked both the technical foundations and the temperament to reconcile these fundamental divergences in any systematic way and to create something both artistically novel and technically sound. Hence the frequent suspicion of trickery in his work and the undeniable strain of evasion in his art.

Denying him the status of a true 'master' Sickert wrote: 'A master is a craftsman who knows how to conduct any work he undertakes through its stages, to the foreseen consummation'.[26] Even his most ardent champions would find difficulty in applying this definition to Whistler, who was more of a gifted and original improviser than a master in the traditional sense. He knew what he wanted and, like some resourceful alchemist, cast about endlessly for some catalyst to transform his vision into gold, sacrificing canvas after canvas in the process.

Only when he forgot for a moment his reputation in the art world and his place in posterity did he produce something genuinely and durably new. 'Arrangement in Grey and Black' was the nearest he came to resolving the irreconcilable, and led directly on to the equally innovatory 'Nocturnes'. In style and technical construction, in its blend of emotional content and formal abstraction, its firm grid and moody atmospherics, the 'Mother' was the closest he came to a stable synthesis. He himself knew what he had done; only when the painting was finished did he take to referring to himself as 'the Master'.

No first hand account exists of the exact techniques Whistler used in painting the portrait. The Pennells merely write: 'How many were the sittings, how often the work was scraped down or wiped out, no one will ever know'.[27] The Greaves brothers, boatmen and amateur painters who lived nearby and helped Whistler in his studio or rowed him on the river (as they once had Turner), seem to have been excluded from the studio on this occasion, like everyone else. Simple men who held Whistler in awe, their recollections long after the event are patchy and not entirely reliable; their absence from his studio did not prevent them producing fanciful, naive paintings of Whistler at work on the 'Mother' after it had become famous. But by examining the picture itself, and piecing together later accounts of his technique, we can get a fair idea of how he worked.

If the 'Mother' had to be reduced to three main ingredients, these would be grey light, raw canvas, and thin paint. To achieve the rarefied, tenuous atmosphere he was seeking, each was essential. The most difficult to control was the paint. To get the inky, washlike effect he needed, instead of keeping his colours side by side and mixing them in small quantities, he made up large amounts of the 'tone' he required, as he had learnt with Gleyre, on a special table with a rim (and with his butterfly motif inlaid in ivory on the corner). The result was described by Whistler himself as a 'sauce', which was sometimes kept in pots or cans while the painter worked.

'Jimmy always said, in London there's atmosphere. You don't need all those bright colours, do you? A bit of Antwerp blue and white and black's all you want — and paint thin' the Greaves brothers record him as saying.[28] No

bright colours, no raw pigment, everything mixed, and the exact tone of the mixture controlled by the use of black and white. Black — the supreme 'harmoniser' — was added to everything. 'Even if he painted a white shirt front,' Menpes wrote later, 'black was always used'.[29]

Even before the 'Mother,' Whistler's use of paint had caused ribald comment. One academician claimed that the artist was obviously losing his eyesight, since he was unable to see that there was no paint on his canvases at all. (The fact that Whistler was indeed shortsighted added point to the barb.) How exactly he made up his paints is of more than technical interest; on it depended the durability of his work, the condition in which it has come down to us, and so our modern assessment of it.

Some of the paint Whistler used on the 'Mother' was thinner than ever before — so much so that the Greaves brothers recalled with amazement that 'there was scarcely any paint on it at all ... the canvas was simply rubbed over to get the dress and, as at first the dado had been painted across the canvas, it shews through the skirt'.[30] (For reasons to be discussed later, it no longer does today.) T.R. Way said that Whistler used paint as thin as water. Even at the time Way thought this a risky business, and he talks of the dangerous fascination of turpentine.[31] Apart from anything else, the 'sauce' tended to run down in streaks that were hard to remove once they had dried. To prevent them from running off, Whistler sometimes put his canvases flat on the floor, and he may have resorted to this expedient with the 'Mother,' where the paint used in the skirt, the curtain, and some other parts of the portrait was particularly parsimonious.

Thin paint on an almost raw canvas was a precarious

procedure in itself; riskier still were the means he used to dilute it. As well as using conventional thinners, such as oil and turpentine, Whistler once confessed to the Pennells the more dubious practice of mixing copal (a hard resin), and — still more dubious — megilp (a jelly-like mixture of lead-drying agents, linseed oil, and mastic varnish) into his 'sauce'. He was even said to have resorted to the lees of port wine to get his blacks right.

Megilp was concocted in the late eighteenth century. From pictures on which it had been used, it was already clear that it could have dangerous consequences, becoming brittle and yellow with age, like copal. If Whistler resorted to it in the 'Mother,' it was probably in a desperate attempt to pre-empt the sinking of the darks that his over-fluid paint might lead to, and to obtain a clean, hard surface when he wanted to rework a particular part of a painting. Another reason may have been to avoid picking up an earlier layer. Today it is hard to be certain; distinguishing one medium from another and from later varnishes is a notoriously tricky business. The fact that he sometimes used such a dangerous concoction as megilp at all underlines how far Whistler had wandered from the sounder techniques he had learned in Paris. (Artists such as Degas did however occasionally use copal as an isolating layer.) However he may have manipulated his pigments in painting the 'Mother,' Whistler certainly mixed in quite a few problems for posterity.

In its painting techniques, as in so many other respects, the 'Mother' was an ambivalent picture, in which tried and untried methods met. Alongside the dangerously experimental methods Whistler used to get the skirt and the curtain as he wanted them, in the background there

were still echoes of Courbet's creamier, more impastoed style. The size of the brushes Whistler used varied accordingly; generally the more traditional and Western the techniques, the smaller the brushes.

When it came to brushes, Whistler was meticulous to the point of fetishism, heating them over a flame to get them exactly the right shape for his purposes. Bernhard Sickert says that 'his palettes were beautifully wiped, his brushes faultlessly kept — everything betokened the fastidious man.'[32] The Hunterian Collection in Glasgow houses the final effects from his studio, including round brushes nearly three feet long and shorter 'rounds' both of hog bristle and of sable. There are long flats (called Brights) and Filberts (with oval ends). The older brushes are tied, before metal ferrules (rings) came in. In the 'Mother' each brush was moulded to achieve the right effect in the right place. Short rounded bristles combining white and yellow paint in different proportions were used to get the pattern of the curtain, and longer, softer, more calligraphic ones — applied with a sort of tense sobriety — to evoke the lines of dim, liquid lilac running diagonally across it. 'Art is as exact as science'[33] was one of his most cherished sayings.

Several distinct areas in the painting suggest both changes and a deliberate indefinition to prevent a closed and dead outline. An example is the intentionally vague back of the chair and skirt, where alterations certainly did happen, but where Whistler used them to leave suggestive options open as he strengthened the opposite line from head to toe. The skirt was brought down to the base, breaking the isolation of the figure and the excessively simplified silhouette.

The drawing of the feet, which had originally overlapped further with the curtain and the shifting of the Thames wharf print to the left, was matched by the crucial addition of the slim border of another print at the top right hand corner. This Japanese touch not only balances the extended fall of the skirt and suggests the unposed informality of a Far Eastern print or a photograph (much as Degas's dog is painted walking out of the Famille Bellelli's drawing room), but shows a certain decision to move away from a characteristically American unbroken contour.

Although the range of colour is tightly compressed, Whistler maximized the impact of each touch. 'Controlled by a strong hand, and the careful guidance of Dessin her master,' he once said, 'colour is a splendid Mistress.'[34] Whether in the pink of the face, the gleam of yellow in the footstool, or the sepia print, each stroke was rationed with a parsimonious hand. There is no abandoned, sensuous, or uncontrolled brushwork, and not a stroke that is self-indulgent or superfluous. It is almost as though anything more extravagant would have been an affront to Anna Whistler's sensibilities.

<p style="text-align:center">★</p>

Just as some modern artists of limited skills seem more at home talking about painting than producing it, Whistler's voluble philosophizing about art helped to disguise his insecurity as a technician of painting. His exotic and dogmatic theories and lofty notions of his profession were partly serious, partly verbal resourcefulness — astutely

polished aphorisms about the nature of art, with a minimum of commentary on its practice.

He liked to expatiate on the supreme importance of never seeing the work in a painting: 'A picture is finished when all trace of the means used to bring about the end has disappeared.'[35] To some extent he was reacting to the dull but dogged craftsmanship of the Pre-Raphaelites, who wanted the proof of an artist's honest labours to be as evident to the public as the strokes of a spade. Whistler genuinely believed in his own doctrine of the effortless creativity of the true artist, in which insignificant detail would be subsumed in the sublime tonal envelope of the whole. It was a belief that might have seemed suspiciously well-tailored to his own level of ability as a painter, had it not been for the integrity of his inner eye. In the privacy of the studio, despite his public bombast, it rarely allowed him easy satisfaction and certainly did not underestimate the demands of simplicity.

Like all his opinions, Whistler's theories on art were expressed with verve, vigour and finality. They are nonetheless confused and confusing — reminding us that at West Point he emerged thirty-ninth out of forty-three in philosophy classes. Much of the time he was skipping with light steps over shaky ground. Full of musical analogies, with 'tones,' 'symphonies,' 'arrangements,' or 'keys', he knew little about music. Somehow he always got away with it. The English writer Max Beerbohm has left a superb description of how he did it. Commenting on Whistler's literary style he wrote:

Like himself, necessarily, his style was cosmopolitan and eccentric. It comprised Americanisms and

Cockneyisms and Parisian argot, with constant reminiscences of the authorised version of the Old Testament, and with chips of Molière and with shreds and tags of what-not snatched from a hundred and one queer corners. It was, in fact, an Autolycine style. It was a style of the maddest motley, but of motley so deftly cut and fitted to the figure, and worn with such an air, as to become a very gracious harmony.[36]

It worked in his writing and talking and sometimes in his painting. But as a teacher in the studio he opened up in Paris toward the end of his life, Whistler was a failure. His *ex cathedra* principles left the students nonplussed. *Scientific,* in Whistler's frequent usage, meant the opposite of what it said. Far from indicating theories established by inductive analysis, the word merely signified that he wished to give a grand, modern-sounding tone to his dogmas. And if ever things looked as if they were getting too serious, his wit was always there to deflect things onto a lighter and safer path.

'Do you know what I mean when I say tone, value, light, shade, quality, movement, construction and so on?' he asked his pupils.
'Oh yes,' they replied.
'I'm glad,' Whistler said, 'for it's more than I do myself.'[37]

In particular he never explained how his doctrine of the magical wholeness of a work tied in with his equally strong assertions of the importance of an aura of incom-

pleteness. Fanciful language helped obscure the contradiction, rather as his blurred tones smothered imprecise areas of paint. 'The work of the master reeks not of the sweat of the brow — suggests no effort — and is finished from the beginning'[38] — sounded wonderful. It is just that anything further removed from the reality of Whistler's struggles with his canvases is difficult to imagine — with the possible exception of the 'Mother.'

While forming a perfect whole from the start, a harmonious entity achieved 'in one wet', a picture must also remain forever 'incomplete'. The truth was more pedestrian. 'None of Whistler's paintings were finished,' Sickert wrote. 'They were left off — which is another thing — sometimes by force of circumstances, sometimes because he could do nothing more to them.'[39]

Whistler's pictures, Sickert explained, were palimpsests — the first chapter written again and again on the same canvas. And naturally his first coat was the best and the freshest. It was painting by trial and error, in which the errors frequently outnumbered the successes. Even when he succeeded, the result could be a precarious beauty — like his butterfly.

In severely practical terms the search for 'oneness' — the elusive ideal of tonal harmony — meant covering the canvas quickly with highly diluted pigments. This could be at the expense of what Sickert called a 'fatal lowering of tone, which the years can only accentuate.'[40] The intimations of mortality that Sickert rightly perceived in some of Whistler's technical adventurousness are well justified by the fate of some of his later pictures, which blossomed and decayed like lilies at a Chelsea flower show.

Miraculously this tour de force came off in the

'Mother,' where he was still in touch with his earlier, more rational French techniques and where the size of the canvas was still almost manageable. It was, above all, suited to the little panels — the 'Nocturnes' and others — where his private fantasy was free and not frustrated by incompatible aspirations. Here the fine layers could be controlled and played against one another in a way that is closer to Guardi than to Canaletto, using light over dark for optical blue mists that contain no blue pigment. While evoking the flat washes of the Far East, the surface recedes into a ghostly depth of translucent airy colour, once defined as that unclassifiable colour one sees with closed eyes. As with his wit he approached colour from behind, inverting it for unexpected effects.

Huysmans came close to putting into words the effects of the little 'Nocturnes,' which were early understood in France: 'Irresistibly, one dreams of the visions of de Quincey, those flowing rivers, watery reveries born of opium. In their pale gold frames, sprinkled with turquoise and touched with silver, these places of atmosphere and water stretching to infinity suggest trails of thought magically conveyed into time yet to come in another life. It was far from the modern world, far from everything, at the extreme confines of painting which seems to evaporate in invisible drifts of colour, on these light canvases.'[41] It was in these small works that Whistler perfectly conveyed his vision.

The admiration of intellectuals like Huysmans was tempered by technical qualms amongst painters. Otto Scholderer wrote to Fantin-Latour in 1872: 'Like Whistler's landscapes more than before, and his portrait-harmony in black and grey — which is very fine — but I

don't know where Whistler's painting can lead.'[42] Yet as the old technical disciplines began to break down definitively at the turn of the century, Whistler's innovatory style became less exceptional. Gradually opinions of his technique veered in a more favourable direction. After his death in 1903, the *Academy and Literature* wondered at the change time had wrought in Whistler's critics, some of whom were 'elderly and enthusiastic.'[43] The voice of the academy which had held him at arm's length during his lifetime, now decided that the artist had been a 'silent pathfinder who chose his own way, and the way was strange and untrodden,' brilliantly rendering on canvas things that others would have thought not paintable, or too difficult to essay, 'In a wonder of dim paint.'

For many artists, Whistler's adventurous methods were beginning to become the norm. The implications for the future of painting were not yet apparent. As we look at the condition of some of Whistler's works today, and the brief structural life of some more modern painting, the irony in the conclusion of the article in the *Academy and Literature* becomes poignant: 'We are all advanced now'.

9

Restoration

The Elusive Original

'The book or newspaper engraver is owing to his immense ubiquity, secure not only from the forger but, what is worse, the incompetent or dishonest restorer.'[1]

James McNeill Whistler

Some years ago I was discussing the condition of the 'Mother' with French colleagues while standing in front of the picture in the Louvre. Overhearing the conversation and unable to restrain himself an American visitor to the museum interrupted. 'They're not going to restore "Whistler's Mother", are they?' he asked in a tone of shocked apprehension. 'Do they realize just what a responsibility that is?' There was nothing naive about his concern; the decision to touch any great painting is a considerable responsibility for all involved. In the case of Whistler's masterpiece, the talismanic status of the

portrait in America was an inhibiting factor, as was its isolated position in the history of art. The need to approach the task with humility as well as prudence was commensurately great.

The 'Mother' is a comparatively young picture, little more than a hundred years old. Well-constructed works of that age often pose only simple problems for the conservator and require minimal attention: the removal of replacement or yellowed varnish or a gentle cleaning of the surface to dispose of accretions of dust and dirt. With the works of Ingres, painted well before the 'Mother', that often suffices. The Impressionists, who painted at much the same time as Whistler, can pose even fewer difficulties; their use of frank, unglazed colour and the avoidance of varnishes have frequently left their surfaces almost as fresh as the day they were done.

In their very different ways Ingres or Degas, Monet and Cézanne were masters of their craft, and their pictures will last for many years to come without the hidden — or painfully apparent — support of restorers. Far older paintings often remain today very largely as they were painted centuries ago. The Flemish masters of the fifteenth century are the obvious example. Those of their pictures that have been fortunate enough to escape damage or the fussy attentions of later generations remind us of the superlative craftsmanship of these artists.

The fact that the 'Mother' poses such awesome problems for the restorer is a result not merely of the shortcomings of Whistler's training as an artist but of the spirit in which the portrait was painted. To simplify greatly, the determination of the Flemish painters that

their images should endure — the painstaking preparation of surfaces built up in infinitely delicate layers, their use of almost imperishable materials — reflected their need to give artistic impression to a belief in 'life eternal.' The twentieth-century artist's lack of concern with the permanence of his or her products is a manifestation of the dominance of life 'here and now' and of the overwhelming pressures on the painter to produce 'original' work. Hankering after a 'rare medium, one that is solid and eternal,' Degas noted that 'those pictures by Memling [a fifteenth-century Flemish painter] have not budged yet'.[2] He went on to brood over the unbridgeable chasm of incomprehension dividing the Old Masters from his own era. Whistler's priorities and preoccupations were different.

It is important not to exaggerate. The 'Mother' is very far from ruin. It is still perfectly accessible to the eye; the 'content' of the painting is as clear as ever it was — too clear for Whistler's own liking, perhaps, insofar as it distracts us from the importance of his surface. Once it was rasping, tense, assertive — as excitable and provoking as the artist himself. Time has always muted the interest of the surface in favour of underlying form, something Renaissance artists took into account, but such long-term strategy was certainly not in Whistler's mind. The changes that have taken place in the tone, balance, and texture of the painting have made it far harder — almost impossible in fact — to re-capture either the mood or the historical significance of the portrait. It is easier to 'read' a four-hundred year old Van Eyck altarpiece or a Chardin still life from the eighteenth century, and to

relate it to its time, than it is 'Arrangement in Grey and Black'.

This is no mere question of academic curiosity or art historical niceties. The fact that the 'Mother' we see today is a far cry from the work that left Whistler's studio distorts our perception of what the portrait is about in significant ways. If we could see it again as it was painted, we would be far more struck by the canvas than we are. Even if we allow for the dulling of our sensibilities by the importunate ubiquity of contemporary styles, if we could glimpse again Whistler's work as he saw it, our reaction might be to exclaim 'How modern!' or 'How far in advance of its time!'

The solution might appear to be simple: If it can be shown that the portrait no longer speaks to us in Whistler's language, and we can establish through science and a study of his methods what that language was, we should simply re-create the 'Mother' as it was: 'get back to the original.' If the portrait was an expression of the painter's artistic and national identity and if its physical mutation has diminished its ability to shock us into a recognition of the essential 'Americanness' of its style as well as of its subject, the restorer must surely aim to recapture its essence.

In recent years we have become accustomed to large claims being made on behalf of restorers, who are credited with 're-discovering' great works, revealing lost secrets, or unmasking cunning and long undetected forgeries. Most such claims are media exaggerations, which exploit a natural public impatience to see the curtain drawn back on the 'mysteries of art'. There have indeed been times when the soul of a work, as well as its

surface, has been revived through the prudent ministrations of the conservator. But for reasons this chapter will discuss, complete resurrection of meaning in 'Arrangement in Grey and Black' will never be entirely possible. This is not because the appropriate technical tools are not available, but for a deeper reason: Like many more modern works, the theory on which the painting of the 'Mother' is based contains the seeds of its own evanescence — an evanescence which is part of 'modernity' too.

<div align="center">*</div>

This is not to suggest that in painting the portrait as he did Whistler was guilty of deliberate trickery. He was merely trying to square too many circles, attempting too much with limited means. In pursuing his aims with a very American mixture of idealism and 'can-do' determination, he jettisoned centuries of experience in Western art. Preparation of the canvas, the balance of the pigment and medium, or the evenness of tone between the 'rich' and the 'lean' parts of the painting — all were wholly or partially sacrificed to immediacy of effect and to the stirring notion of the artist as an instant creator, whose genius must not be impeded by the recalcitrance of his materials.

Technical risk taking is no monopoly of the twentieth century; examples go back to at least the Renaissance, when the very versatility of artists and their spirit of inventiveness led some of the most talented painters into extremes of refinement that endangered the future of their works. (Examples include ever more exquisite

glazing or daringly suggestive brushwork, sometimes over dark grounds, or high-minded experimentation of the sort Leonardo incorporated into his ill-fated 'Last Supper' (recently once again restored, as far as it is possible). But as the restless search for novelty in painting has gathered pace, the temptation to break free of the constraints imposed by the artist's materials has grown, too. Strangely, perhaps, this disregard for the demands of technique has gone hand in hand with a worship of technology. The unspoken assumption appears to be that when things go wrong, there will always be some ingenious 'scientific' means of recovering the loss.

Some time ago, when I published a book criticising the excessive restoration of paintings and the over-reliance on technology, and sought to analyze the philosophy behind this trend, I was asked for more specific instances of the problems.[3] Whistler's portrait of his mother is the perfect example of the limits of the possible, and of the desirable, in restoration. Nothing could illustrate better than his work the ultimate impossibility of recapturing the past.

The arguments against over-restoration are four-fold. First, the underlying assumption is that modern methods make it possible to 'get back to the original,' so re-discovering 'what the artist really meant to say.'

Second, conversely, there is a disinclination to recognize that the artist's intentions are sometimes irrecoverable because of fundamental changes (chemical or otherwise) in the paint; or that imprudent attempts to retrieve them will engage the restorer in a process of infinite recession, thus removing the painting increasingly farther from the original, while unwittingly

bringing it closer to our own times. Not only has the painting changed, but so also has its audience, including the restorer.

Third, during this process the painting itself will be distorted in a series of ways to make it more appealing to twentieth-century aesthetic prejudices. Broadly these are cleanness, clarity, flatness, brightness of colours, and easy accessibility to a mass audience. Consciously or inadvertently, subtleties of colouring and tonal transitions will be tidied up and sharpened to heighten the painting's public appeal. ('We are all advanced now.') Since Impressionism and photography light has always been seen as synonymous with positive values, dark as negative. The modern obsession with hygiene and youth will mean that whatever appears old and dark must be made younger and brighter — even though movement from dark to light does not necessarily mean progress toward truth, if truth should lie in the penumbra. In musical performance also conductors talk of the modern tendency to bring everything into the foreground, leaving little in the middle ground and no distance. Even the use of authentic instruments and tempi challenges the hindsight of modern audiences. But music has the luxury of a constant, unadulterated text to which new performers can always return.

Fourth, in the course of radical restoration, art-historical judgement will be sacrificed to 'scientific' rationalism, as the availability of technology, rather than its need or effectiveness, predetermines its use. As a result, drastic alterations of the pictorial surface can be unconsciously or even intentionally produced. The most familiar examples are the removal of patina (with all that

includes, such as possible traces of the artist's final touches); the wearing away of glazing and the desiccation of the original paint by frequent or ill-informed cleaning, in the relentless pursuit of every trace of old varnish; or the flattening of the painted surface by strong solvents or harsh relinings. In the worst cases, even the most seasoned Old Master can come to bear a remarkable resemblance to a coloured photograph.

Such a fate can and has befallen technically sound paintings. Difficult works are even more vulnerable, and as the venerable conservator at the Louvre warned me, it had long been recognised that 'Arrangement in Grey and Black' was a problem picture. The alteration of the painted surface had long been evident — but so had the difficulty of doing anything about it. Fortunately for the 'Mother,' the restoration policy of the Louvre has been prudent in the extreme. There was no question of simply handing the portrait over to technicians in the confidence that they would contrive the appropriate solutions. In deciding that the time had come when some attention was inevitable, art-historical and aesthetic factors were given due weight, as was the portrait's restoration history.

★

The first need was to find out as much as possible about how the artist painted the picture and how it looked when he finished it. For this, technology — X-ray, infrared and ultraviolet photography, and laboratory analysis of paints and varnishes — was clearly invaluable. Yet none of these provided all the answers. In the last

resort science can often add little more than interesting footnotes to the greater understanding of painting, consisting as it does of such unquantifiable elements as perception, visual memory, suggestion, tactile awareness, and ultimately sensuality.

The very shape of most paintings — a golden section — is unmathematically founded. We are not dealing with a scientific construction that can be de-coded with the right techniques but with a fragile illusion created by an artist applying a few millimetres of paint to an unstable surface. To re-create the illusion in our mind's eye requires as much imagination as analysis. Inevitably that in turn will mean that there will always be an element of subjectivity in how we think the 'Mother' looked when it was first exhibited at the Royal Academy in 1872. Opinions will always vary to some degree.

In a sense one can sympathize with the Academy judge who mistook the painting for a black-and-white drawing or with those who claimed that Whistler's work was not really a picture in the conventional sense at all. In 1872, when it was still fresh, the darks must have been exquisite: as thin and rich as Japanese ink or an etching's velvety burr, but with the peculiar translucence of oil. Through them the grain of the canvas would have been far more apparent than today. Against the blacks the pure white lead pigment of the handkerchief, the muted whites of the bonnet, and the gold and silvery touches on the curtain would have emerged as wonderfully fine and cool. The contrast with the high gloss and raucous colours of the English pictures at the Royal Academy must have been astounding.

The deterioration of Whistler's enchanting surface

began almost at once. The 'Mother' was far from exceptional: some later paintings decayed more quickly. Even the Pennells, always at pains to defend him against the charge of dubious workmanship, admitted that some of his early, more thickly painted canvases, such as 'Wapping' and 'At the Piano' soon cracked, and correctly ascribed this to 'his want of knowledge of the chemical properties of paints and mediums,' while insisting that he later gave 'great attention to these matters.' It was with 'sadness' that they subsequently noticed that the Sarasate portrait at the Carnegie Institute in Pittsburgh was cracking, too, fewer than twenty years after it was painted.[4]

The problems of the 'Mother' were different. To achieve both richness and transparency, thinness yet vibrancy — particularly in the skirt — Whistler had used black pigment so fine it was like dust. To 'coat' his very delicate pigment, he had used oil with an inordinate amount of diluent — turpentine — and perhaps megilp too, in an attempt to counteract the drying effect he foresaw. (Velázquez, his hero, used more coarsely ground pigment, more glutinous oil, probably thickened in the sun over many months, a nonabsorbent ground and no dubious additives to his medium. His blacks remain rich today).

Whistler wanted two irreconcilable things: the lustrous depth of a fully saturated pigment and the matt, velvety quality of Japanese ink. He drowned his pigment in diluent, which the insufficiently primed canvas thirstily absorbed. The result was to leave the pigment stranded like dust on the surface of the canvas. The effect over time on the appearance of the picture was

fundamental. Because the light now bounced back off the powdery particles of paint, rather than entering a rich coating of oily medium around them, the refractive index of the surface was altered; instead of being vibrantly dark, the blacks quickly became grey, opaque and dull.

The visual damage was not confined to the darks. The repercussions on the rest of the picture were radical. As the blacks and darks receded, the precarious tonal balance of the portrait changed. The contrasts with the whites and greys diminished, and with it one of the most revolutionary aspects of the painting. And as the impact of the black skirt shrank, the power of the picture shrank with it. In musical terms, the crescendo of contrasts — from tinted greys, golds, and the pinks of the flesh toward the percussive impact of the pure lead white handkerchief, dragged over the very deepest blue-black area of the skirt — became gradually enfeebled.

When the deterioration began to show on the finished picture, the artist tried to revive the sinking image. Whistler's habit of what he euphemistically called 'oiling out' the darks in his paintings probably dates from the period of the 'Mother' and is attested to by Greaves.[5] All this meant was that when the painting began to go dull and recede, he brushed oil and yet more varnish (including possibly copal or megilp) onto the fading surface. In the short term the result would be highly satisfactory — like wetting a mat, grey pebble to bring out the refinements in its colouring.

But the process became a vicious circle. The more oil was applied, the more patchy the darks would become; the fresh pigment even shifted in places where it was

weakly bound or rubbed further into the canvas. Over time there would also be a gradual loss of transparency and a yellowing effect as the layers of oil and varnish accumulated and deteriorated on top of and — even worse — within the paint. Slowly the ridged and grainy canvas would become saturated and clogged, so that the painting lost its spare, dry feel. It was not simply that it began to look dull or brown, in the way all varnished paintings do after a time, with a yellowing but generally replaceable, protective film; the change was more permanent, as year by year the unique aesthetic balance between the portrait's 'European' tonal equivocations and its 'American' sparseness was upset.

The thicker, moodier scumbled grey paint of the background, with its echoes of Paris and Courbet, became more pronounced, while the thin grandeur of the skirt and curtain, swollen and overlaid with 'gummy' concoctions, was drawn closer to it. The more sensuous side of the painting was slowly gaining ascendancy over its puritanical ethos. From the first years of her existence the 'Mother' was imperceptibly adjusting to what was to be her European home.

★

As the years went by, every change to the picture worked in the same direction. An unusually early relining of the canvas moved the painting another stage farther from the original, toward a fuller, more saturated traditional European surface. A new canvas was affixed to the back in 1891, immediately before it was sent to the Luxembourg Museum in the same year. Normally there

would be no need to reline so young a picture, and there is no evidence that it was made necessary by damage or a hole in the canvas (the usual reasons for relining).

Whistler must have been aware that having a new canvas stuck to the back so soon was bound to have some repercussions on the painted surface. The sale of the 'Mother' to France was the high point in his life. Not untypically he appears to have been concerned at the indignity of presenting the French with a canvas with an aborted picture on the back (evidence of his technical uncertainty). Fortunately the relining seems to have been competently done (by a Mr Grob, of London). But it can take up to half a century for an oil painting to harden fully. It had been only twenty years since the portrait was done, and the paint would still have been relatively soft — not least because of Whistler's frequent 'oilings out.'

Traditional liners were usually skilled enough to avoid crushing the surface or flattening any impastoed paint (of which there was relatively little) while they fitted the new canvas to the back. But it was always ironed on with glue. Under the pressure and the heat, the varnish from the front and the glue from the back would have been driven into the still fresh paint and unprimed original canvas, rather like butter in a toasted sandwich.

Since the lighter areas of paint contained white lead, which helped them dry out more quickly, and had needed no 'oiling out,' they would have been relatively unaffected. But in the dominant darks, paint, varnish, oil, megilp, glue, and probably dust would now be inextricably intermingled. This would make it extremely difficult for any future restorer to remove decayed and disfiguring varnish without damaging the paint. Whistler

spoke about the picture having mellowed with a skin on it, but the mellowing was more than skin-deep. To compound the effects of premature relining, yet more varnish would have been added after the operation to even up the surface of the painting and unify the texture.

Only its powerful contours saved the figure from being weakened by such changes of emphasis. But by the time it entered the Luxembourg in 1891, the painting's freshness was apparently noticeably diminished. The remark of the critic in the *Chronique des Beaux Arts* in the year of its acceptance into the Luxembourg — that it already had the patina of a Rembrandt or a Velázquez — may not have been so fanciful.[6]

Far from disturbing them, to French fin de siècle intellectuals such as Mallarmé or Huysmans, the soft veiling effect and the muting of the painting's more aggressive, rasping qualities may have added to its attractions. And Whistler was not one to be displeased by comparisons of his work with the Old Masters — even if in the long run it might prove less of a compliment than it appeared at the time.

★

Despite its early 'maturing,' the portrait must still have stood out like an alien object when it was hung in the Luxembourg Museum in 1891. Its minimum of impastoed paint and sensual brushwork must have contrasted starkly with the French pictures around it, such as the work by Gleyre, the artist whose studio Whistler had spasmodically attended as a student. Compared with them, Whistler's surface must have

appeared flat, stern, and, in a painterly sense, 'undercooked'. The contrast with more recent French painting would have been stronger still: Impressionism was in full flood, darks no longer in fashion, and black had been wiped off the palette since 1870 when even Manet had given up using it.

Over a period of time pictures, like people, tend to become acclimatized to the country they are in. It is a simple and demonstrable fact that restoration styles vary significantly from country to country. National aesthetic prejudices, reflected in conservation styles, subtly change the appearance of works of art over time. As paintings move from one country to another, nurture gradually affects nature.

Examples are legion. Works by the French painter Millet which were brought by enlightened Americans at the end of the nineteenth century and are now in American museums look quite different from those that remained in France. Sadly, radical cleaning has often flattened and impoverished their carefully built up surfaces. For similar reasons, a painting by Titian restored in Britain is likely to have a quite different appearance from one restored in Italy, as 'messy' or ambiguous areas of colour in the original are tidied away in conformity with Anglo-Saxon tastes. The 'original' is thus unconsciously altered to reflect perennial differences of national temperament and aesthetic sensibility. (As the restoration profession swells, and the habit of holding exhibitions of a single artist's work culled from international collections grows, the effects of different conservation styles are becoming more visible.)

The French had appreciated Whistler's painting

enough to install it in their national museum. Yet it would be expecting too much to suppose that the portrait could remain in France for long without being influenced by its new environment. Before it reached the Louvre in 1926, it continued to accrete a 'Continental' skin. The first stage was when a layer of shellac was applied to the picture, probably toward the end of the century. Shellac — a hard and shiny varnish made of Sudanese resin — was widely used to give a gloss to furniture. Like synthetic resin in America or England today, it was the fashionable varnish at the time and was applied to many French pictures. Apart from being much more difficult to remove than the usual mastic or dammar varnish, shellac would have given the 'Mother' a hard and brittle sheen, bringing it more into line with other pictures in the gallery at the time.

Meanwhile, the repercussions of Whistler's hazardous technique would have continued to be visible. In 1919 Jacques-Emile Blanche wrote that the portrait was in a sorry state, but that no one dared restore it. Probably around this time tests seem to have been made by restorers to see if anything could be done to retrieve the surface of the sinking painting. They must have decided that the risks of any radical treatment outweighed the advantages. Whatever their reasons, little appears to have been done, and the openings made in the varnish to see through into the picture were covered up again.[7]

By this time even such a routine operation as the removal of decayed and disfiguring varnish would have been difficult. Normally in quite recent paintings there is a relatively clear line of separation between paint and varnish, so that the latter can be taken off without

damage to the former. In the 'Mother' the paint had become inextricably entangled with successive layers of yellowing varnish. To the wandering eye of the casual museum visitor the intrusively original American portrait must have become increasingly indistinguishable from its surroundings.

Like Whistler before them, French restorers of the period were probably forced into the expedient of 'oiling out' in an attempt to revive his surface. To judge by the condition of the painting a few years ago, some of the early treatment probably took the form of the application of 'museum juice' — a glutinous mixture of old brown varnish mixed with new. Just as seventeenth- and eighteenth-century painters used the juice from the pots in which they dipped their brushes to tone in an obtrusive place in the picture, so restorers used darkened varnish accumulated from many sources to glaze over a cleaning test or to screen a damaged or worn patch. In the nineteenth century it even became normal practice to give the entire painting a golden museum glow, suggestive of maturity and antiquity.

It is therefore quite conceivable that some of the 'juice' brushed onto the 'Mother' might have come from far older pictures. (The thought of 'Arrangement in Grey and Black' being touched up with decayed varnish removed from a Canaletto or a Velázquez would have had Whistler in ecstasy.) Once again, the cumulative effect of such treatments, together with the painting's structural inadequacies, would have been to neutralize its New World characteristics, transforming its once-stark and subtle surface into a big brown soup.

Whistler and His Mother

★

Records suggest that from the time the 'Mother' entered the Louvre, no attempt was made at a comprehensive restoration. By 1986 it was in a somewhat depressed state. It says much for the strength of Whistler's original conception that despite its brown shroud, the blanched patches and the lumps of clotted varnish in the once-transparent skirt, and its sunken appearance, the painting still looked imposing. (The same is not true of some other Whistler paintings, which are confined to museum store rooms, unsuitable for either restoration or display.) The cleaning philosophy of the Louvre is to interfere with pictures to the minimum possible extent consistent with the conservation of the paint and canvas and respect for the artist's intentions. The decision to proceed to a more comprehensive restoration of the 'Mother' was taken after careful consideration by conservators and art historians and tests on the picture itself.

It was recognized from the start that however seductive the promise of seeing the portrait as the artist painted it, there could be no question of seeking to get back to the original in any fundamental sense. The darks and blacks — the key to the whole work — not only had been absorbed by the effects of time and successive coats of varnish, but were simply no longer recoverable in any meaningful sense, having sunk irretrievably within the canvas itself. The only means of re-creating them would have been to cover large areas with overpaint — an impracticable and unethical procedure. Instead the aim was to rescue as much as could be rescued and to maintain a balanced compromise across the rest of the

painting; in other words to find a scale of values that would be true to the original in relative, muted terms.

The first step was to open a series of 'windows' to look into the structure of the picture, analyze the paint, and see how much could be safely done. These small openings were not made at random but deliberately targeted in the lighter portions of the picture, such as the background above the mother's head. Such areas are more resistant to the mild solvent used (a diluted alcohol) than the darker parts since they contain white lead paint.

Even this preliminary stage of making small openings in the varnish onto the surface of the portrait was slow and anxious work. A scalpel had to be used to remove the most obstinate discoloured varnish from the grain of the canvas; excessive use of chemicals might have softened and damaged the paint. Gradually, over several days, as solvents and scalpel removed layer after layer of accretions, the exquisitely refined tonal play on Whistler's scumbled grey wall came into view. The sight caused a small leap of hope. Despite all the forensic evidence, what if it were possible to recover the blacks in the same way? Since I had read so much about the painting, the possibility of securing a glimpse of it as Whistler's contemporaries had seen it was an enticing prospect.

A few days' work on the blacks dissolved the illusion. On the darks, even making an aperture proved impossible. There was no distinct paint layer at all. To the naked eye it was like opening a window onto a murky impenetrable night. Analysis of the varnishes in the laboratory confirmed the worst. Any solvent capable of

dissolving the stubborn layers of varnish, including shellac, which had turned the skirt from limpid black into a greeny-grey colour, would dissolve the paint as well, so intricately interlinked had the various layers become.

The almost complete intractability of the darks raised the central, strategic decision that would condition the whole operation. If the light areas were largely recoverable and the darks not, the obvious solution might seem to do as much as possible in each: to clean the grey background and the whites to the maximum extent while doing as much as was safe to the blacks — the skirt and the curtain. Something would be better than nothing; from the viewpoint of the present-day observer, revealing the virtuoso flourishes of the white that composed the bonnet and handkerchief and giving a clearer impression of the magnificent, Courbet-like wall, would be intensely satisfying. At the very least it would provide some glimmering of what part of the picture had been like.

But the cost of such an approach would be immense: the ultimate disintegration of what Whistler valued most and what formed the centre of his aesthetic creed — harmony. In technical terms the cleaning of the walls, the head and the hands would have been a relatively simple matter. Yet it would have had little to do with 'restoration' in the best sense of the term. However closely these colours were brought back to their original state, it would not have restored their true value in the painting, which mattered far more than the exact colours themselves. The value of one colour cannot be computed in isolation from others. As the very title of

the portrait shows, the greys, whites and blacks were an 'arrangement' with an intricate inter-relationship. The 'true' colours of the picture were neither the lights nor the darks, but the harmonics between the two. You cannot successfully readjust one note in a symphony, however historically accurate, if the others are several tones flat.

The problem of how far to go in the cleaning of old paintings is by no means unique to the 'Mother'. The cleaning process, wrongly seen as the most straightforward aspect of the operation, is central to the debate over contemporary restoration styles. To realize that there is indeed a problem, it is sufficient to go to almost any major gallery in Britain or the United States today (fortunately, there are exceptions), visit the Italian rooms, and ask oneself why the sky in the Italian Renaissance landscapes importunes the eye so insistently. Italian skies are intensely blue, but the Italian craftsman who painted them never intended them to shout at the viewer as raucously as some do today.

The reason they do is twofold. First, the blue the Italians often used in the Renaissance was ground lapis lazuli — a pigment as hard and pure as the stone itself and one that retains its power far longer than others. Browns and blacks tend to sink and fade with time. More important, some greens (derived from copper), the crucial link between cold and warm colours, suffered a complete chemical change into a dark reddish brown, warmer than almost everything else in the painting, undermining the careful aesthetic equilibrium between the foreground and background. The blues had been tied into this balance by greens on one side and pinks on the

other: the grassy fronds attaching the Madonna's robe to the ground, or the sky laced with green leaves and delicate strands of sunlit pink near the horizon drawing it into the brown foreground, or the warm shadows under clouds thinly glazed across the blue. If such glazes are also lost or damaged in an attempt to 'restore' the blue, and the greens subside into brown, then it is not surprising that the sky leaps out of the dislocated balance.

Attuned to bright colours by the advent of electricity, the advertiser's aggression, the modern concoctions of the paint manufacturing industry and by the impatient twentieth-century ethos itself, the public might applaud the startling result; to them it may seem the result of the magical ministrations of the conservator. But the public would be wrong, not necessarily through insensitivity but because it has been encouraged to defer to technology rather than to believe its eyes.

In the 'Mother,' an immediately pleasing effect could easily have been secured by lifting the brown veil which obscured the starched lacy bonnet, the handkerchief, or the light-grey background. A soft wash with a quite mild solvent would have dissolved most of the old varnish, and a scalpel would have dealt with the crevices. Yet it would have been a dangerous first move: for the shouting lapis lazuli blues in the skies of the over-restored early Italian artists, substitute the lead-based whites in Whistler's portrait. Accurate reconstruction of this or that detail of a picture does not add up to a larger truth. Brought back to its former, pristine state, the bonnet would shine forth from the surrounding penumbra like a lighthouse. Unveiling the lights while leaving the

blacks opaque would overaccentuate the carefully subdued balance of the picture, causing Anna Whistler to leap from the frame in harsh silhouette, like a cutout.

In Whistler's original painting there was already a carefully controlled suggestion of this, a faint echo, perhaps, of the American primitive portraits the artist must have seen in his youth. But with his concern for harmonious understatement, Whistler would not have wished to overdo the effect. We know from some of his own remarks that he was sensitive to the risk of his mother's becoming too detached from her surroundings. When people complained that the portrait was flat and the colour meagre, Whistler replied that he knew it would be put in a frame (as always of his own design) that would set it back farther, but he was unrepentant: 'I did not wish to represent my dear mother as jumping upon the beholder'.[8] In a rare criticism of one of his works — his portrait of Maud Franklin, 'Arrangement in White and Black, No 1' — as un-Whistlerian in this respect the Pennells wrote that 'she seems to be walking out of the depths of the background, breaking through the envelope of atmosphere.' Whistler also used to frame his paintings under glass on his easel and study them at length after bouts of obsessive work. There is no doubt that he saw glass not just as an additional veil but as a distracting element, preventing the subject from starting from its frame.

Cleaning some areas of the picture more than others would upset another crucial balance: between 'warm' and 'cool' colours, on which the emotional mood of the painting rests. In the picture hints of warmth were sparsely distributed. Nonetheless, they are there: in the

rose-coloured flesh of the face, the yellowish matting, and the small hints of yellow in the curtain and footstool. The beautifully contrived modulations between puritanical simplicity and sternness and flesh-and-blood affections depend directly on such details. (Whistler himself once referred to his mother as 'my little touch of colour.')[9]

What all this meant in practice was that the limits of what could safely be done were severe. For anyone aspiring to revive the painting to its initial splendour, the conclusion was as clear as it was frustrating. There could be no question of miraculous transformations to intrigue art historians with the new insights they might suggest or to startle the public with sharper contrasts between background and foreground, no sudden excavations of a lost past or unearthing of buried treasures. Sacrificing what remained of the first spirit of Whistler's portrait to gratify our inquisitiveness about its components would be like pulling a flower to pieces to see how it 'works'.

There would have to be a compromise; restoration would have to be partial, not complete, though given the deep brown of its uncleaned state even removing several superficial layers of varnish would be a transformation. Advancing too far in the cleaning of one area would inevitably be at the expense of another. The risk of wrenching the picture from what remained of its 'atmospheric envelope' was too great. As it stood the envelope was faded and brown, and the 'message' inside no longer easy to decipher. But by working within the limits of the painting's internal harmony, and without dismembering the surface of the picture the better to read it, it was possible to do something to make 'the

message' more legible, and to remind us more clearly of what it had once been.

★

The first step was to remove the superficial layer of dust, dirt, and grime with a few carefully measured drops of ammonia heavily diluted with water (a fraction of a drop too much, and the ammonia would eat through the varnish.) Beneath were the many layers of varnish and shellac and the impenetrable barrier of the blacks. Since it was clear from the tests that any attempt to disentangle the early layers of varnish from the paint was foredoomed, all that could be done on the skirt and other darks was to skim the surface lightly and then attempt to regenerate the deeper, blanched varnish.

Even this proved unexpectedly complicated. The surface of the picture was highly uneven from previous treatments; in texture as well as colour the canvas — once flat and sparsely painted — was now more like tortoiseshell. Indiscriminately reviving the old varnish across the whole surface of the blacks would not have allowed the light to penetrate, so bringing to life the luminous darks; it would only have shown up more clearly the mottled greeny brown or grey patches that the ageing varnish had to some extent mercifully disguised. Here again, inconsistency and compromise were necessary; to preserve some minimal unity of tone, where it was possible some areas of the skirt and curtains had to be revived more than others.

The process was painstaking and time-consuming. Crawling centimetre by centimetre over that great dark

expanse was like negotiating a jungle at nightfall, when everything is a shadowy and sinister mixture of green, brown and black, glowering before your eyes. Almost every avenue turned out to be an impasse. Every square centimetre of paint had developed differently, each one obscured by its own uniquely impassable undergrowth.

In places that had been partially cleared in the past it was necessary to tread especially lightly, for fear of plunging through the softer 'museum juice' into what remained of the original paint. In areas where the paint had become most hopelessly confused with the varnish, it was hard to set foot at all. In others, where the surface was relatively firm, the temptation to go too quickly had to be resisted, to avoid uneven progress and an even more patchy appearance at the end of it all.

When sudden clearings appeared, they tended to be rimmed with recalcitrant clots of shellac and occasionally a worn surrounding area. (Cleaning tests always run the risk of putting extra stress on the paint at their edges, involving a double dose of solvents along the hardened rim; however necessary they may be for demonstration and a decision they should be few, brief, and preferably not square.) Relying on patient advances by scalpel in an attempt physically to divide the pure from the impure was equally impossible; that would have left crystallized, whitened shellac. Even a biological treatment by enzymes would only have left stranded, powdered, emigrant pigment that early treatment when the paint was still soft had shifted to foreign soil. Genetic engineering has the potential to disentangle complex mixtures, but it is hard to see in this case how errant pigment could be reconstituted, for example from deep

within the canvas. Even scientific advances in non-intrusive fields, such as polarizing light to see further through obscuring layers, would come up against the same problems.

★

I worked with the painting on an easel. Laying it flat, as is sometimes done in today's restoration laboratories, one would have risked becoming confused by detail, losing sight of the whole. Changes to one part, however minute, affect the look of another. Standing back to review progress before reimmersing myself in the jungle of the darks, in the constant knowledge that the ideal was unattainable and that there would never be any clear way out, was not always a heartening process. The only reliable map dated from 1872: a photograph of the picture a year after it had been completed. A public-spirited collector of Whistler's prints, Mr. Avery, left it to the New York Public Library. The photograph was of good quality, though it is always a mistake to place too much reliance on photography in restoration, considering the inherent limitations of the camera. In Avery's photograph certain documentary details are clear, but almost everything that makes a painting a sensual experience is overlooked by the dispassionate gel.

Subject apart, there were major differences, which showed up even in a nineteenth-century black-and-white photograph. The details of the old lady's profile were far more striking at the time the photograph was taken, and the ambivalence between rigour and

tenderness must have been much more evident. The play of blacks and whites in the figure were also far crisper. And what Greaves had said about the extraordinary thinness of the paint was right: in the photograph the thinness of the dress was such that you could see the line of the black dado clearly through it, and the raw grain of the canvas showed through very markedly both in the skirt and in the lighter background. The pattern of the curtain was a good deal sharper, too: in the picture I was working on in the Louvre nobody could have heard in its icily restrained colours, as Beardsley had, 'tinkling, silver notes.'[10] The delicate lines on the footstool had gone, as had much of the detail of the matting. Even the butterfly was distinctly battered and wan.

The struggle with the skirt and the dress went on for months. As I crossed the river from the Louvre to the Left Bank in the evening after each day's work, shades of black swam before my eyes. I remember stopping to rest them on the river and on the magnificent vista along the Seine and put the picture out of mind. But as I walked on, everything conspired to remind me of some episode of Whistler's stay in Paris.

The footbridge I used to cross the river was the one from which he had dropped a copy of a picture in the Louvre as a student when it had failed to sell (maybe he had painted it too thinly for French taste). When I reached the Left Bank one of the first things confronting me was an artist's materials shop advertising 'Whistler Brushes.' And by a strange coincidence, the house of the friend where I sometimes dined while working on the 'Mother' was a stone's throw from the charming little three-storey house at the end of an alleyway in the Rue

du Bac that Whistler shared with his wife. Like my friend's house, it overlooked the garden of the convent, where the singing of the nuns had enchanted Whistler during his later years, a reflection of his fascination with tradition perhaps, rather than an echo of his religious upbringing at the hands of his mother.

<div align="center">★</div>

The lighter parts of the picture posed less of a problem but were almost as time-consuming as the blacks. To maintain a balance, it was necessary to leave a carefully calibrated, if scarcely perceptible layer of varnish over the paint. Given the roughness of the grain of the canvas, this involved a difficult balancing act: using a sable brush to soften the varnish, then working through magnifying spectacles to disentangle the caked varnish from crevices with a scalpel, while leaving some on the ridges to prevent an impression of grids of brown lines. The face, hands and above all the bonnet and handkerchief were only partially cleaned up, too, to prevent them from starting from the picture. Evening up the two disparate types of surface — the opaque darks and more translucent lights — was the next task. Here, too, there were limits to what could be achieved; in a raking light, the contrast will always be there and will be the exact reverse of Whistler's original intention: where the blacks were thinner they are now denser than the lights and vice versa. Degas's statement that 'in painting you must give the idea of the true by means of the false'[11] could define the restorer's plight.

Like patients, pictures need time to absorb their

treatment. The next step was to leave the 'Mother' on her own for a while to allow any residue of solvents to evaporate. Before the retouching, a thin coat of varnish (natural resin, which always remains easily soluble, in preference to the synthetic variety, which turns grey in time, rather than the yellow that at least the artist expected) was applied. It was brushed rather than sprayed on for surer protection, as well as to remain as close as possible to the artist's surface. Varnishing involves an almost infinite number of variables with subtly distinct effects. The aim in varnishing the 'Mother' was to bring out some of the richness of the blacks, without making the irregularities too visible, and to attempt to play down the discrepancy between the thicker and thinner tones. Varnish settles in not altogether predictable ways, and much of the look of a painting, and hence its meaning, hangs on the way that varnish brings out that meaning, or distorts it. This is why varnishing day has always been a tense moment for artists, as it is for the restorer.

Next came the retouching. This was done on top of the varnish, with a mixture of diluted varnish and pigment. Different media, as well as pigments, change at different rates, and however close a match a colour may seem today, in a few decades' time the differences may show; this is one reason why the artist's own materials are not necessarily used. Sandwiching today's retouching between layers of varnish and using easily soluble varnish-based paint will make them easier to remove again when the time comes.

Fortunately only a few areas needed retouching at all. The only old filling that needed attention was on a line between the hand and the head, where there had once

been a scrape or tear, and in exceptionally irregular patches in the skirt. As is commonly the case, there was a very worn area round the signature. Signatures tend to be rubbed by generations in an effort to make them more visible. In the 'Mother', however, a far larger area showed signs of distress, almost as though Whistler had erased one butterfly to substitute another — now almost formless. His uncertainty may have been due to the fact that these were the fairly early days of his butterfly signature, which he had probably drawn from decorative Japanese motifs.

His butterflies were to evolve considerably over the last half of his life, becoming increasingly crisp and witty, sometimes acquiring venomous-looking tails like scorpions, sometimes tilted and wickedly frivolous. For him the position, size and colour of his personal symbol were an important part of the painting. One can see why he may have hesitated before deciding precisely what sort of butterfly was appropriate for his 'Mother'; it was she who had been the first to use it as a name for him.

CONCLUSION

'A thin but strong presence: a mist, a cloud, a climate ...'
Irving Howe's definition of the national culture
in *The American Newness*[1]

One part of Whistler — his ultimate seriousness and intensity of purpose — was of his age. Another harked back to eighteenth-century nonchalance, dandyism and stylistic refinement, and forward to fin de siècle aestheticism and twentieth-century self-consciousness and exhibitionism. The 'Mother' was at the fulcrum, a fine and rare balance between enduring nobility of content and fragile evanescence of form.

It was natural that such an artist should inspire contradictory assessments. At different stages of his life Walter Sickert took both sides of the argument.

Reflecting on Whistler's art nine years after his death, the former enthusiast and acolyte came to some devastating conclusions. Only a 'shadow of a shade' of Whistler was left. Worse, except for 'a certain vivid and superficial appreciation' of Japan and Velázquez, there had been nothing very much there in the first place. Whistler's whole work had been 'a planet without roots and bearing no fruit'.

Rootless Whistler's art almost certainly was; fruitless it was not. Sometimes — as in the 'Nocturnes' — like some exotic plant Whistler seemed almost to dispense with roots, drawing stylistic nourishment from the surrounding air, while in the 'Mother,' impelled by the sheer seriousness of his subject, he rose above himself, capturing the essence of his own country in a way that only a deracinated cosmopolitan could.

Before working on the 'Mother,' I had restored Degas's 'La Famille Bellelli' a year or two earlier, also for the opening of the new Musée d'Orsay in Paris. Though each makes a powerful psychological impression, in many senses Degas's portrait is the very antithesis of Whistler's. The Bellelli family (relatives Degas had stayed with in Italy) is a nexus of emotional tensions between man and wife, parents and pinafored children. Figures and forms overlap in an enclosed room, the family hierarchy is oppressively evident, and the picture is dense with an almost explosive intensity.

The contrast between the claustrophobic impact in Degas and the ethereal spaciousness of the 'Mother' is forceful. Nor is it an atypical example. In American portrait painting, figures frequently seem in every sense abstracted. The feeling is of people lifted from some

more natural habitat and put down in a void, sometimes seeming blank or dazed by their loneliness, abstract in the sense of being marked out from their surroundings more by their contours than by a rounded humanity.

More than any other picture of its time, the 'Mother' contained the seeds of a specifically American approach to painting, of what Americanness could be in art. In the simplest terms of pictoral content there is an evident continuity between the portrait and later, unmistakably American painters such as Grant Wood, Andrew Wyeth, Edward Hopper, or even Andy Warhol. Wood's gaunt 'American Gothic' couple in front of their church, Wyeth's 'Christina' in a field, Hopper's man in a late-night bar, Warhol's Marilyn Monroe multiples, or Anna Whistler stranded alone against the wall of her son's studio — all are 'thin but strong presences,' marooned in space. When we look back to the 'Mother' the feeling of isolation these images convey seems to grow chronologically more intense, more tragic.

For all her loneliness, Anna Whistler has her steadfast faith. Grant Wood's couple retain the same consolation; they also have work to do. Hopper's dejected night-owls have no creed, company or purpose. Suffocated in an emotional vacuum behind the rictus of an endlessly replicated fame, Marilyn kills herself.

★

To perspicacious American eyes, the picture's link with the present day is clear. Near the end of *Underworld*, Don DeLillo captures the portrait brilliantly: '…a figure lifted out of her time into the abstract arrangements of

the twentieth century, long before she was ready... caught in the midst of a memory trance, a strong and elegiac presence despite the painter's, the son's, doctrinal priorities.' There are other ways in which Whistler increasingly appears as a harbinger of modernism. His technical insouciance has been sufficiently stressed; it is an evocative thought that works by some of the greatest names of twentieth-century American art may soon begin to accumulate beside un-restorable Whistlers in the basements of America's museums.

Then there is Whistler's salesmanship. 'How much,' Walter Sickert exclaimed, 'these pictures required the defence of the brilliant and sympathetic personality that produced them.'[2] It was a characteristically penetrating remark. Despite his agonised search for perfection alone in his studio, Whistler can also now be seen as the prototype of a new sort of painter: the artist as personality and performer, rather than craftsman and creator, whose work will not always outlive its maker. Stylistically, the aim was to dazzle and distract. It was the 'idea' of art that mattered, the way you talked about it, the way you dressed, the way you played the part. Once the pose was perfected, the aphorisms on art rendered impenetrable, the clothes right, the publicity arranged, the image projected, masterpieces would materialize of themselves.

The artist as showman has had a long run. As we are seeing in the Young British Artist phenomenon, Andy Warhol was not the terminal point in the series. At first sight, fewer artists would seem to have fewer things in common than Warhol and Whistler. Yet if we step back from our own time, comparison between them becomes revealing. Starting from completely different directions

— Whistler from 'high' and Warhol from commercial art — they converge at important points. Each aimed at instant 'creativity' with minimum reference to the past, Whistler seeking a shortcut to the production of great works 'in one wet,' Warhol finding them lying on the shelves of shops or in the streets. Each produced disposable work — Whistler sometimes inadvertently, Warhol deliberately ('My pictures won't last. I used cheap paint'). And both in their own way were dandies of art: appearance, presentation and persona mattered almost as much as the painting.

It was Whistler, after all, who was the first to turn exhibitions of his work into events themselves — into 'happenings', in fact. Except for the 'Mother' and a few other magical pieces, his claim to immortality could almost be said to rest as much on his wit as on his work. With Warhol, the wit (or tediously elaborated irony, depending on taste) is contained in the work. Painting itself has become a more or less sophisticated joke. Neither in Warhol's works nor in his verbal fatuities does the artist aspire to an afterlife. Limp-winged and artlessly camouflaged in the colours of its surroundings, the butterfly holds close to the ground.

Seen in this perspective, the high-flown obscurities in Whistler's 'Ten O'Clock Lecture' become a fore-echo of solemnly opaque art-talk about abstract painting. There is a logic here. Once 'content' was taboo, technique disdained, and 'art' itself supreme, anything was acceptable. It was only a few steps from notions of painting too rarefied to substantiate, to art taking to the streets and everybody's becoming famous for fifteen minutes. Today 'Art is upon the town' indeed. In a sense

the fate of the 'Mother' in America is a nice illustration of the transition. The work seen by Whistler and continental aesthetes as an ultrarefined expression of celestial harmonies struck a single homely chord among the American public, and became the most banalized image in the history of American art.

Such a view of Whistler would, of course, be unfair and unhistorical. He simply happened to arrive on the scene from nowhere at what can now be seen as the beginning of a turning point in the fortunes of painting. It is in the nature of his position in the history of painting that definitive judgements should be difficult. Reincarnated today, would he loudly lament the demise of tonal painting — or press to the forefront of whatever was happening in London and New York?

*

Beyond all theories, analysis and speculation lies the portrait itself, and its impact upon the eye. The harshest surroundings in which a picture can be judged are when it is undergoing repair. The restoration studio is a highly democratic place, where pictures of all qualities and conditions mix. Naked without their frames, deprived of their hierarchical status in their galleries, reduced to a frail assemblage of paint and canvas, wood and tacks, paintings stand or fall by their intrinsic worth.

At one point during the restoration of the 'Mother' she found herself for a time next to Ingres's great portrait of Napoleon — a massive, full-faced figure in scarlet and gold. The pinched little widow from Wilmington, North Carolina, held up remarkably well in this august

company. Somehow she retained her own commanding presence. If the emperor's orb and sceptre had been miraculously transferred to her hands, they would not have looked out of place. If republics had queens, they would look something like Whistler's Mother.

NOTES AND SOURCES

Epigram on title page from Alexander Pushkin, *Mozart and Salieri*, 1831, translation by Anthony Wood (Angel Books, London and Dufour Editions, Chester Springs, 1982).

1. THE PORTRAIT AS ENIGMA

[1] Jacques-Emile Blanche, *Essais et Portraits* (Paris: Dorbon-Aîné 1912). This essay was first written in June 1905 for *Renaissance Latine* and later further elaborated for *Propos de Peintres de David a Degas* (Paris: Emile-Paul 1919). An English translation appears in *Portraits of a Lifetime — The Late Victorian Era* (London: Dent 1937).

[2] *Whistler's Mother's Cookbook*, ed. Margaret Macdonald (London: Paul Elek 1979).

[3] Jacques-Emile Blanche, *Essais et Portraits* (Paris: Dorbon-Aîné 1912; English).

[4] Theophile Gautier, *Mademoiselle de Maupin* (Paris: Renduel 1835; English edition, London: Penguin 1981).

[5] Joris Karl Huysmans, *A Rebours* (Paris: 1884; English edition, *Against Nature*, London: Penguin 1959).

[6] Joris Karl Huysmans, *Certains* (Paris: Unions Générales d'Editions 1889).

[7] Mortimer Menpes, *Whistler as I Knew Him* (London: Adam & Charles Black 1904).

[8] 'Je sens que je suis devenu plus mysterieux et plus enveloppé de mist (sic) que tous les mystères jusqu'á present entrepris.' Philippe Jullian, *Robert de Montesquiou, Un Prince. 1900.* (Paris: Perrin, 1965).

[9] Florida Art Education Association journal, 1987.

[9] Theodore Reff, *Degas, the Artist's Mind* (Cambridge, Mass.: Harvard University 1987; originally London: Thames & Hudson 1976; New York: Harper Row 1976).

2. PRELUDE TO A MASTERPIECE.

[1] James McNeill Whistler, *The Gentle Art of Making Enemies* (London and New York: Heinemann 1890, enlarged 1892).

[2] J. and E. Pennell, *Life of James McNeill Whistler* (Philadelphia: Heinemann, 1908) later expanded and published as *The Whistler Journal* (Philadelphia: J.B. Lipincott 1921).

[3] Ibid, from the *Daily Telegraph*, 1860.

[4] Emile Zola, *L'Oeuvre* (Paris: 1886), in *Oeuvres Completes*, ed. Henri Mitterand (Paris, 1966-69).

5. J. and E. Pennell, *Life of James McNeill Whistler.*

6. Walt Whitman, *Leaves of Grass* (1855, deathbed edition), Philadelphia, David McKay, 1891).

7. J. and E. Pennell, *Life of James McNeill Whistler.*

8. Walter Richard Sickert, *A Free House*, ed. Osbert Sitwell (London: Macmillan, 1947).

9. Camille Pissarro, Letters, eds. John Rewald and Lucien Pissarro (London: Routledge and Kegan Paul, 1943).

10. J. and E. Pennell, *Life of James McNeill Whistler.*

11. Walter Richard Sickert, *A Free House.*

12. Henry James, originally published in *Roman Nation* (June 6, 1878), included in *The Painter's Eye* (Madison: University of Wisconsin Press: 1989).

13. Anna Whistler's letters, Glasgow University.

3. THE MOMENT OF CREATION

1. Anna Whistler to Kate Palmer, 3 November 1871. Nigel Thorp Selected Letters and Writings, Carcanet, 1994.

2. J. and E. Pennell, *The Whistler Journal* (Philadelphia: J.B. Lipincott 1921).

3. J. and E. Pennell, *Life of James McNeill Whistler.*

4. Ibid.

5. James McNeill Whistler, *The Gentle Art of Making Enemies* .

6. Whistler to Fantin-Latour (undated), Pennell Collection, Library of Congress, Washington DC.

7. J. and E. Pennell, *Life of James McNeill Whistler.*

8. Anna Whistler to Kate Palmer, 3 November 1871. Selected Letters and Writings, Carcanet, 1994.

9. Jacques-Emile Blanche, *Essais et Portraits* (Paris: Dorbon-Aîné 1912; English Edition, *Portraits of a Lifetime, the Late Victorian Era*, London: Dent 1937).

10. Walter Richard Sickert, *A Free House.*

11. Anna Whistler to Kate Palmer, 3 November 1971. Selected Letters and Writings, Carcanet, 1994.

12. J. and E. Pennell, *Life of James McNeill Whistler.*

13. James McNeill Whistler, 'Ten O'Clock Lecture', in James McNeill Whistler, *The Gentle Art of Making Enemies* (London and New York: Heinemann 1890, enlarged 1892).

14. Mortimer Menpes, *Whistler as I Knew Him.*

15. Jacques-Emile Blanche, *Essais et Portraits.*

16. J. and E. Pennell, *Life of James McNeill Whistler.*

17. Ibid.

18. Aubrey Beardsley, quoted by J. and E. Pennell, *Life of James McNeill Whistler.*

19. Frank Harris, *Contemporary Portraits* (London: Methuen 1915).

20. J. and E. Pennell, *Life of James McNeill Whistler.*

21. T.R. Way, *Memories of James McNeill Whistler* (London and New York: John Lane, The Bodley Head: 1912.

22. Whistler: 'Ten O'Clock Lecture', in James McNeill Whistler, *The Gentle Art of Making Enemies.*

23. J. and E. Pennell, *Life of James McNeill Whistler.*

24. Ibid.

25. Comte Robert de Montesquiou, *Memoires*, (Paris: Emile-Paul Frères 1923)

26. Anna Whistler to Kate Palmer, 3 November, 1871. Selected Letters and Writings, Carcanet, 1994.

27. Joris Karl Huysmans, *Certains* (Paris: Unions Générales d'Editions 1889).

28. Walter Richard Sickert, *A Free House.*

29. J. and E. Pennell, *Life of James McNeill Whistler.*

30. Baudelaire, Curiosités Esthétiques, Editions Garnier, Paris, 1962.

31. Whistler to Fantin-Latour, 4 January 1864, published by Léonce Benedite in 'Artistes Contemporains, Whistler,' *Gazette des Beaux Arts*, vols. XXXIII and XXXIV, 1905.

32. Anna Whistler to Kate Palmer,

Notes

3 November 1871. Selected Letters and Writings, Carcanet, 1994.
33. Philippe Jullian, *Robert de Montesquiou, Un Prince. 1900.* (Paris: Perrin 1965).

4. HIS MOTHER AND OTHER WOMEN

1. J. and E. Pennell, *Life of James McNeill Whistler.*
2. Charles Dickens, *American Notes* (1842, London: Penguin, 1972).
3. F.W. Coburn, *Whistler and His Birthplace*, eds Edith Williams Burger and Liana de Girolami Cheney (Tewkesbury, Mass: P and J Printing 1988).
4. J. and E. Pennell, *Life of James McNeill Whistler.*
5. Anna Whistler's Russian diary, Pennell Collection, Library of Congress, Washington DC.
6. Whistler to Fantin-Latour, 13 September 1868.
7. J. and E. Pennell, *Life of James McNeill Whistler.*
8. Anna Whistler's Russian diary, Pennell Collection, Library of Congress, Washington DC.
9. Anna Whistler to her son, 20 January 1849, Glasgow University Library.
10. Ibid, 11 December, 1848.
11. Ibid, 15 February 1849
12. J. and E. Pennell, *Life of James McNeill Whistler.*
13. Ibid.
14. Ibid.
15. Anna Whistler to her son, 30 April 1855, Glasgow University Library.
16. Ibid, 2 September, 1852.
17. J. and E. Pennell, *Life of James McNeill Whistler.*
18. Ibid.
19. Ibid.
20. Ibid.
21. Ibid.
22. Jules Barbey d'Aurevilly, *Du Dandysme et George Brummell* in *Who's A Dandy?* by George Walden (London, Gibson Square, 2002).

23. J. and E. Pennell, *Life of James McNeill Whistler.*
24. Walter Richard Sickert, *A Free House.*
25. Mortimer Menpes, *Whistler as I Knew Him.*
26. Henri Mürger, *Scènes de la vie de Bohème* (Paris: Gallimard,1845).
27. Whistler, 'Ten O'Clock Lecture', in James McNeill Whistler, *The Gentle Art of Making Enemies.*
28. Ibid.
29. Algernon Charles Swinburne, 'Mr Whistler's Lecture On Art', *Fortnightly Review* (June 1888), in James McNeill Whistler, *The Gentle Art of Making Enemies.*
30. Joris Karl Huysmans, *Certains* (Paris: Unions Generale d'Editions 1889).
31. J. and E. Pennell, *Life of James McNeill Whistler.*
32. Ibid.

5. THE PORTRAIT AS PATRIOTISM.

1. Henry James, Ed. F. O. Matthiessen, 'The Madonna of the Future', *Stories of Writers and Artists* (New York: New Directions 1944).
2. Freer to William Webb. Freer collection, Washington, D.C.
3. Théodore Duret, *Whistler* (Paris: Flourys, 1904).
4. J. and E. Pennell, *Life of James McNeill Whistler.*
5. *The Times* (London), July 18, 1903.
6. Théodore Duret, *Whistler* (Paris: Flourys, 1904).
7. Mortimer Menpes, *Whistler as I Knew Him.*
8. J. and E. Pennell, *Life of James McNeill Whistler.*
9. Jonn Ruskin (1819-1900). His article, which resulted in the libel trial of November 15, 1878, appeared in *Fors Clavigera* of July 1878. The relevant passage reads: 'For Mr Whistler's own sake, no less than for the protection of the purchaser, sir Coutts Lindsay ought not to have admitted works into the gallery in which the ill-educated conceit of the artist so nearly approached the aspect

233

of willful imposture. I have seen, and heard, much of cockney impudence before now, but never expected to hear a coxcomb ask two hundred guineas for flinging a pot of paint in the public's face.'

10. *Daily Telegraph*, 1881.

11. James McNeill Whistler, *The Gentle Art of Making Enemies.*

12. Mortimer Menpes, *Whistler as I Knew Him.*

13. J. and E. Pennell, *Life of James McNeill Whistler.*

14. *Examiner*, June 22, 1872.

15. *Academy*, May 15, 1872.

16. *The Times* (London), May 21, 1872.

17. *Illustrated London News*, June 8, 1872.

18. J. and E. Pennell, *Life of James McNeill Whistler.*

19. Ibid.

20. Ibid.

21. Bernhard Sickert, *Whistler* (London: Duckworth 1908; New York: E.P. Dutton 1908).

22. John Ruskin, *Modern Painters* (London 1843).

23. *Evening News and Post*, May 14, 1889.

24. *Pall Mall Gazette*, 1891.

25. Beatrix Whistler to M.E.G. Kennedy, March 19, 1892 (Library of Congress.)

26. Gustave Courbet quoted in a 1863 letter to Whistler which appears in A. Maclaren Young: *The Painting of James McNeill Whistler* (Newhaven, 1807).

27. Fernand Desnoyers, quoted in Joris Karl Huysmans, *Certains* (Paris: Unions Generale d'Editions 1889).

28. Quoted in J. and E. Pennell, *Life of James McNeill Whistler.*

29. Joris Karl Huysmans, *Certains* (Paris: Unions Générales d'Editions 1889).

30. Comte Robert de Monte-squiou, 'Moth,' in *Poèmes*, vol. 2, *Les Chauves-souris.* (Paris: 1907).

31. Jacques-Emile Blanche, *Essais et Portraits.*

32. Ibid.

33. *L'Univers Illustré*, May 19, 1883.

34. *Union Médicale*, May 24, 1883.

35. *Le Jour*, May 5, 1883.

36. *Gazette des Beaux Arts*, 1883.

37. *Ouinze Jours au Salon*, 1883.

38. *Le Rappel*, May 26, 1883.

39. *Le Figaro*, November 27, 1891.

40. *Chronique des Beaux Arts*, 1891.

41. *Le Gaulois*, November 30, 1891.

42. Louis Gillet, *An American Painter, Whistler* (Paris: Bibliotèque Universelle, 1907).

43. F.W. Coburn, *Whistler and His Birthplace.*

44. Pennell, *Life of James McNeill Whistler.*

45. Henry James, review of the Grosvenor Gallery Exhibition. The *Nation*, May 23, 1878.

46. Henry James, 'London Pictures'. The *Atlantic Monthly*: August,1882.

47. Henry James, review of the Grafton Galleries Exhibition. *Harper's Weekly*:, June 26, 1897.

48. Henry James, 'On Art Criticism and Whistler'. The *Nation*, February 13, 1879.

49. Henry James, 'London Pictures'. The *Atlantic Monthly*: August,1882.

50. J. and E. Pennell, *Life of James McNeill Whistler.*

51. Ibid.

52. Ibid.

53. G.W.S., *New York Times*, December 30, 1891.

54. *The Art Interchange*, September, 1895.

55. Customs form, March 1, 1903.

56. *New York Times*, July 18, 1903.

57. *New York Times*, July 21, 1903.

58. *New York Times*, August 25, 1903.

59. *Boston Evening Transcript*, July 18, 1903.

60. Ibid.

61. F.W. Coburn, *Whistler and His Birthplace*, eds Edith Williams Burger and Liana de Girolami Cheney

(Tewkesbury, Mass: P and J Printing 1988).

62. *Art News*, October 15, 1932.

63. *Art Digest*, February 15, 1933.

64. *Boston Evening Transcript*, May 24, 1933.

65. *Art News*, October 21, 1932.

66. *Art Digest*, May 15, 1934.

67. Ibid.

68. Ibid.

69. J. and E. Pennell, *Life of James McNeill Whistler.*

70. Charles H. Caffin, *Story of American Painting* (New York: Frederick A. Stokes).

71. Ibid.

72. Elbert Hubbard, *Little Journeys to the Homes of Eminent Artists*, (New York: Roycrofters 1902).

73. Allen S. Weller, 'Expatriates' Return', *Art Digest*, January 15, 1954.

74. *Art Digest*, May 15, 1933.

75. Richard Bober, 'Stories My Mother Never Told Me', in *Twentieth Annual of American Illustration* (New York, Hastings House).

6. THE 'MOTHER'S ROAD TO FRANCE

1. Whistler to Booth Pearsall, 1884. Pennell Collection, Library of Congress, Washington DC.

2. Fantin-Latour to Whistler, 1891, Fonds Montesquiou, Bibliotheque Nationale, Paris.

3. Berthe Morisot, quoted in *Histoire de la Grande Amitie de leurs Dernieres Annees* (Mallarmé-Whistler correspondence, ed. Carl Paul Barbier (Paris, Nizet, 1964).

4. Mallarmé to François Coppée, quoted in Charles Mauron, *Mallarmé* (Paris: Seuil, 1964).

5. Whistler to Mallarmé, dated October 1896, in C.P. Barbier ed., *Mallarmé-Whistler, Correspondence, Histoire de la Grande Amitié* (Paris: A.G. Nizet 1964).

6. Whistler, 'Ten O'Clock Lecture', Mallarmé's translation published in *Oeuvres Complètes*, Eds Henri Mondor and G. Jean-Aubrey (Paris: Biblioteque de la Pleiade1945).

7. *Revue Independante* (fortnightly), June 1888.

8. Mallarmé to Whistler, 5 January 1890, in C.P. Barbier ed., *Mallarmé-Whistler, Correspondence, Histoire de la Grande Amitié.*

9. *Le Gaulois*, November 4, 1891, ibid.

10. Mallarmé to Whistler, November 7, 1891, ibid.

11. Whistler to Mallarmé, November 10, 1891, ibid.

12. Mallarmé to Whistler, November 10, 1891, ibid.

13. Whistler to Mallarmé, November 11, 1891, ibid.

14. Mallarmé to Whistler, November 13, 1891, ibid.

15. Whistler to Mallarmé, November 14, 1891, ibid.

16. Mallarmé to Whistler, November 16, 1891, ibid.

17. Théodore Duret to Whistler, November 18 1891, University of Glasgow Library.

18. Léon Bourgeois to Whistler, November 19, 1891 in C.P. Barbier ed., *Mallarmé-Whistler, Correspondence, Histoire de la Grande Amitié.*

19. Whistler to Mallarmé, November 20, 1891, ibid.

20. Mallarmé to Whistler, November 20, 1891, ibid.

21. Whistler to Léon Bourgeois, November 23, 1891, ibid.

22. Mallarmé to Whistler, November 24, 1891, ibid.

23. Whistler to Mallarmé, November 25, 1891, ibid.

24. Léon Bourgeois to Whistler, November 30, 1891, ibid.

25. Whistler to Léon Bourgeois, December 9, 1891, ibid.

26. Mallarmé to Whistler, November 30, 1891, ibid.

27. Mallarmé to Whistler, November 27, 1891, ibid.

28. J. and E. Pennell, *Life of James McNeill Whistler.*

29. Whistler to Beatrix Whistler January 31, 1892.

30. Whistler to Mallarmé, November 20, 1891.

Notes

31. Whistler to Beatrix Whistler, January 31 1892.
32. J. and E. Pennell, *Life of James McNeill Whistler.*
33. Whistler to Mallarmé, 17 December 1891.
34. J. and E. Pennell, *Life of James McNeill Whistler.*
35. Ibid.
36. Léonce Benedite in 'Artistes Contemporains, Whistler,' *Gazette des Beaux Arts*, vols. XXXIII and XXXIV, 1905
37. *Journal*, December 20, 1892.
38. Whistler to Mallarmé, December 20, 1892 in C.P. Barbier ed., *Mallarmé-Whistler, Correspondence, Histoire de la Grande Amitié.*

7. ORIGINS AND INFLUENCES

1. Walter Richard Sickert, *A Free House.*
2. Edgar Allan Poe, 'The Fall of the House of Usher' (1839), in *Tales of the Supernatural* (London: Penguin, 1967).
3. J. and E. Pennell, *Life of James McNeill Whistler.*
4. Mortimer Menpes, *Whistler as I Knew Him.*
5. Whistler to D.C. Thomson, May 2, 1892, Pennell Collection, Library of Congress, Washington D.C.
6. J. and E. Pennell, *Life of James McNeill Whistler.*
7. Jean Baptiste Camille Corot, *Odilon Redon Journal*, (Paris, 922).
8. *Who's A Dandy?* by George Walden (London, Gibson Square, 2002), contains a commentary and new translation of Barbey's essay.
9. Charles Baudelaire, 'Revue de Paris', March–April 1852, reprinted in *Curiosités Esthetiques* (Paris: Classiques Garnier, 1986).
10. Mallarmé to Whistler, dated October 1896, in C.P. Barbier ed., *Mallarmé-Whistler, Correspondence, Histoire de la Grande Amitié.*
11. Charles Baudelaire, 'Revue de Paris', March–April 1852, reprinted in *Curiosités Esthetiques* (Paris: Classiques Garnier, 1986).
12. Ibid.
13. Walt Whitman, *Civil War*, Ed. Walter Lowenfels (New York: Knopf, 1961).
14. Ibid.
15. *La Vie Parisienne*, 1868.
16. Roger Marx, *Le Japon Artistique*, (Paris, 1891).
17. The brothers de Goncourt, *De Goncourt Journal*, vol. 3 1887-96 (Paris: Laffont, 1989).
18. Mortimer Menpes, *Whistler as I Knew Him.*
19. Ibid.

8. TECHNIQUE: ASPECTS OF INSECURITY

1. Ambroise Vollard, *Pierre Auguste Renoir* (Paris: 1920).
2. Max Beerbohm, *The Works of Max Beerbohm*, (London, The Bodley Head, 1922)
3. Mortimer Menpes, *Whistler as I Knew Him.*
4. J. and E. Pennell, *Life of James McNeill Whistler.*
5. Whistler to Fantin-Latour, quoted by Léonce Benedite in 'Artistes Contemporains, Whistler,' *Gazette des Beaux Arts*, vols. XXXIII and XXXIV, 1905.
6. J. and E. Pennell, *Life of James McNeill Whistler.*
7. Ibid.
8. Henri Loyrette, *Degas* (Paris: Fayard, 1991).
9. Walter Richard Sickert, *A Free House.*
10. Ibid
11. Bernhard Sickert, *Whistler* (London: Duckworth 1908; New York: E.P. Dutton 1908).
12. J. and E. Pennell, *Life of James McNeill Whistler.*
13. Mortimer Menpes, *Whistler as I Knew Him.*
14. Ibid
15. Edward Burne-Jones, *Burne-Jones Talking*, Ed. Mary Lago (London, 1982).
16. John Everett Millais, *Millais Speaks* (London, 1899).
17. Walter Richard Sickert, *A Free House.*

Notes

18. Mortimer Menpes, *Whistler as I Knew Him*.

19. Ibid.

20. Ibid.

21. Ibid.

22. Ibid.

23. Ibid.

24. Walter Richard Sickert, *A Free House*.

25. J. and E. Pennell, *Life of James McNeill Whistler*.

26. Walter Richard Sickert, *A Free House*.

27. J. and E. Pennell, *Life of James McNeill Whistler*.

28. Tom Pocock, Chelsea Reach: *The Brutal Friendship of Whistler and Walter Greaves* (London: Hodder and Stoughton, 1970).

29. Mortimer Menpes, *Whistler as I Knew Him*.

30. Greaves quoted in J. and E. Pennell, *Life of James McNeill Whistler*.

31. T.R. Way, *Memoires of James McNeill Whistler*.

32. Bernhard Sickert, *Whistler* (London: Duckworth 1908; New York: E.P. Dutton 1908).

33. James McNeill Whistler, *The Gentle Art of Making Enemies*.

34. Whistler's letters to Fantin-Latour, published by Léonce Benedite in 'Artistes Contemporains, Whistler,' *Gazette des Beaux Arts*, vols. XXXIII and XXXIV, 1905.

35. Whistler, *Propositions No 2*, May 1884.

36. Max Beerbohm, *The Works of Max Beerbohm*, (London, The Bodley Head, 1922)

37. J. and E. Pennell, *Life of James McNeill Whistler*.

38. James McNeill Whistler, *The Gentle Art of Making Enemies* (London and New York: Heinemann 1890, enlarged 1892).

39. Walter Richard Sickert, *A Free House*, ed. Osbert Sitwell (London: Macmillan, 1947).

40. Ibid.

41. Joris Karl Huysmans, *Certains* (Paris: Unions Générales d'Editions 1889).

42. Volume 19, *Studies in the History of Art*, 'J. McNeill Whistler, A Re-examination', National Gallery of Art, Washington.

43. *Academy and Literature*, July 25, 1903.

9. RESTORATION: THE ELUSIVE ORIGINAL

1. J. and E. Pennell, *Life of James McNeill Whistler*.

2. Denis Rouart, *Degas: In Search of His Technique* (New York: Rizzoli, 1988).

3. Sarah Walden, *The Ravished Image*, with a foreword by Ernst Gombrich (London: Weidenfeld 1984; New York, St Martins, 1985). To be re-published in Autumn 2003 by Gibson Square Books.

4. J. and E. Pennell, *Life of James McNeill Whistler*.

5. Greaves quoted in Pennell, *Life of James McNeill Whistler*.

6. *Chronique des Beaux Arts*, 1891, quoted in James McNeill Whistler, *The Gentle Art of Making Enemies*.

7. Jacques-Emile Blanche, *Essais et Portraits*.

8. J. and E. Pennell, *Life of James McNeill Whistler*.

9. Ibid.

10. Beardsley to Scot Clarkson, 1891, quoted in Pennell's *Life of James McNeill Whistler*.

11. Daniel Halevy, *Degas Parle* (Paris: La Palatine, 1960).

CONCLUSION

1. Irving Howe, *The American Newness* (Cambridge, Mass, Harvard University Press, 1987).

2. Walter Richard Sickert, *A Free House*.

3. Whistler, 'Ten O'Clock Lecture', in James McNeill Whistler, *The Gentle Art of Making Enemies* (London and New York: Heinemann 1890, enlarged 1892).

INDEX

Index

Index